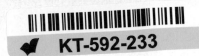

David Hockney

EDITED BY PAUL MELIA

Manchester University Press

Manchester and New York

distributed exclusively in the USA and Canada by St. Martin's Press

Published by Manchester University Press
Oxford Road, Manchester M13 9NR, UK
and Room 400, 175 Fifth Avenue, New York NY 10010, USA

Distributed exclusively in the USA and Canada
by St. Martin's Press, Inc.,
175 Fifth Avenue, New York, NY 10010, USA

British Library Cataloguing-in-Publication Data
A catalogue record is available from the British Library

Library of Congress Cataloging-in-Publication Data applied for

ISBN 0 7190 4404 9 *hardback*
ISBN 0 7190 4405 7 *paperback*

Designed by Max Nettleton FCSD
Typeset by Koinonia, Bury
Printed in Great Britain
by Bell and Bain Ltd, Glasgow

Contents

Illustrations

Measurements are given in centimetres and inches, height before width. Hand-printed titles vary on some of Hockney's editioned works. In some cases the editor and the artist's agents have been unable to trace the present owners of a work.

Plates

0.5—7
A Lawn Sprinkler, 1967, acrylic on canvas, 122 x 122 cm (48 x 48 in.)
PRIVATE COLLECTION

1.1—11
Cecil Beaton, photograph of the artist, Peter Schlesinger and model with *Christopher Isherwood and Don Bachardy*, 1968, acrylic on canvas, 212 x 304 cm (83.5 x 119.5 in.). Photograph published in *Vogue*, December 1968

1.2—14
'The Scene', tourist map, *Time*, 15 April 1966

1.3—17
The artist with *A Grand Procession of Dignitaries in the Semi-Egyptian Style*, 1961, oil on canvas, 214 x 367 cm (84 x 144 in.). Photograph published in *Queen*, 27 February 1962

1.4—17
The artist with *Life Painting for a Diploma*, 1962, oil on canvas with paper, 122 x 91.5 cm (48 x 36 in.). Photograph published in *Town*, September 1962

1.5—19
Photograph of the artist published in *Daily Express*, 3 May 1965

2.1—30
'A Black Cat Leaping', 1969, etching and aquatint, 24 x 28 cm (9.5 x 11 in.), from *Illustrations for Six Fairy Tales from the Brothers Grimm*. Edition of 100

2.2—32
Leaping Leopard, 1962, ink on paper, 33.5 x 49 cm (13.25 x 19.25 in.)
PRIVATE COLLECTION

2.3—37
'Cold Water about to Hit the Prince', 1969, etching and aquatint, 39 x 28 cm (15.5 x 11 in.), from *Illustrations for Six Fairy Tales from the Brothers Grimm*. Edition of 100

2.4—38
Seated Woman Drinking Tea, Being served by Standing Companion, 1963, oil on canvas, 198 x 213 cm (78 x 84 in.)
PRIVATE COLLECTION

2.5—39
The Cha-Cha that was Danced in the Early Hours of 24th March, 1961, oil on canvas, 173 x 158 cm (68 x 60.5 in.)
PRIVATE COLLECTION

2.6—41
Doll Boy, 1960-61, oil on canvas, 122 x 99 cm (48 x 39 in.)
HAMBURGER KUNSTHALLE, HAMBURG

2.7—42
A Bigger Splash, 1967, acrylic on canvas, 243.8 x 243.8 cm (96 x 96 in.)
TRUSTEES OF THE TATE GALLERY

2.8—45
The Fourth Love Painting, 1961, oil on canvas with Letraset, 91 x 72 cm (36 x 28 in.)
PRIVATE COLLECTION

2.9—46
We Two Boys Together Clinging, 1961, oil on board, 122 x 152.5 cm (48 x 60 in.)
THE ARTS COUNCIL OF GREAT BRITAIN

Contributors

NANNETTE ALDRED
teaches the history of twentieth-century visual culture at the University of Sussex. She has written on Graham Sutherland and on the films of Powell and Pressburger. She has also written for the German Film Museum, Frankfurt, and has contributed articles to *The British Journal of Aesthetics*, *Creative Camera* and the forthcoming *Encyclopedia of Twentieth-Century Culture*.

ANDREW CAUSEY
Senior Lecturer in History of Art at Manchester University, has published widely on twentieth-century British art and is author of monographs on Paul Nash (1980) and Edward Burra (1986). He is currently writing a book on sculpture since 1945.

SIMON FAULKNER
lectures in the History of Art at the Manchester Metropolitan University. He is presently involved in preparing a Ph.D. dissertation on the London art world during the 1960s.

WILLIAM HARDIE
was Keeper of Art and Deputy Director of Dundee City Art Galleries and Museums and also Director of Christie's (Scotland) before founding the William Hardie Gallery, Glasgow, in 1984. He has written several catalogues and numerous articles for periodicals, is the translator of the *Larousse Dictionary of Modern Art* and the author of *Scottish Painting from 1837 to the Present* (1990).

PAUL MELIA
lectures in the History of Art at Manchester and Staffordshire Universities and lives in Manchester. His published works include *David Hockney: We Two Boys Together Clinging* (1993) and *David Hockney: Paintings* (1994), written with Ulrich Luckhardt. With Luckhardt he curated the 1995-96 retrospective exhibition of Hockney's drawings.

ALAN WOODS
teaches art history at Duncan of Jordanstone College of Art, a faculty of Dundee University, and lives in Edinburgh. He writes regularly for *The (Glasgow) Herald* and *The Cambridge Quarterly*, and has also written for *Critical Quarterly*, *Modern Painters*, *Sight and Sound*, *The Literary Review*, *Alba* and *Edinburgh Review*. He is founding editor of *Transcript*, a journal of the visual arts and is presently writing a book on the work of Peter Greenaway.

Acknowledgements

The editor would like to thank Andrew Causey and Paul Dewhirst for their advice, and Dimitri Aretakis for his encouragement.

The editor and publishers are grateful to David Hockney, without whose co-operation this book would not have been published, and to Karen S. Kuhlman, Courtney Crane and Cavan Butler who provided material for many of the illustrations.

Introduction

PAUL MELIA

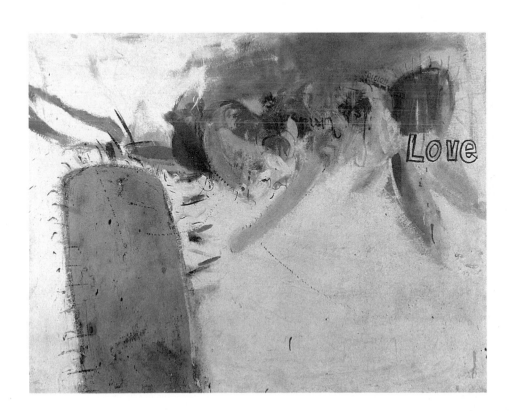

0.1
The First Love Painting,
1960

It is surely beyond dispute that David Hockney is now regarded as one of the most distinctive post-war artists. Born in Bradford in 1937, he attended the local School of Art from 1953 to 1957. Typical paintings from this period show working-class domestic scenes, people at leisure and the urban landscape of Bradford (see for example Figure 0.2). The realism of these works depended upon a set of beliefs concerning the function of art and the role of the artist which derived from the Euston Road School and the so-called Kitchen Sink painters (one of whom, Derek Stafford, was his teacher).

The young Hockney displayed a strong ethical stance. After leaving Bradford School of Art he registered as a conscientious objector and, as an alternative to armed service, worked in the National Health Service for two years. During this time he designed political posters for the Campaign for Nuclear Disarmament, attended the 1958 march to the atomic weapons research centre at Aldermaston, subscribed to *Peace News* and became a militant vegetarian, handing out leaflets condemning cruelty to animals. The principal attraction of CND to Hockney was probably that it served as a vehicle for protest outside class-organised politics; accordingly, humanitarian and moral issues –

0.2
Bolton Junction, Eccleshill,
1956

marginal to traditional analyses of class politics – were central.

It was with these commitments that Hockney enrolled at the Royal College of Art, London, in 1959 for a three-year post-graduate course in painting. The move was important for a number of reasons. There was a greater variety of influences on, and options for, artists, as well as a discernible avant-garde tradition with its own means of exhibition. Consequently, a major shift occurred in Hockney's practice. Taking as his example the work of older British and American abstract artists – such as Alan Davie, Roger Hilton and Jackson Pollock – he played down his earlier concern with social realism and spent the

0.3
November, 1959

beginning of his course producing abstract paintings (Figure 0.3). Like other students, he subscribed to the idea that painting should communicate the artist's subjectivity through the expressive use of form, colour and surface. Abstraction did not provide him with the technical means to address those moral issues which interested him, however: 'American abstract expressionism was the great influence. So I tried my hand at it, I did a few pictures, about twenty ... and then I couldn't. It was too barren for me' (Hockney 1976: 41).

In a number of works produced towards the end of his first year at college, Hockney began to move away from the purely abstract. For example, a series of works, which were either painted over or have since disappeared, deal with the subject of vegetarianism. They had titles like *Two Cabbages* and *Bunch of Carrots*, vegetables signified by patches of colour or by words written in paint – 'lettuce', 'tomatoes', 'cabbages'. As *The First Love Painting* (Figure 0.1) demonstrates, by this time he was no longer prepared to adhere totally to the tenets of abstraction. The phallic shape, an explicitly sexualised sign for a male, and the words 'love' and 'suspicion' inscribed upon the surface demonstrate a wish to maintain the human figure as a viable subject for painting and to deal with a theme of specific interest. Hockney had begun to address moral preoccupations such as vegetarianism and male homosexuality – which other artists either avoided or did not have the technical means to include. This shift distinguishes not only Hockney's work of the early sixties but also that of his fellow students. In different ways, the paintings of Derek Boshier, Pauline Boty, Allen Jones, R. B. Kitaj and Peter Phillips demonstrate a renewed confidence in realism. During 1961 and 1962 their work came to be perceived as a development of Pop Art in Britain, and Hockney, whom critics found an engaging and articulate subject, lent himself readily to the role of pop-star of painting.

As the titles of his submissions to the Young Contemporaries exhibition of February 1962 may suggest – *Figure in a Flat Style*, *Tea Painting in an Illusionistic Style*, *Swiss Landscape in a Scenic Style* (Figure 5.1), and *A Grand Procession of Dignitaries in the Semi-Egyptian Style* – artistic style also became the object of considerable attention while at the College. His self-consciousness about style, and his interest in ancient Egyptian art which does not betray the individuality of its maker, suggest that the received idea of style as an index of the artist's inner self could no longer facilitate a full, imaginative engagement: it was capable of giving rise only to work characterised by visual cliché. This experience was not peculiar to him; it was one that many artists of his generation shared, in both Britain and America, and one that they, too, dealt with in their work, crucially so in paintings by Jasper Johns. By using several styles in one picture – that is, by bringing two contrasting conceptions of painting into sharp focus on one canvas – questions pertaining to resemblance and illusion, picturing and naming became the subject of investigation and exegesis within Hockney's art.

In many paintings produced in London following his graduation, including *Domestic Scene, Notting Hill* (Figure 4.5), *The First Marriage (A Marriage of Styles I)* and *Picture Emphasizing Stillness* (Plate 1), Hockney continued to be

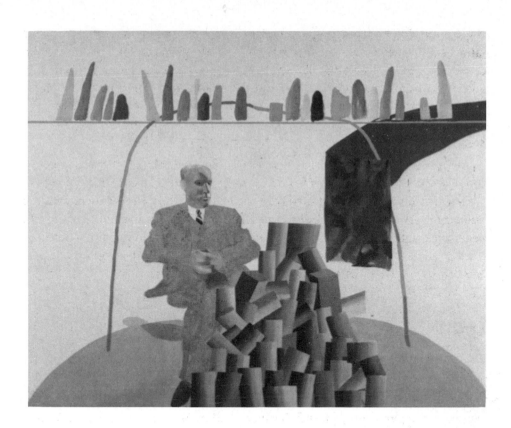

0.4

*Portrait Surrounded by
Artistic Devices*, 1965

preoccupied with style, with received ideas about painting and with depicting incongruous relationships, both homosexual and heterosexual ones. Following his visit to the city in 1964, Hockney decided to use Los Angeles as a base throughout the sixties and, by the end of that decade, had come to be identified as *the* painter of southern California. However, the works produced should not be regarded as ingenuous portrayals – as they have been and often still are – of either his first, or subsequent, impressions, as Chapters 3 and 5 argue.

Between 1965 and 67, Hockney drew liberally on both Modernist abstraction and Minimalism. *Portrait Surrounded by Artistic Devices* (Figure 0.4) can be understood as one result of such an encounter. Since the title of the painting informs us that he has depicted a portrait, and not merely a figure, the other elements also have to be understood as being visual citations. The abstract marks are 'quotations' from American abstraction, as is the technique of staining unprimed cotton duck with diluted acrylic. The shadow and the pink circular floor derive from the work of Francis Bacon, however. The painting can be understood neither simply as a parody of abstraction – in the way that his 1963 painting *The Snake* parodies the work of Kenneth Noland – nor just as a 'marriage of styles'. Rather, it exemplifies his desire to resolve the schism between abstraction and figuration that had existed for a number of years within the professional world of modern art. In paintings he produced over the next two years, the artist put into practice the precepts of *Portrait Surrounded by Artistic Devices*. About *A Lawn Sprinkler* (Figure 0.5) Hockney has written,

'Before the sprinkler was put in, before the windows were put in, it looked at one point exactly like a symmetrical Robin [sic] Denny painting' (Hockney 1976:126). In *Savings and Loan Building* (see Figure 3.7), six palm trees are shown in front of a visual cliché for Minimalism.

Towards the end of 1967, at the very moment critics sought to defend the crumbling authority of Modernism, however, Hockney began to pursue a more naturalistic manner of representation, finding the move as exciting as the discovery of an avant-garde technique. *The Room Tarzana* (Figure 3.9) and *The Room, Manchester Street*, two paintings from the autumn of 1967, mark the beginning of a ten-year period spent making large portraits, just under life-size, many of them featuring two people, friends or relations. This series includes such major canvases as *Christopher Isherwood and Don Bachardy*, *Mr and Mrs Clark and Percy* and *Model with Unfinished Self-Portrait* (see Figures 4.6 and 4.7, and Plate 9).

During the mid-seventies, Hockney produced relatively few paintings, electing to concentrate instead on a series of drawings and etchings, often executed in an academic manner. In his autobiography he writes of a painting block and the 'trap' of naturalism. Despite the difficulties he experienced in practice, however, Hockney had become an influential member of an informal group of artists and critics who sought to reinstate the human figure as a subject fit for modern painting at a time when the authority of Modernist theory was in decline. In January 1977, for example, the *New Review* published a conversation between R. B. Kitaj and Hockney in which they called for a return to figurative painting. During the conversation, in a moment of exasperation, Hockney exclaimed, 'What I don't understand is this: why is it that Seurat could study a painter of 300 years before – Piero della Francesca – and produce in 1880 a version of Piero's ideas, updated or progressed or whatever word you want to say, and if that was valid in 1880 why is it not valid in 1977?' Two years later, in an article for the *Observer* (4 March 1979), 'No Joy at the Tate', Hockney discussed official British attitudes towards modern art and criticised the Tate's director and the Tate's purchasing policy for being biased in favour of non-representational art. (His article initiated a debate which was covered in subsequent issues of the newspaper.) *Looking at Pictures on a Screen*, one of a number of paintings from 1977 which herald his return to painting, shows Henry Geldzahler looking at reproductions of works by four great painters of the human figure, Vermeer, Piero della Francesca, van Gogh and Degas. The painting serves as evidence of Hockney's need to recover a sense of contact with the European tradition to which, it is implied, his own work belongs.

During the late seventies and early eighties, Hockney produced a series of works – including *Mulholland Drive: The Road to the Studio* (Plate 12) – in which he adopted a certain informality of technique. He also introduced new stylistic characteristics (the juxtaposition of stronger colours, for instance) to suggest directness of observation, spontaneity of expression and freedom from the conventions of naturalism, to which he had felt himself increasingly bound

during the seventies. With such works, Hockney appeared to advocate a 'new spirit in painting', a return to 'humanistic' themes, in opposition to the perceived aberrant departures of late Modernism.

Between 1982 and 1984, however, he temporarily abandoned painting and turned to photo-collage, producing over 400 in the space of some two years. These works signalled a change in Hockney's preoccupations: by emphasising the surface of the work, thereby drawing attention to the material aspect of the visual sign, and by including devices to intensify the viewer's awareness of the activity that is required to make images signify, Hockney was clearly preoccupied with the technical concerns of early modern artists, especially the Cubists. (In a lecture delivered at the Victoria and Albert Museum in London during 1982, Hockney spoke of his photo-collages in terms of Cubism's 'destruction of a fixed way of viewing'). At various moments in the early eighties, Hockney became interested in seeing how his new understanding of representation – gained from his work with the camera – would translate into the media of drawing, printing and painting. Indeed, there is a strong case to be made for viewing all of Hockney's work of the mid-eighties as facets of a single

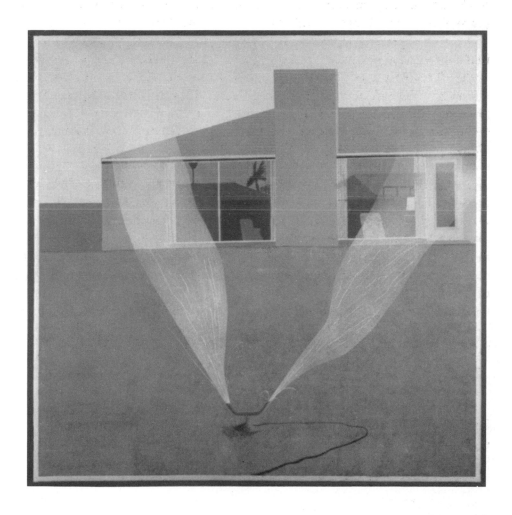

0.5
A Lawn Sprinkler, 1967

unified activity. In the last decade, he has worked in a variety of media and used relatively new technology, such as the fax and photocopier machines, to produce prints and multiples. Chapter 7 of this book offers an over-view of his activities.

Despite a veritable plethora of publications on Hockney over the last two decades – particularly during the last seven years – detailed discussions and analyses of his work are largely noticeable by their absence. As Marco Livingstone observed some thirteen years ago, articles and reviews 'are at once too numerous and too slight to mention.' (Livingstone 1981: 245). As might be expected, articles produced for immediate consumption – exhibition reviews, for example – lay stress on artistic technique and style or focus on the 'colour-ful' personality of the artist. Although they vary in approach and reliability, the catalogues published to accompany the numerous Hockney exhibitions, often contain introductory essays and even commentaries on individual works. Few match the sustained level of interest of Andrew Brighton's introduction to the 1979 catalogue published to accompany the exhibition *David Hockney: Prints 1954-77*, however. It is one of the few essays on Hockney's work which can be recommended as essential reading. If, as Peter Webb has estimated, Hockney's work is now exhibited 'somewhere almost everyday of the year' (Webb 1988: 245), there is then a pressing need for catalogue essays and even whole exhibitions which focus on particular paintings or themes in his *œuvre*.

David Hockney, Livingstone's 1981 monograph written for Thames and Hudson's 'World of Art' series, was the first study of the artist's career and remains the basic handbook for students and the general reader; a revised edition was published in 1987. Each point is illustrated by reproductions and there is a clear and methodical account of the artist's stylistic development. Webb's 1988 unauthorised biography, which draws on interviews with Hockney and the artist's friends, models and associates, offers useful biograph-ical information and reproduces little-known works. While further monographs will doubtless be produced the limitations inherent in the format should not be forgotten; the work, discussed chronologically, is interwoven with a biography of the artist. A descendent of the nineteenth-century 'Life and Letters', it is based on the assumption that the meaning of the work can be deduced from the life and the intentions of the artist – a topic discussed in Chapter 2 of this volume.

What is significant about much of the literature on Hockney, however, is how difficult it seems for authors to get away from the assumptions and omis-sions of *David Hockney by David Hockney: My Early Years*, the first volume of the artist's autobiography, published in 1976. Although Hockney's account of the genesis of his paintings is extremely persuasive, his descriptions – often highly amusing – do little to elucidate their meaning. Hockney is not the first artist to protect the generative conditions of his art with trivial but appealing explana-tions.

The scholarly catalogue published to accompany the 1988 retrospective

exhibition of the artist's work – complete with a biography, bibliography, and the professional, exhibiting and teaching record of the artist – signalled a shift in Hockney studies. Four of the six chapters focused on aspects of Hockney's work – Gert Schiff's essay examines Hockney's dialogue with Picasso, for example. This shift is still far from complete, however, and it is hoped that this book will contribute to the move into more critical and speculative territory.

This volume offers a range of approaches to understanding particular moments or themes in Hockney's *œuvre*, from a focused study of a single painting to the analysis of an entire phase in the artist's career. In Chapter 1 Simon Faulkner discusses Hockney's place within 'Swinging London', and identifies the problems it has posed for critics and academics who have subsequently sought to ratify both the artist and his work. Alan Woods deals primarily in Chapter 2 with a single painting from 1962, *Picture Emphasizing Stillness*. In its examination of temporality in static images, and in its theatrical manipulation of the viewer, Woods shows that the painting is prophetic of Hockney's later work, from the 'Splash' paintings of the mid-sixties through to the photo-collages of the early eighties. But he is also concerned with how the painting has been discussed by both the artist and critics and with what their accounts tellingly overlook. In Chapter 3, my own contribution, I discuss the significance of Hockney's move to Los Angeles and consider why he represented the city as a tropical utopia – as though it were an outpost of an empire – rather than one of the most super profitable centres of industry in the world. Hockney's portraits and figure paintings are examined by Nannette Aldred in Chapter 4. Although she begins her discussion with works from 1961 to 1963, she is principally concerned with his large double portraits from the late sixties and seventies. She discusses Hockney's use of metonym and of a complicated perspectival system, and shows how they are both employed in order for Hockney to represent his relationship to his sitters: the double portraits are, she argues, records of a *triangular* relationship. Her contribution concludes with a consideration of two self-portraits from 1977, in which, through a process of visual displacement, Hockney identifies himself with Picasso at the very moment he was publicly advocating a return to figurative painting.

Andrew Causey begins Chapter 5 with a consideration of Hockney's landscape paintings, extending his discussion to include several portraits – of friends and collectors – and a number of photo-collages from the early eighties. He considers both the manifest facticity of these works and the artist's appropriation of 'readymade' images (including visual clichés), arguing that their facticity is tellingly associated with some historical forms of realism. In Chapter 6, his second contribution to this volume, Alan Woods considers Hockney's photographs and photo-collages and their relationship to the artist's practice as a painter. He argues that the photo-collages, which constitute one of the most important sections of Hockney's entire *œuvre*, extend the exploration of the means of representation evident in his paintings of 1980 – *Mulholland Drive*, for example. In the final chapter, William Hardie offers an overview of the

artist's recent work – the *Home Made Prints*, the *Very New Paintings*, and the recent designs for operas – and suggests connections between it and work from earlier moments in the artist's career.

This book, then, does not attempt to discuss all aspects of the artist's career; rather, it is intended to provide a critical introduction to Hockney's work. We hope it will aid and encourage others to study the artist's work in further detail.

Note

1
See, for example, Michael Fried's essay, 'Art and Objecthood', published in *Artforum*, Summer 1967.

I

Dealing with Hockney

SIMON FAULKNER

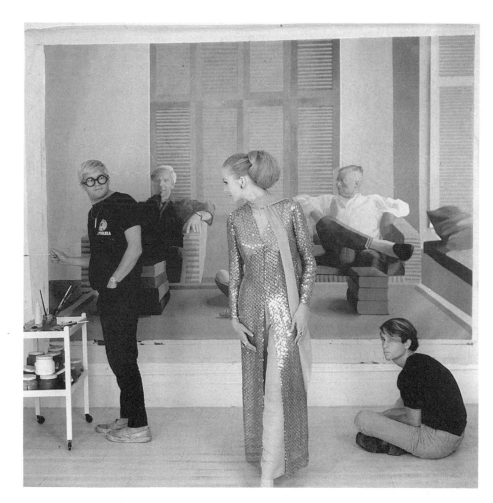

1.1 Cecil Beaton
Photograph of the artist,
Peter Schlesinger and
model. 'David Hockney's
studio, the painter working
on a portrait of
Christopher Isherwood
and Don Bachardy. The
girl wears pale lilac
sequins all of a shiver over
pure chiffon culottes, and a
chiffon muffler. By Leslie
Poole, 85 gns together,
from Adele Davies, 4
Beauchamp Place, s. w. 3.
Rings and earrings from
Hooper Bolton [...] The
hair throughout by Roger
of Vidal Sassoon. For sizes,
colour, see Stockists',
Vogue, December 1968

The practice of David Hockney has been an anomaly within the mainstream history of post-1960 British art. Although he has been given a significant place in that history, his status is contested. His adoption of a form of naturalism in the mid-sixties has, in terms of the conventional assumptions concerning progress in modern art, been viewed by many as a retrogressive step. There is a tendency within the art world to view him as a 'lightweight'. As the artist has observed, 'I have "official recognition", and I haven't. The art world's relation to me has always been ambiguous. They never know exactly where to put the pictures.' (Fuller 1980: 169). However, it has not been only his work which has caused problems for conventional critical ratification, but also his unusual popularity, and his status as a popular figure. This chapter will examine the contexts in which Hockney's public persona[1] was constructed during the sixties, and the reactions of critics and art historians to it, during the seventies and eighties.

The art world and 'The Scene'

To understand the construction of Hockney as a public figure during the sixties, it is necessary to examine the way in which the contemporary art scene was represented in the media during this period. Accounts of both art and culture in London during the early and mid-sixties relate art to a wider picture of a youthful 'cultural revolution'. In a recent discussion of the sixties' art scene, for example, George Melly stated that artists 'weren't just painters and sculptors, but part of a package deal with pop music at the centre' (Melly 1993:38, see also Hewison 1986 and Hebdige 1988). This tendency to link art to other aspects of metropolitan culture, was established during the decade of the sixties itself, when the art boom was represented as part of wider cultural changes. Hockney was central to this relationship.

In 1967, the Professor of Painting at the Royal College of Art, Carel Weight, summarised what he considered to be the changes that had occurred within the London art world during the sixties:

'If you haven't hit the jackpot by the time you are twenty-five, you've had it', said the ambitious young painter and I could not help thinking back to the thirties when I was a student, when London was an artistic backwater boasting of about a dozen dealer's galleries, none of which would seriously consider giving an exhibition to a young painter emerging from art school. The sixties have produced a very different picture; there are at least a hundred galleries and the hunt for the young genius has until recently been the order of the day. (Weight 1967)

As Weight points out, one of the major changes in the London art world which made success for young artists easy to attain, in contrast to the pre-war era, was the opening of a number of new dealer-galleries specialising in contemporary art. The most important of these were the Rowan Gallery and the Robert Fraser Gallery both founded in 1962, and Kasmin Limited, founded in April 1963. John Kasmin, who began selling Hockney's work in February 1961 and became his official dealer in July 1962, was a good example of the shift in attention that this new fraction in the gallery system produced. After leaving Marlborough Fine Art, where he had been working as director of their New London Gallery, Kasmin opened a gallery on Bond Street in partnership with Sheridon Blackwood, the fifth Marquess of Dufferin and Ava. With the exception of Hockney, Kasmin's stable comprised contemporary American and British abstract artists, such as Morris Louis, Kenneth Noland, Anthony Caro and Bernard Cohen. Kasmin introduced the contract system which Marlborough used, whereby the artist signed a three-year renewable contract declaring Kasmin their sole dealer and, in return, received a regular income.[2] Hockney, for example, was actually able to commit himself to painting full-time after he graduated from the Royal College in July 1962. Although the effects of the new support structure provided by these galleries should not be exaggerated – the statements of dealers testify to the difficulty of selling contemporary art during this period (see Aitken 1967: Ch. 8) – it did, as Weight suggests, provide the economic base for the success of Hockney's generation. With Kasmin's promotion Hockney rapidly achieved a degree of commercial success unusual for a young painter. All the paintings in his first solo exhibition at Kasmin Ltd in December 1963 were sold, and the exhibition gained considerable attention from the art press. The two main bodies of official patronage in Britain – the Tate Gallery and the Arts Council – had purchased his work by 1963.

The new galleries and the generation of artists they promoted also attracted a great deal of notice among the press outside the art world. The contemporary art scene formed a significant aspect of the complex cultural world which was, by 1966, represented as 'Swinging London'. The significance of these galleries and artists to the image of the swinging city was shown in a photograph taken to accompany John Crosby's article, 'London the Most Exciting City', printed in the *Sunday Telegraph Magazine*, in April 1965. The photograph shows 17 representatives of the expanding professions of design, fashion, arts and communications, who, the article claimed, were 'some people who make London swing'. Included with Hockney, John Kasmin and Peter Blake, were sixties' notables such as Mary Quant, David Bailey, Gerald Scarfe and Susan Hampshire. David Hall's sculpture *Box* (1965), around which these figures are arranged, was not merely a prop. In 1965, contemporary sculpture was an example of the kind of fashionable avant-gardism associated with Swinging London. Exhibitions of British sculpture were on display at the Tate and the Whitechapel Art Gallery at the time Crosby's article appeared. Through

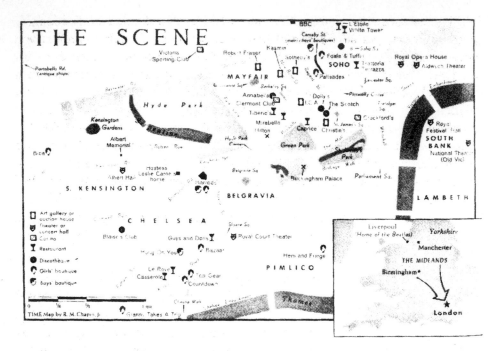

I.2
'The Scene', tourist map,
Time, 15 April 1966

these exhibitions, the established generation of sculptors shown at the Tate –
led by Barbara Hepworth and Henry Moore – was contrasted with the 'New
Generation' of young sculptors shown at the Whitechapel. The marked differ-
ence between these two exhibitions – the former, with its conventional materi-
als, being described as a 'Mausoleum', and the latter as an 'ice cream parlour',
because of the new materials and bright colours used (Lynton 1965) – meant
that the new sculpture was understood within the context of a difference
between staid, 'Establishment' London and the new world which the swinging
scene was taken to represent.[3]

In April 1966, the picture constructed by Crosby of London as youthful and
exciting, after years of post-war austerity, was elaborated in a feature entitled
'You Can Walk across It on the Grass' in the American magazine *Time*. This
brought together on a map (Figure 1.2) what the editors considered to be the
characteristic activities of the 'Swinging City', and the places frequented by a
community which it called the 'new aristocracy'. The article also invented a set
of 'storyboards' for an imaginary film on the subject. The map gave Swinging
London a specific physical geography in which the sites of 'The Scene', which
included the Robert Fraser Gallery and Kasmin Limited, were laid out across
central London. (The Robert Fraser Gallery was also chosen as one of the scenes
for the storyboard, since it was 'currently In enough' to attract members of the
new aristocracy.) The high profile given to contemporary art in the photograph
used in Crosby's article and *Time*'s mapping of Swinging London, indicates that
the contemporary art scene was an important part of this international image of
London life.

The construction of the artist, especially the Pop Artist, as a fashionable personality was part and parcel of the construction of Swinging London, and began as early as 1962, in Ken Russell's BBC 'Monitor' programme *Pop Goes the Easel*. This focused on four young artists: three postgraduate students from the Royal College – Derek Boshier, Pauline Boty, Peter Phillips – and Peter Blake who graduated from the Royal College in 1956. The programme did not concentrate on the artists at work, but on their life and lifestyles outside the studio. For example, Peter Phillips is presented as a cool representative of mod youth, shown at one point in the film driving through London in an American car to the sounds of fashionable modern jazz. After seeing an early version of the film, the editor of 'Monitor', Huw Wheldon, complained that the programme only showed 'a lot of wankers drifting about, playing pintables', and he insisted that Russell show the artists discussing their work (Ferris 1990: 152).

Hockney's promotion as a public figure was concurrent with the construction of the artist as a fashionable type within Swinging London. He contributed to, and benefited from, the development of this image of young artists. Contemporary art became important to journalists who were eager to link different areas of culture in an image of the so-called 'youth boom', and as the next section shows, by the mid-sixties, Hockney had become a symbol of these associations.

Hockney as swinger

The early sixties were marked by a new culture of publicity produced by the expansion of the mass media. It was at this time that the term 'image' – used to define the way in which products, whether consumer goods or 'beat' bands, were promoted – entered common language, from the advertising and public relations industry (Booker 1969: 42; and see Nevett 1982: Ch. 8). At the Royal College of Art Hockney showed an understanding of image construction and self-promotion, and developed a variety of strategies for drawing attention to himself and his work. Peter Webb describes how, at the beginning of the first term in 1959, Hockney wore a blue boilersuit and a German Panzer unit cap in order to establish himself as an eccentric personality (Webb 1988: 27). He gave long titles to his paintings at the annual 'Young Contemporaries' exhibition in 1962, so that they would require more space in the catalogue, drawing attention to his name. He dyed his hair during his first trip to the United States in 1961; this 'thatch of blond hair' subsequently became the main element of his public persona. In 1962, when Hockney started to receive attention from the press, his dyed hair became a sign of youthful unconventionality. Perhaps his most well-known strategy was his decision to wear a gold lamé jacket at the award ceremony for his diploma in July 1962. This act of levity was a symbolic gesture against the academic structure of the painting course and the sensibilities of its staff, who were representatives of what Andrew Ross has called the 'tweedy

sponsors of European tradition' (Ross 1989: 148). By wearing an item of clothing popularised by the rock and roll stars of the fifties, Hockney light-heartedly transgressed high cultural 'good taste'. He developed these strategies at a time when the studios in the painting department had become almost like a gallery, with visitors arriving every day to see the 'exhibits'.

Hockney was obviously adroit in handling situations for specific promotional effects. This is not to suggest that he developed these activities within a structured agenda for gaining success; his tactics seem more opportunistic than planned. But, as a student determined to succeed in the art world without the support of an independent income, Hockney clearly understood that any promotional opportunity was useful.

Towards the end of his course, Hockney received attention from magazines not directly connected to the art world, including the revamped 'glossies' *Man About Town* (hereafter *Town*), purchased by Michael Heseltine and Clive Labovitch in 1960, and the 'society' magazine *Queen*, bought by Jocelyn Stevens in 1957. By the beginning of the sixties *Town* and *Queen* were well established in the practice of representing glamorous lifestyles to their limited readerships, estimated to be jointly around 120,000 in 1961 and consisting mainly of the upper middle and upper class in London (Booker 1969: 47). By the mid-sixties they were promoting new lifestyles to an affluent and fashion-conscious young constituency. *Queen* was 'no longer aimed at the society deb and her parents, but the Chelsea girl of "Swinging London"' (Whiteley 1987: 107); while *Town* was aimed at a similarly 'with it' male readership. The newspaper colour supplements, beginning with the *Sunday Times Colour Magazine* in 1962, performed a similar function to the glossies but for a larger and more diverse readership. By the mid-sixties all these publications, along with British *Vogue*, were supplying their limited markets with a steady diet of glamour, affluence and youthful iconoclasm. They constituted what David Mellor has termed 'mechanisms of celebrity', by which a stock of young personalities were promoted as representatives of changes in London's cultural life (Mellor 1993: 143). 'Young London', published in *Vogue* (May 1964), was representative of the articles in which this occurred. It presented a number of young personalities, and proclaimed that London was 'a city of and for the young', where 'enthusiasm, energy, iconoclasm' abounded, through the practices of a 'new aristocracy of talent'. It was this conception of London which was reproduced by Crosby in 1965 and *Time* in 1966.

'Here and Now', a feature in *Queen* (February 1962), reproduced a photograph of Hockney (Figure 1.3) in front of his painting *A Grand Procession of Dignitaries in the Semi-Egyptian Style* (1961). He was defined in the accompanying text as a witty young talent (an image that was reproduced by subsequent reports). But unlike later photographs, the centre of attention here was the painting: Hockney is out of focus and is appropriately described in the text as an 'emergent blur' – Mellor suggests that this 'blur' can be taken to

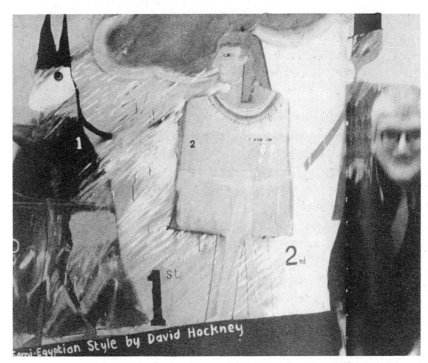

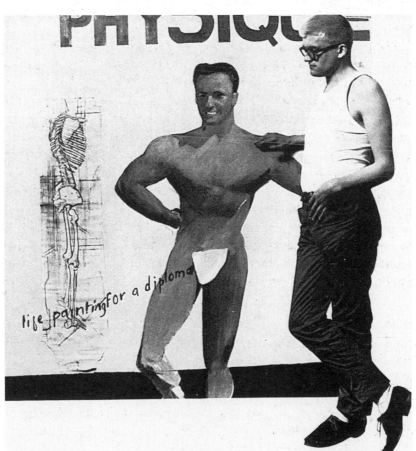

signify the velocity of his perceived success (Mellor 1993: 143). As his reputation increased, however, the various reports on Hockney between 1962 and 1965 increasingly defined him as a personality separate from his work. For 'Clown With Vision', a feature by Emma Yorke in *Town* (September 1962), Hockney was photographed in front of his *Life Painting for a Diploma* (1962) (Figure 1.4), which he claims to have painted in order to satisfy the Royal College's requirement that students produce a certain number of life-paintings. The picture is a travesty of this academic practice, the purpose of which is to refine observational skills. By presenting a figure which was clearly not from life, Hockney displayed his disregard for academic convention. With its quotation of the figure and the section of title at the top from a magazine, the painting is closer to Pop Art than to academic life-painting. It is perhaps significant that Yorke does not comment on the fact that Hockney's nude is male, nor that it is appropriated from the Los Angeles *Physique Pictorial*, a homoerotic magazine. The homosexual meanings of Hockney's work appear to have been overlooked not only in this article, but elsewhere in the media during this period. Nevertheless, the irreverence evident in his act of iconoclasm was paralleled in other material in the magazine. This issue of *Town* was called 'The Young Take the Wheel' and concentrated on images of disrespectful and socially ascendant youth – themes which were among the staples of the glossies.

Hockney's clowning is thus presented as part of a broad social movement. This feature in *Town* was followed by 'British Painting Now', an article by David Sylvester printed in June 1963 in the *Sunday Times Colour Magazine*. The article included photographs of Hockney in the street and in his flat wearing the gold lamé jacket he had worn for his graduation. This re-presentation of his earlier act of iconoclasm established the jacket as a central sign in the Hockney myth and defined him as someone whose life was characterised by acts of unconventionality. Hockney stated in 1967: 'In a way I regret buying that Bloody Coat. For I think people thought I had worn it every day. In actual fact I only wore it twice' ('The Point is in Actual Fact' *Ark* 10, 1967). This comment attests to the construction of an image, which once re-presented by the press, made it difficult for people to gain an appreciation of the complexities of his life. The distance between Hockney's person and his public persona as one of the people who made London swing is paralleled by his actual absence from London during much of the sixties.

The public presentation of Hockney was extended in 1965 by his inclusion in the series of portraits by David Bailey, collected as the *Box of Pin-ups*. This photograph showed Hockney against a white background, wearing a broadly striped shirt, a casual jacket and round sunglasses. The shirt is worn open necked and is not tucked in at the waist, while the jacket is stretched outwards from his body by his hands which are in its pockets. This image marked a shift in the development of this public persona, as the portrait did not include any signs of his profession. By then Hockney was sufficiently well known outside the art world for an image separate from his art to be constructed. Bailey's *Box*

constituted a personal representation of the community which formed the core of Swinging London and was aimed at a market similar to that of the glossies. It defined Hockney as one of the personalities of the scene – placing him along-side fashionable figures such as Michael Caine, Jean Shrimpton, John Lennon and Mick Jagger. Bailey's portrait of Hockney can be seen as a point in the process through which Hockney's image was transformed from that of the eccentric artist of the early articles to a symbol of outlandish youthful style and ostentation. His fashionableness distinguished him from the conventional image of the artist as bohemian, his appearance being closer to that of the contemporary Soho mod.

A *Daily Express* article on men's fashion, 'The Young Peacock Cult', printed in May 1965, showed Hockney alongside designers from the Royal College (Figure 1.5). This also concentrated on Hockney's appearance, using it to promote specific items of contemporary clothing. The accompanying text, based on an interview, pays great attention to this image – his 'thatch of blond hair, owlish heavy black specs' and his colourful attire. References to his expensive tastes – 'I've got a black silk [suit] ... It cost me £50' – were mixed with descriptions of his unconventional and 'chaotic' dress sense – his 'fluorescent shirts' and 'dayglo socks' (Prust-Walters 1965). Here the penchants of the youthful metropolitan rich for extravagant consumption were combined with forms of sartorial iconoclasm. The article states that colour is the only criterion Hockney employs to choose his attire, making reference to his status as a colourful Pop Artist. It contrasts his taste with the conventional men's fashion that, within the reporting of Swinging London, was taken as a symbol of Establishment and 'square' Britain.

These representations of Hockney from 1962 to 1965 can be read as pointers to the formation of the elite community which was to be represented as Swinging London. The early articles in the glossies, especially 'Clown with Vision' (*Town*, September 1962), presented Hockney as an eccentric, whose humorous comments at the expense of 'grey' Britain were compatible with the anti-Establishment attitudes of the contemporary 'satire boom'. This boom had begun with the opening of the Establishment Club in Soho, and the founding of *Private Eye*, both in late 1961. These were aimed at a young upper and upper middle-class constituency from Chelsea and Belgravia. This constituency also formed much of the readership of the glossies and the clientele of clubs in Mayfair, such as the Saddle Room which opened in the summer of 1961. The satire boom, the glossies and these new clubs were part of the culture of a group within the metropolitan upper classes, who saw themselves as unconventional.

The re-presentation of Hockney's iconoclasm in the glossies had meaning for this constituency. The later images produced in 1965 – David Bailey's portrait of Hockney and the *Daily Express* article 'The Young Peacock Cult' – which present Hockney as highly fashion conscious, can be related to a shift in the centre of fashionable London from the almost exclusively upper and upper

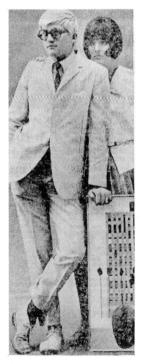

1.5
Photograph of the artist published in *Daily Express*, 3 May 1965

middle-class milieu of Chelsea, Belgravia and Mayfair, to the world of the new aristocracy around clubs like the Ad Lib in Soho. The Ad Lib opened in February 1964 and by 1965 had become the centre of an exclusively young, highly image conscious and supposedly classless world of clubs, restaurants and boutiques frequented by the famous and the fashionable. In this world the members of the upper classes mixed with new working class celebrities – pop stars, fashion photographers and actors. By 1965, the fashions and youth lifestyles of Swinging London were being disseminated to the rest of Britain, in a relationship which George Melly described as 'feudal', and in which the 'edicts filtered down' from the Ad-Lib club through the pop programmes and the magazines, to the 'teeny-boppers in the outer darkness' (Melly 1970: 90-1). The construction of Hockney as a swinger can be related to this dispersion, through his inclusion in the *Daily Express* article.

Hockney, the North and Swinging London

Most of the people photographed for David Bailey's *Box* were members of the new aristocracy, who had climbed the social ladder and, with their overt unconventionality, represented exotic figures in British society. Mellor has argued that the setting of figures against a white background in these photographs was meant to symbolise the way in which these people stood out against conventional British society, in apparent detachment from established class positions. In this way, the erasure of class that Swinging London was meant to symbolise was given a visual form. The status of these personalities was not defined according to the conventions of Establishment society, but in relation to the new criteria of style. *Box* therefore needs to be positioned within the contemporary discourse of classlessness, which was part of the wider discourse of affluence that marked sixties' culture (Hill 1986: ch. 1). John Crosby's 1965 article, 'London the Most Exciting City', was also part of this discourse. He stated that London had been transformed by an explosion of 'vitality' unleashed by the ending of post-war austerity, and that youth had taken command: London had become a young person's city. He argued that this youthful revolution had been made possible by the activities of both affluent working-class youth and upper and middle-class youth – mixing in a 'classless' world of youthful innovation. According to Crosby, the British class system was 'breaking down at both ends'. But the discourse of affluence highlighted slight changes in the British class structure, while covering over the more significant continuities. Affluence enabled some members of the working class to adopt the lifestyles of the middle class, but there was no more movement between the classes than there had been prior to the sixties. Despite Crosby's assertion, the class structure had not broken down. The image of Swinging London as classless belied a more complex set of class relations.

In the upper and upper middle-class milieu of Swinging London, the likes

of Hockney were few in number. Hockney's own retrospective comments about the scene are instructive here: 'if you're a working class person from outside London you're an outsider, just like a foreigner' (Hockney 1976: 158). Hockney was part of the influx of northern musicians, actors and artists in London during the late fifties and early sixties, represented by the insert and arrow in the *Time* map. This group of working-class northerners became part of the London scene, but their assimilation, as Hockney's comment suggests, did not entail the suppression of class difference. The dance floors where the classes were supposed to meet on equal terms, which Crosby uses as an example of classlessness, were in fact places were they merely mixed. Hockney was not an example of the anxious 'scholarship boy', described by Richard Hoggart in 1957, placed at the 'friction-point of two cultures' by the opportunities for social betterment provided by the 1944 Butler Education Act (Hoggart 1957: 242). Nor did he seem to be wracked by the kind of guilt suffered by the 'New Left' about the plight of the communities they had left behind. Hockney's comments about 'boring' Bradford ('It's Much too Dull in Bradford', *Evening Standard*, 19 December 1963), attest to his lack of regret about leaving the North. Nevertheless, he was still a 'foreigner' in London's urbane society.

This status as an outsider made Hockney an attractive figure within the swinging community. It was not merely his upward social mobility which had a value within this milieu, but also his northernness. His retrospective comments do not provide any evidence of his origins being an advantage in London, but is worth considering a remark made in 1967 by the writer Margaret Forster:

I'm terribly pleased to be working-class because it's the most swinging thing to be now ... a tremendous status symbol really ... I'm very conscious of it, because I know it's a good thing and it makes me seem all the brighter and cleverer and more super to have come from the muck of the North. People are such comic inverted snobs nowadays. All the mass media are biased in favour of anyone young and working-class, it's like having a title must have been a hundred years ago. I wouldn't have been born anything but working-class whatever you'd offered me. (Aitken 1967: 264)

For the communities in which Forster lived – Oxford and, later, the entertainment world of London – her northern working-class background was significant: northernness made people attractive. Mellor points out that Hockney emerged on this scene at the same time as metropolitan culture was deeply engaged with representations of northernness. The most prominent of these representations were the British New Wave films, which constructed the North as a 'mythical site' (Mellor 1993: 147).

An interest in Hockney's origins can be seen in phrases from many of the reviews of his work; his 'earthy West Riding realism' (Whittet 1963: 253) for example, and his accent that 'even an amateur Professor Higgins can immediately pinpoint as "Bradford"' (Wraight 1963). The myth of northernness was highly masculine, however. The New Wave films contrasted traditional working-class masculine culture – associated with the world of physical labour – with

the new world of mass entertainment and consumerism. In these films this new world – associated with the female characters – was represented as a threat to 'authentic' working-class life since it feminised working-class culture (Hill 1986: ch. 7).

Hockney was hardly a good example of this myth of working-class manliness. For example, he bore no resemblance to the brawling artist/miner from Yorkshire in Clancy Sigal's novel *Weekend in Dinlock* (1960), which reproduced the conventional romanticisations of the North. The 1962 photograph for 'Clown With Vision' showed Hockney with his bleached hair wearing a working man's vest. This juxtaposition of a sign of the 'inauthentic' and feminine world of the consumer and a sign of Hockney's northern working-class origin defined his northernness as a site contradiction. Hockney's dyed hair was a sign of his homosexuality, although it was not construed as such in the media. Signs of his homosexuality were seen as part of a persona compatible with the heterosexual images which were, by 1965, associated with figures like David Bailey. As George Melly has argued, Bailey 'transferred those qualities which until the 60s, were thought of as essentially homosexual and made them available to what used to be known as "red blooded males" ... the chic, the "amusing", the new; the love of glitter ... these [were] now acceptable within a heterosexual context' (Melly 1970: 143). Hockney's glitzy image – the hair, the coat – found its meaning with reference to the ability of heterosexual males, no longer restricted by traditional masculine identities, to indulge in new forms of display.

Yet if Hockney's persona was the antithesis of the characterisation of northerners in the New Wave films, his northernness was still significant within the urbane culture of the metropolis. Patrick Procktor describes how, during a debate at the Institute of Contemporary Art in the early sixties, Hockney countered the critic Lawrence Alloway's claim that there was no Pop Art in England by asking in a 'very flat Bradford accent': 'What do you mean there's no Pop Art in England?'. This reduced the meeting to a state of hilarity, not only because of Alloway's 'pricked pomposity', but also because of Hockney's 'Yorkshire vowel' (Procktor 1991: 46). Procktor and, one assumes, the audience found not only the audacity of Hockney – contradicting a senior figure in the London art world – but also his accent significant. Another example of an interpretation of Hockney's accent as a sign of something significant is Cecil Beaton's description of his encounter with Hockney in 1965, in which he goes to great lengths in order to record Hockney's accent phonetically:

Noh, I'm nut corld. Is it corld outside? I get into my car and the heat's automatically on and I get out at the plaice I arrive at. You may think this cappe is a bit daft, but I bought ert at Arrods because I wasn't looking whaire I was gohin and I knocked over all the hat stall and I put the mun to so mooch trooble, I thought ah moost buy sommut! (Beaton 1978: 26)

Both these examples link Hockney's accent with an insouciant or naive disregard for the protocols of metropolitan life. This took the form of contrariness in the arena of the art world and regional gaucheness at Harrods.

Such acts constituted a large proportion of Hockney's public persona. The northernness signified by his accent was a marker of difference from urbane culture, of which both Procktor and Beaton were part. Like Hockney's acts of iconoclasm, his northern origins gained their significance in relation to the self-image of unconventionality which marked the swinging section of the metropolitan social elite. The elite community which formed much of Swinging London can be defined in terms of the adoption by its members of cultural practices and tastes which stood in contrast to those associated with the Establishment. These tastes were marked by a propensity to treat culture – both high and popular – as a disposable commodity in line with the new 'throw-away' consumer culture. This attitude stood in stark contrast to the accumulation of the durable, 'timeless' cultural capital provided by high art, upon which sections of the old elite depended. The new taste relished those things which high cultural taste found vulgar. It preferred the artificial and the exaggerated; 'style' over 'content'; refused the 'seriousness' of high culture, and, treated the serious as frivolous.[4] This is where Hockney's persona was important – his hair, the gold lamé jacket, the frivolous statements, even the work with its contrived naivety and its literal emphasis on style over content. Hockney's persona was a set of signs to be read by the constituency of knowing consumers formed by the swinging elements of the metropolitan elite and catered for by the glossies.

The swinging community was especially concerned with the cultural differentiation of itself from the 'squares' or 'dodos', as Francis Wyndham called members of the Establishment (Booker 1969: 44). Part of this differentiation involved an engagement in practices which were considered non-U. In an article entitled 'In Search of Swinging London', a critique of the representation constructed by *Time*, the magazine *London Life* commented, 'It amuses the in-crowd to drink in working class bars among surroundings that have been considered non-U.' (*London Life*, 18 June 1966: 7) In this sense, non-U did not merely denote accent, but defined a range of cultural practices which marked lower-class life. For the swinging elite, associating with working-class northerners, with their inurbanity and their almost foreign accents, was amusing because it distinguished them from members of the Establishment, who would not do this, and this functioned in a similar way to engaging in anti-Establishment cultural practices. This was one of the reasons for the class inter-mixing which marked Swinging London. Hockney's northernness combined with his dress, and his manner, to form a package of anti-Establishment symbols.

The problems of popularity

Hockney has been given a significant place within the official history of post-1960 British art. However, his position is ambiguous – he has yet to achieve a secure canonical status.

Hockney's acceptance has taken place within the framework of the art

world's dominant evaluative discourse, which is inscribed in the practices of art criticism and art history and involves a set of broad distinctions between what is considered to be good and bad in art. It is conventional in this discourse to distinguish high art, and practices relevant to its production and reception, from the multifarious practices of popular culture. Through this distinction the former is defined as superior to the latter. Artistic practices which adopt the traits of popular culture, whether in the art objects themselves, or in the ways they are disseminated, are seen to involve the vulgarisation of art.

This distinction structures the evaluation of art in two ways. First, works of art are evaluated in terms of their relationship to popular culture. Second, because it is conventional to view art as a direct expression of the artist's personality, the work is evaluated in relation to the persona of the artist who produced it. The conventional artistic persona defines an individual who is concerned with serious, or spiritual, or aesthetic matters, which are seen to be elevated from the level of the everyday, and from the frivolous concerns of popular culture. A persona which conforms to this conventional model will help define the work of the artist as serious. Whereas, if an artist's persona is associated with what is seen to be trivial and meretricious, his or her art will not be as highly valued.

Hockney's work has been devalued partly because of his status as a popular figure. His artistic persona has been a site of contradiction between those aspects of this persona which define him as a serious artist and those which define him as a swinger and a hedonist. His canonisation has involved a series of attempts to redefine his artistic persona by distinguishing it from its popular aspects. These attempts are an index of a persistent anxiety for commentators about the intersection of the world of the popular media and the world of serious art, which occurred in the construction Hockney's persona during the sixties. Such anxiety can be identified as early as the mid-sixties.

The reviews of his solo exhibitions at Kasmin Limited and the Kensington Print Centre in December 1963 were on the whole favourable. For example, Brett (1963), Whittet (1963) and Wraight (1963) commented both on his work and on the signs of his colourful personality: his dyed hair and the gold lamé jacket. But not all the reviews expressed unreserved approbation. Bryan Robertson writing in *The Times* on the 'opportunities and pitfalls' of what he termed the 'New Generation' of artists,[5] expressed reservations about the nature of Hockney's success. Robertson observed that although this success was well deserved, the way Hockney was using his talent was leading to vulgarisation of his art. To illustrate this, Robertson invented an imaginary scenario in which Leonardo da Vinci holds two concurrent exhibitions and produces: 'Leonardo greetings cards', 'Leonardo drawings' for newspapers, 'Leonardo sketches' of the Nile for a magazine, 'Leonardo dust jackets', and a 'Leonardo film for television'. Although a classic figure in the history of Western art, when 'overdisseminated' in this way, da Vinci's work would lack 'any real meaning'. This scenario with its reference to the drawings of Egypt Hockney produced in

October 1963 for the *Sunday Times Colour Magazine* (although the illustrations were not used), was clearly meant as a cautionary tale directed at Hockney. This did not mean that Robertson viewed the success of Hockney and other young artists within the gallery system as a problem in itself. Problems only arose when this success was accompanied by excessive publicity.[6]

In his review, Robertson cited a television interview with Hockney, his work for the *Sunday Times Colour Magazine*, and a public discussion of his work at the Institute of Contemporary Art as examples of exposure which he felt gave 'pause for disquieting thoughts'. Robertson made similar observations in the book *Private View* (1965), in which he commented that in the current art world an artist was 'not news unless he [sic] [had] been seen on television, or [was] willing, like (name omitted), to answer any question, no matter how inane, that a newspaper ... put to him' (Robertson, Russell and Snowdon 1965: 172). The omitted name is surely Hockney: given the amount of attention he received from the press between 1962 and 1965, it is hard to think who else it might be. In 1965, Hockney was, once again, central to what Robertson viewed as the debasement of art by its 'overexposure' in the media. As Robertson saw it, publicity distracted artists from their primary task of producing art and lowered the standard of their work through its popularisation. Because the media did not adopt the serious attitude he believed Hockney's art required, they trivialised his work. In his view, Hockney needed to conserve his talent for the production of art, rather than waste it on gaining popular acclaim.

Robertson's assessments in both 1963 and 1965, of Hockney's status in the media were informed by the evaluative conventions already outlined. Since the media belonged to the world of popular culture, it seemed inevitable to Robertson that serious art would be trivialised by being lowered to the level of a media spectacle. This is not to suggest that Robertson was entirely opposed to media coverage. He actually welcomed attention when it followed the conventions of high art discourse. The problem he sought to highlight was that the media did not treat art as a separate and special area of culture, but as simply another part of the world of popular entertainment, in which art was turned into book jackets and magazine covers, and the artist became a popular celebrity. Under such conditions the conventional function of art and the conventional persona of the artist were seen to be debased.

By the end of the sixties, when Hockney's popular celebrity was established, attempts to evaluate a decade of his work began to involve the separation of his art and his artistic persona from his image as a swinger, which continued to be conflated in the late sixties (see, for example, Figure 1.1). This can be clearly seen in reviews of his retrospective exhibition held at the Whitechapel Art Gallery in April 1970.[7] The reviews acknowledged Hockney's status as a popular figure. Writing in the *Sunday Times*, John Russell described the artist as an 'index' to the ambitions of London's sixties' generation. Richard Cork in the *Evening Standard* and Edward Lucie-Smith in *Nova* both observed that Hockney's public

image was part of the 'myth of the Swinging Sixties'. However, for these reviewers, Hockney's popular image obscured the 'true' value of his work. The reassessment of his work, which the exhibition not only enabled, but demanded, was dependent on distinguishing a 'real' and 'serious' Hockney from the myth of the sixties. As Lucie-Smith put it in the title of his review: 'At last – the real David Hockney steps forward' (Lucie-Smith 1970).

In the first part of his autobiography, published in 1976, Hockney also distances his work from the swinging image constructed during the sixties. He only mentions Swinging London to deny its existence, for example, commenting that the world in which it was supposed to have occurred was far too class-bound and exclusive. Although this is undoubtedly true, and although the construction of Hockney's persona was mostly beyond his control, one can hardly give too much credence to his statement that he 'was associated with all that by accident' (Hockney 1976: 158). The only references he makes to the mechanisms of his promotion are those which belong to the conventional art world: there is no mention of the glossies, the colour supplements, television interviews, or David Bailey. His dyed hair is only mentioned within a discussion of his first trip to the United States. These omissions do not in themselves prove that Hockney was attempting to make his work more serious by separating it from his 'swinging' image. However, his autobiography was published during a period in his career when it was necessary for him to consolidate his status as a serious artist. Like his 1970 retrospective, his autobiography, despite the inclusion of anecdotes, defines his practice as a subject for serious discussion, rather than as the subject of journalistic references to his 'golden boy' image, and jokes about his reputation as a 'pop' artist.[8]

It is useful to compare his attitude towards his celebrity status with that of Andy Warhol. Both Hockney and Warhol actively sought, and were given, considerable attention by the media and both achieved celebrity status beyond the art world. But whereas Warhol sought publicity as an end in itself, Hockney appears to have viewed it only as a temporary strategy to further his career as an artist. An insight into Hockney's attitude towards publicity during the seventies can be gained by considering his initial reaction to Jack Hazan's film on Hockney, *A Bigger Splash* (1974). Hockney recounts that, after a screening of the film in February 1974, he requested that the credit 'starring David Hockney' be removed, as, in his view, he was not a film star and did not want to be (Hockney 1976: 286). This is not something one would expect Warhol to have said. Unlike Hockney, he was fascinated by celebrity status, and pursued it throughout his career. In Warhol's persona both artist and celebrity were thoroughly merged; and he saw no real need to separate the two, as Hockney did during the seventies.

In his 1981 monograph on Hockney, Marco Livingstone also felt that in order to assess Hockney's work, it was necessary to distinguish Hockney the popular personality from Hockney the serious artist. The first three pages of his book are devoted to the problem of Hockney's popularity. Livingstone seeks to explain why critical attention given to Hockney has not been serious. He argues

that this is because his work has been anomalous within the history of post-war modern art, and also because it has gained popular acclaim. He recognises that within the dominant evaluative framework of the art world, 'serious achievement in art is measured in inverse proportion to its popularity, for the two have been defined as incompatible' (Livingstone 1981: 10). But he also comments that Hockney may be popular because people are attracted to his work for the 'wrong reasons':

because it is figurative and, therefore, easily accessible on one level, or because the subject-matter of leisure and exoticism provides an escape from the mundanities of everyday life. Perhaps it is not even the art that interests some people, but Hockney's engaging personality and the verbal wit that makes him such good copy for the newspapers. (Livingstone 1981: 10)

He then asks if these mistaken forms of popular attention 'negate the possibility that [Hockney's] art has a serious sense of purpose' (Livingstone 1981: 10). Judging from the rest of his book, Livingstone assumes that they do not. But, despite his attention to the structure of values which defines popular art as inferior, the result of his argument is that popularity is, yet again, taken to be negative. It is implied that if Hockney is to be assessed as an artist with a 'serious sense of purpose', his work must be separated from these misguided forms of attention. Livingstone's argument suggests that Hockney's work has been appropriated and misrepresented by its wide audience, and can be retrieved from this audience only through serious scholarly attention.

Livingstone also defines the image of Hockney as a swinger as a misrepresentation, from which his credibility has suffered because it has 'tended until now to obscure the importance of [his] art' (Livingstone 1981: 11). Livingstone contrasts the established images of Hockney's glamorous life and apparent lack of cultural depth with an image of him as a 'working artist' and as someone who is highly cultured. It is implied that Hockney's true artistic identity lies behind the image of him as a swinger. The new artistic persona delineated is one of seriousness, integrity and cultural sophistication – a persona which is able to define Hockney's art as serious.

The pattern which has emerged in this series of separations is one in which Hockney's artistic persona from the sixties is redefined. The elements which identify him as a conventional artist are taken to be his authentic traits, whereas those which identify him as a swinger are taken to be part of a myth which obscures his real authorial identity. As a final example of this pattern it is worth considering some of the reviews of Hockney's 1988 retrospective exhibition at the Tate Gallery. Eighteen years after his first retrospective and seven years after Livingstone's monograph, critics still thought Hockney and his work had to be proved serious: 'to many [Hockney] is an eternal light weight. Andrew Graham-Dixon discovered a man who wants very much to be taken seriously' (*The Independent*, 22 October 1988); 'in the end, [Hockney] is proved by the retrospective, to be a very Serious Artist indeed' (Stemp 1988); 'Pop goes the myth ... David Hockney is revealed at last as a brave, serious master of his art' (Shone

1988). In his review Richard Shone declared that 'The exhibition is a victory for reality over myth' and continued by writing that 'in many ways' Hockney is 'famous for the wrong reasons'. According to Shone, Hockney's swinging and hedonistic image, and the conventional view of him as a painter of glamorous locations and 'unruffled pools under an even, West Coast sun' have hidden a *serious* artistic identity. In Shone's view Hockney's work has not only been marked by hedonism and humour, but also by 'an undeniable charge of melancholy' (Shone 1988); here Hockney's artistic persona is even refashioned to introduce an element of the archetypal romantic artist.

In view of the pattern of separations which these reviews extend, and the persistence of the structure of values which makes it necessary still to establish Hockney's seriousness, it is reasonable to assume that attempts to make the 'real' David Hockney step forward will continue. The image of Hockney as a swinger has remained an established part of his artistic persona. Despite attempts to deny the relevance of this aspect, as the reviews of the 1988 retrospective suggest, this is something which is difficult to repress. Because of this Hockney's ongoing canonisation will remain a subject of contention. Those who seek to define Hockney as a candidate for secure canonical status continue to separate those aspects of his persona which contradict his serious image. In so doing they reproduce the conditions which mean that his canonical status is problematic, because they do not attempt to examine why his swinging image is a problem. These attempts no matter how successful continue to be marked by reservations and anxieties, which cannot be explained within the structure of values which produce them. Hockney's status is therefore continually undermined. To secure it against such doubts, it will be necessary to address this issue from outside the conventional evaluative discourse of the art world, rather than continuing to fruitlessly to separate one part of his history from another.

Notes

My thanks to David Peters Corbett and Paul Melia for advice on this chapter.

1
Persona is used here to define a public image which is constructed by the artist, and by forms of publicity applied to the artist in the media and through the practices of hagiography specific to the art world. This persona is distinct from the artist's 'person' – see, Watney (1988).

2
This information on Kasmin Limited was gained from two interviews with John Kasmin, one by Paul Melia, 14 June 1990, the other by the author, 27 Oct. 1993.

3
The term 'Establishment' was used during the late fifties and the sixties to define the elite derived from the British upper class, who appeared to have a monopoly on power in a range of British political and cultural institutions. In the latter, the Establishment was associated with high culture – see Hewison (1981). The term was also used by members of the metropolitan upper and upper middle class to describe those people within these classes who were seen to be steeped in convention – see Quant (1966: 73). In this chapter the term is used in both these senses. During the sixties 'Swinging London' was taken to be constituted both by aspects of the culture of a community of the rich and famous, and by aspects of the culture of affluent teenagers. This chapter concentrates on the former. On Swinging London I have found the following books useful: Booker (1969), Hebdige (1988), Hewison (1986), Masters (1985), Mellor (1993), Nehring (1993), Whiteley (1987). Despite the work undertaken by these authors, this subject demands further attention.

4
This definition of taste I take to be compatible with that which Sontag (1966) defined as camp taste.

5
The term 'New Generation' was used by Robertson to describe the group of young artists who had gained exposure in the London art world during the early sixties, in Robertson (1963) and Robertson, Russell, Snowdon (1965); and as the title of the exhibitions he organised at the Whitechapel Art Gallery in 1964, 1965 and 1966.

6
During the mid-sixties it was not only excessive media publicity which was seen to be damaging to young artists and art in general, but also the supposedly excessive exposure of art and artists to the art market, by means of the new galleries. See, *The Connoisseur*, 'The Young Artist Today', Sept. (1965) and Wraight (1965).

7
This exhibition included 45 paintings, 116 items of graphic work and 47 drawings. It travelled from London to Hanover, Rotterdam and Belgrade.

8
For example, *The Sunday Times* entitled an article on Hockney's departure for Los Angeles: 'Pop Artist Pops Off' (Davies (1966)).

2

Pictures emphasising stillness

ALAN WOODS

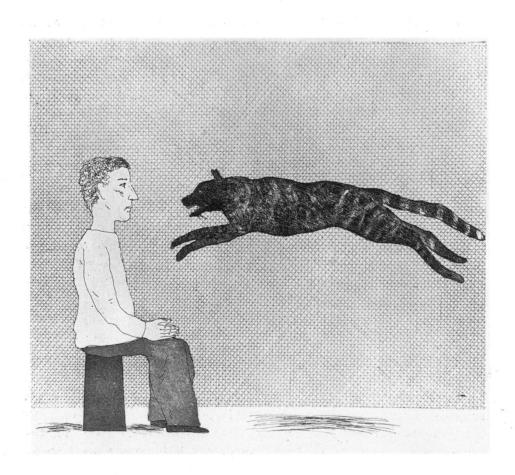

Most of the extensive literature about David Hockney's work is authored, or co-authored, by Hockney himself. His voice is familiar, engaged and engaging, and we hear it behind the texts it produces, notably *David Hockney by David Hockney* and *That's the way I see it.* Hockney is an accomplished (and photogenic) communicator and populist who likes to explain what he and other artists are doing. It is possible that his willingness to meet the public half-way and his direct appeals to an audience outside a mainstream artworld both stem from his background. As a young man in Bradford – and as an older, successful artist returning home – he must have found himself defending art, including his own, at a lower, but also more vigorous and less snobbish level of debate than he would have encountered in a less provincial background. At the same time, this democratic gift has helped Hockney to establish himself as a personality, even while a student at the Royal College of Art, promoting his work always in relation to himself, and largely on his own terms.

His media skills fit effortlessly into contemporary middlebrow packagings of and assumptions about art. Broadsheet populism, the new glossy magazines accompanying the daily and Sunday newspapers, the recent cult of biography, the gossip of the chattering classes; these, and artist-centred, largely uncritical, interview programmes such as *The South Bank Show*, all locate meaning not in the artwork itself, but in artists and their intentions. If we want to know what specific artworks mean, they propose that we only have to ask the artists for their original intention. Hockney has always been happy to answer such questions.

But there are, as Hockney himself has warned, problems with this (auto)biographical approach. It tends to reduce meaning to anecdote. It assumes a simple but untenable relation between intention and meaning, and also that intention can easily be defined, which it cannot be, for a number of reasons. There are the deep Freudian waters of unconscious motivation, now considerably muddied by the popular definitions of Freudian theory which have made us all so self-conscious about the unconscious. There are the consequences of Wittgenstein's remark that motive is what emerges after an event, in response to a question or challenge. Mostly, we do things, and then wonder or explain why we do them afterwards. Motives, therefore, are as much descriptions of actions as they are reasons for them.

Many art forms are collaborative, which makes intention complex, to say the least. Most art works take a long time to make, and most paintings have longeurs, mechanical tasks, as a part of their making. Moment by moment, the artist is usually involved with the minutiae of creation. Of the many thoughts, feelings and associations that pass through an artist's mind while a work is

being made, some are relevant, some are irrelevant, and many may be either, depending on how the work is continued. They cannot all be retrieved by either artist or viewer, however.

Moreover, unforgivably for any serious consideration of meanings in the visual arts, the origin of a work nowadays tends to be sought primarily in texts and statements. If we ask writers of a text to explain what they meant through interviews, we are asserting a primacy of speech over writing, which, however dubious, is still a primacy within language. If we ask Hockney what he meant, the primacy is of his speech/text over his painting, and there can never be a verbal closure of the visual. No painter can ever be happy with this state of affairs, and many understandably retreat into aphorisms or the silence which, as Rothko remarked, is so *accurate*. Hockney prefers to keep on explaining, to use language as a pointer to send us back to vision, although he is also unapologetically a 'literary' and narrative painter, and increasingly a didactic one.

The present chapter deals primarily with a single painting, *Picture Emphasizing Stillness* (Plate 1), a major work (183 x 157.5 cm) of 1962 which has been little discussed. It is characteristic of Hockney's work of the early sixties both in its use of language as a part of the picture and in its theatrical manipulation of the viewer. It is prophetic of his later work, from the 'Splash' paintings through his photographic collages to the present day, in its examination of temporality in static, spatial images. Beyond this, and against the grain of Hockney's own accounts of it, it is also one of the most complex and least hedonistic or propagandist treatments of homosexuality in his *œuvre*. But I shall begin by considering how Hockney has presented it.

Guy Brett, in an early example of the grateful writer summarising Hockney's

2.2
Leaping Leopard, 1962

Picture Emphasizing
Stillness, 1962

PLATE I

Detail from *Picture Emphasizing Stillness*, 1962

PLATE 2

articulate accounts of what he and his paintings were doing, mentioned *Picture Emphasizing Stillness* in his article for *London Magazine*, published in April 1963:

sometimes he simply makes a joke in his paintings... One of his most recent paintings shows a huge lion, or similar monster, in mid-air about to descend upon two unsuspecting figures having a quiet conversation. The caption, placed between the lion and the figures, reads 'They're perfectly safe; this is a still'. Hockney told me that he got the idea from seeing some huge battle scenes in the Tate. 'In spite of one's immediate impression, there is of course no action in these paintings at all. Things don't actually move – the figures are, and will always remain, exactly where the painter put them. The same thing that struck Keats when he saw the Grecian Urn.'

The obvious way in to the painting, however, is Hockney's own account, given thirteen years later in 1976:

One reason for using writing on paintings is that it makes you go and look at the picture in another way. It's a technique I used especially in 1962 in *Picture Emphasizing Stillness*, where from a distance it looks like a leopard leaping on two men who were just having a quiet talk, having taken a walk from a little semi-detached house; it looks strange, as if the leopard's about to leap on them and eat them, or fight them. And as you walk a little closer to the picture, because you notice a line of type, you read the type first; in a sense this robs the picture of its magic, because you interpret the picture in terms of the written message, which says: They are perfectly safe, this is a still. You realize the leopard will never reach the men. My intention was to force you to go and look closely at the canvas itself, and then in that sense it's naughty because it's robbed you of what you were thinking before, and you've to look at it another way. That was the intention. If you put a real message on a painting it is meant to be read, and it will be read. I began the painting without actually knowing its complete subject. Then I realised that what was odd and attractive about it was that, although it looks as though it's full of action, it's a still; a painting cannot have any action. It was the incongruity of it that attracted me to it as a subject. (Hockney 1976: 61)

Hockney explains to us that the 'complete' subject is something which the artist discovers in the course of painting the picture, and that the picture is altered as a consequence: he writes on it. Brett's account suggests that this subject has been discovered outside, and by implication perhaps before, the act of painting. Hockney has read Keats's meditation on the differences between temporal and spatial arts; he has looked at battle paintings in London, quite distinct from his source, a painting of a leaping leopard in a museum in Berlin from which he made a sketch during his European travels in 1962 (Figure 2.2). But considering the gap in time between the two accounts, their similarities are more striking than their differences, even in phrasing – 'quiet conversation' and 'quiet talk'. Both are centred on the line of text. For Brett, the image, the non-action, more or less illustrates a simple joke; for Hockney, the image, and its magic, are erased by the text as it is read. In the final section of this chapter I shall return to that image, and consider what exactly is under erasure within it. But first I shall consider the device itself, and its manipulation of the viewer, in the context of Hockney's modernism, his frequent resort to theatricality, and his interest in pictorial time.

Before he became more relaxed about it, Hockney was much exercised by the need to be a modern artist. When he was a student at the Royal College, the contemporary view of what the modern was assumed a commitment to abstraction. From the outset of his career Hockney interpreted his aim of being a modern artist as requiring him to work in opposition to the art of his own time. (It is clear from *That's the way I see it* that he now relishes this outsider status.) While his work has been representational, it has also been about the simple physical elements of painting, the paint as paint and the canvas as canvas. It has always appeared to have been driven by thought, by wit, rather than by feeling, however openly autobiographical its sources. It was therefore neither abstract nor expressionist, and neither Greenberg's formalism nor Rosenberg's subsequent theories of action painting related to it.

When, in 1967, Fried presented his theory of absorption and theatricality, Hockney had been exploring theatricality for some time. But Fried, although writing primarily about Minimalism, was hostile to precisely those manipulations of the viewer described in Hockney's account of *Picture Emphasizing Stillness.* We are made aware of our bodies, brought forward by the type, and our experience is temporalised, given a before and after of the kind normally only present in experiences of *trompe l'œil.*

We are, then, drawn forward by the text. (This description itself, it should be added, is in a way theatrical, fictional, since it is written, not in front of the painting, or from notes made in front of it, but in an office with black and white and colour reproductions of the work beside me, from notes initially intended for a lecture, during which I was able to move around in front of – though also, as it turned out, beneath – a projected image of the painting. In front of the picture itself, a lot would depend upon whether it was viewed in a house, just hanging there, or in a gallery, with a little notice beside it giving the artist and title – so that we would already, in advance of our viewing, have done that little dance we all do in front of labelled paintings in public spaces, and have been alerted to the picture's subject, so that our first question of it would be, well, how does it emphasise stillness?)

If we view the New York School as the last heroic project of Modernism, and note how styles, for Hockney, are something to be chosen, discarded, mingled, parodied, ironised, a case emerges to present Hockney, as Warhol has been presented, as post-modern in advance of the term. However, Hockney's own contempt for contemporary post-modernism is clear from *That's the way I see it*; and post-modernism as presently defined in regard to painting is primarily a development of a major strand of Modernism itself, easily traced back at least as far as Manet. How can one be a contemporary artist when to be an artist at all is to be defined by the 'timeless' values of the past, burdened by the weight of an art history which suggests that one is too late within it? Representation, for Hockney, has always involved eclecticism, from necessity rather than whim. He has entered into dialogues both with abstraction, which he often drags back into representation, and with the giants of Modernism, Picasso and Matisse, artists

committed to representation. Any anxiety he may feel about being influenced by others is offset, in the sixties, by iconoclasm, wit and a self-confidence in the personality which takes from various styles. Later, in Hockney's relation to Picasso in particular, the influence is acknowledged but defused by conscious homage.

If Hockney's paintings have never been simply about paint as paint and canvas as canvas, they have always emphasised the physicality of painting, and the artificiality of its conventions. When he writes, 'This is a still', he is saying, 'This is a picture'. This statement was an essential premise of Modernism, though not, as it became in America, the only one. A picture is not a window on the world; it is an object in the world. A woman once complained to Matisse that the arm of a woman in one of his paintings was too long. He replied, 'Madame you are mistaken; this is not a woman, but a painting.' Such ideas were not new to Modernism, but they were central to it, and were often, as in Cubism, expressed in a witty and playful way. They became a part of what modern pictures were about.

Hockney's early work involves a whole range of formal and rhetorical devices which insist that we are first and foremost looking at pictures of the world and not at the world itself. What was defiant about this at the time was the insistence not simply that they are pictures but that they are pictures *of the world*. Like the Cubists, he was examining representation, fictions, signs. To consider the distance between images and the world is also to confirm and examine a connection, to acknowledge the necessity for painting of a world outside and around the practice of painting.

Hockney often left large areas of canvas unpainted. He made no concessions to illusionism or naturalistic picture space, preferring, when the subject was traditionally coherent (figures in a room, say) to edit out all aspects of it that he was not interested in. As a result the works were diagrammatic in conception if not execution. This was something he apparently learned from Picasso, whose work (in Hockney's own reading of it) follows the eye's priorities of attention rather than naturalism's lens-like (and therefore fundamentally anti-realist) indifference to them.

The distinction between the psychology and the physics of vision is particularly sharp in pictures of the nude: if we enter a room with a naked person in it, we do not notice the wallpaper. *Domestic Scene, Notting Hill* (1963) (Figure 4.5), with its central nude, lamp, curtain and seated figure, its tulips and light bulbs, all simultaneously present in a space otherwise undefined but suggesting an order of viewing, is perhaps the best example of this. (There is also an interest in pattern – the armchair, the lampshade – which may be a nod to Matisse; but far from establishing an overall decorative rhythm the pattern is isolated.) The way the nude stands on the strange carpet as if upon a hill is curious, but consistent with *The First Marriage* (*A Marriage of Styles 1*) and *The Marriage* (both 1962) as well as with *Picture Emphasizing Stillness.*

The early paintings incorporate images which are clearly based on other paintings or sculptures or other found visual material: graffiti, photographs, tea packets. Often, several styles coexist on the same space – on, rather than in, because this technique of painted collage, these 'marriages', to use a term Hockney was fond of at the time, emphasise that the canvas is a flat surface on which the elements of the picture meet.

Hockney also began to experiment with theatricality, as in the 1963 paintings *The Hypnotist, Two Friends and Two Curtains, Play within a Play* and *Closing Scene*. This is often a literal theatricality, with curtains and staged spaces. More interesting, though throw-away and whimsical, is the tiny *Accident Caused by a* [real] *Flaw in the Canvas* of 1963, precursor of a whole number of self-referential games with painting, which dramatise the conventionality of conventions, and through this our own role as viewers. Hockney's interest in theatricality was confirmed by the series of paintings by Domenichino purchased by the National Gallery in 1963. As he describes in a passage in *Hockney by Hockney* (p. 90) comparable to his account of *Picture Emphasizing Stillness* he suddenly saw 'what they were about' – the artificiality of painting, not its mythological or social content; the painting/tapestries, and not the stories they told, or the dwarf in front of them.

So when Hockney speaks of the words in *Picture Emphasizing Stillness* as if they destroy some kind of narrative or illusion, he ignores the extent to which we have already been made aware of the pictureness of the picture, to use a clumsy formulation. In fact all paintings – except for the curious *trompe l'œil* experiments which paint violins on doors, say, in an effort to deceive – depend for their effect upon our initial and unquestioned knowledge that they are pictures. We do not test them, asking whether they are picture or world. Nor do we compliment the world itself, as we thoughtlessly compliment a realist picture, for being life-like. (Domenichino has it both ways, since he offers *trompe l'œil* images of tapestries that are really paintings. So did Braque, with his famous *trompe l'œil* nail in *Violin and Pitcher* (1910), which turned the rest of the painting into a drawing pinned to a wall.)

But some pictures make an issue, a subject, out of the fact that they are pictures, and Hockney's work is one of them. We come to the image, and, having immediately recognised that it is a painting, we begin to make sense of its language, focusing in particular on its diagrammatic account of the two men and the leaping leopard. (The precise narrative relation which Hockney suggests between the men and the house – the walk – seems to me more fanciful, or at least less immediate, and open to interpretation, unless we are already aware of Hockney's own account and have accepted it.) We do not think we see a real leopard, or real men, but we do think we see a picture of two men being leapt upon by a leopard. And this is, truly, what the picture is most obviously about: the threat, the leap, which Hockney had decided to make more interesting by showing two men talking to each other, oblivious of the leopard. His preparatory sketch shows one man, taking evasive action (Figure 2.2). (In 1969

2.3
'Cold Water about to Hit
the Prince', 1969

he returned to the same action, in 'A Black Cat Leaping', one of the Grimm illustrations (Figure 2.1). Here the hero faces the leap, but impassively, since he does not fear it. Later, he awaits with identical *sang froid* the cold water which finally teaches him to shudder, in another image of ironised time (Figure 2.3), half way between the previous leaps and the splashes.)

The line of language does a number of things. For at least as long as we are reading, it focuses our attention on the words, to the exclusion of the rest of the picture, in a way which does not happen when we concentrate on a normal

detail of a larger image. It disrupts the picture space, because the space of words on a surface is a very different one from that of any picture space. Then, when we return from our reading to the picture, with the memory of the reading guiding our attention, it acts as a physical – again, diagrammatic – barrier between the leopard and the men, just as the lines around them suggest a box between the men and the leopard, a conceptual check also to that diagonal flow of paint, against the leap, which rises from left to right. But it also makes us realise how we have taken for granted the fact that still images can depict movement. If, as we looked at the picture – and we have different words for looking at still objects or images and watching moving ones – the leopard had moved, had reached the men, as the figure moves in M. R. James's horror story 'The Mezzotint', we would have been very surprised indeed. But before reading Hockney's words, we had nevertheless thought of the image as representing an action. Hockney has it both ways. He depicts an action, and then claims that a painting cannot have any action.

However, paintings surely can and do have actions, just as they have spaces, through conventions. Any description of Hockney's picture which avoided

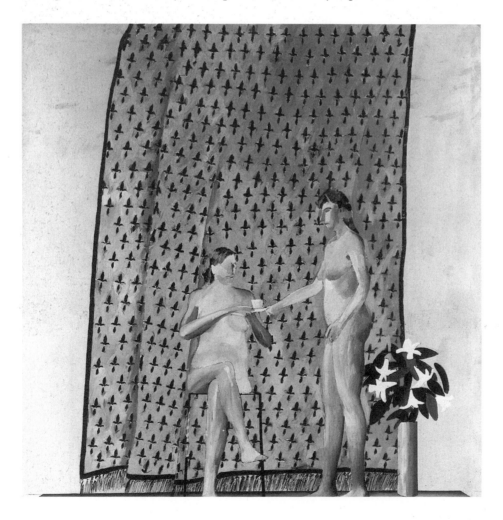

2.4
Seated Woman Drinking Tea, Being served by Standing Companion, 1963

words like 'leap', which considered the relation between the leopard and the men as simply identical to that between the house and the men would be false to our experience, both after and before we have read the text. Hockney's text is to picture time as Braque's nail is to picture space, disrupting, not illusion, but convention. We still see space, we still see a leap. What is really interesting is not *whether*, but *how* paintings have actions; and I shall return to this question. But first I would like to consider the ways in which words can be in pictures.

In one way or another words condition our perception and understanding of paintings even if they are not physically part of them. As Hockney's friend R. B. Kitaj once remarked, some books have pictures, some pictures have books. Hockney's description of *Picture Emphasizing Stillness* has become a part of it, as, more emphatically, has its title. Hockney has always been alert to the possibilities of titles. One early painting after Muybridge (Figure 2.4) was partly inspired by a title: 'I loved the title of the photograph [*Seated Woman Drinking Tea, Being Served by Standing Companion*, the title Hockney retained for his

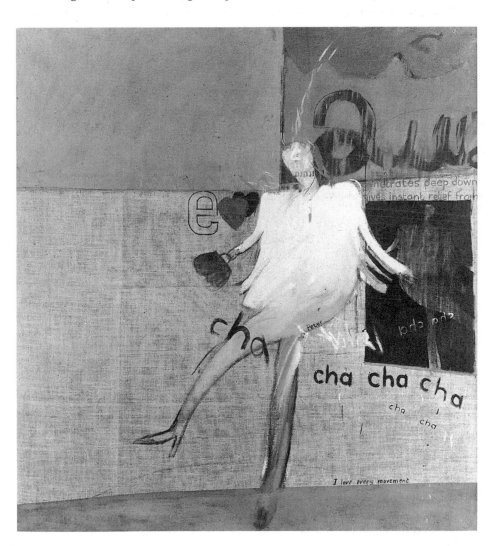

2.5
*The Cha-Cha that was
Danced in the Early Hours
of 24th March, 1961*

39

painting]; his titles are marvellous and direct. It makes no mention of the woman being nude, which is slightly odd, and I liked that: it's dry. If you said 'Seated Lady Nude Being Served by a Standing Nude Companion', it's not as good' (Hockney 1976: 91). Dry is a good word for many of Hockney's own titles: *Rocky Mountains and Tired Indians*, for example, where he used the word 'tired' to account for the chair he had put in the picture. Several early pictures have their titles painted onto them: *The Last of England?* (Figure 3.2), *The Cruel Elephant*, *Ordinary Picture* and *The Hypnotist*.¹ Titles confirm or alter our approach to works of art.

Words can be represented in pictures, because they were already in the world, in the artist's visual field. We may tend to think of language as an entirely abstract set of symbols separate from the visible, but of course language is there in the world in all its instances to be painted. (Even speech, although invisible, has long since found a visual convention to describe it in the speech bubble so dear to Lichtenstein.) When Hockney moved to America and his work became a more realistic account of California he began painting and drawing street signs and hotel signs and shop signs – Wilshire, Washington and Olympic Boulevards, Pacific Mutual Life – and his later photographs, especially *You Make the Picture*, similarly incorporate language.

When words are used in paintings more abstractly, not just as a part of the urban landscape, their shapes remain aesthetically relevant in ways in which they are not when they are simply being read. Since paintings have no time of their own to organise, since they are spatial not temporal (in Lessing's long-established distinction, explored in Keats's 'Ode on a Grecian Urn', the distinction of which *Picture Emphasizing Stillness* reminds us), the eye does not simply move over the words and leave them behind. It assesses them, letter by letter, it delights in how they look, it rhymes them with each other and with other shapes in the picture, it distinguishes between official and personal, printed and written languages, graffiti and poetry.

While Abstract Expressionism placed great emphasis on the artist's painterly gesture as it is, retained on canvas, Hockney's 'Love' paintings, and the work of artists such as Dubuffet and Cy Twombly, considered how individuality is expressed through handwriting, the quick sketch, the scrawl. The point, in both drawing and language, was urgency, not beauty; and the individuality, in an early Hockney, need not be the artist's own. His 'Love' paintings drew equally on anonymous advertisements for the self, messages on toilet doors, and the poetry of his heroes, Auden and Whitman. (*Rimbaud – Vowel Poem*, another painting of 1962, reproduced but not discussed in *David Hockney by David Hockney*, referred to Rimbaud's synaesthetic attribution in 'Voyelles' of different colours to vowels, though Hockney painted all the vowels in the same colour.) The 'Love' paintings also use simple codes, 4.8 standing for David Hockney, 3.18 for Cliff Richard, 23.23 for Walt Whitman (though 69 stands for *soixante-neuf*).

While the eye is noting all this, it never quite abandons reading. Almost in

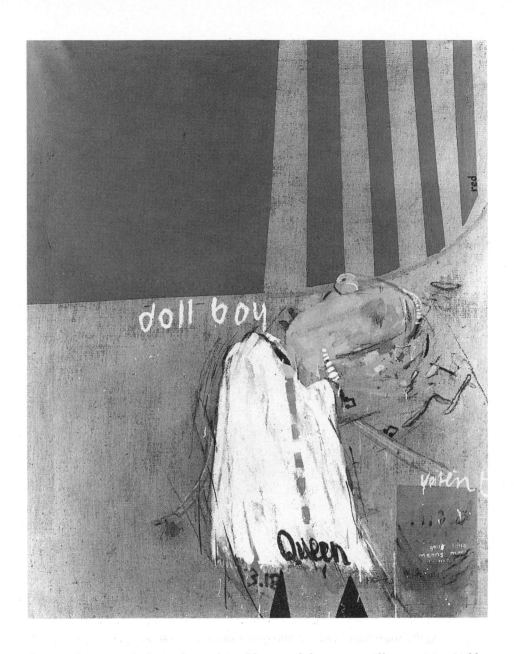

2.6
Doll Boy, 1960-61

the way that sounds from the real world around dreamers will enter into and be adapted by their dreams, the ways in which the eye is exploring pictorial space include the meanings and implications and associations of those words which define and mark and float within that space. These fluid interactions of colours, marks and meanings can be poetic, philosophical – *Picture Emphasizing Stillness* is an artwork which investigates the nature of art – or polemical; some Hockneys are propaganda for homosexuality, or pacifism, or vegetarianism. The artist can even suggest tunes. *The Cha-Cha that was Danced in the Early Hours of 24th March* (Figure 2.5) quotes a line from the song 'Poetry in Motion', and might therefore be read as another picture emphasising stillness, contain-

41

ing an action pictures cannnot really have. *The Most Beautiful Boy in the World* pointedly adapts a song title (boy replacing girl) and contains lines of music; *Doll Boy* (Figure 2.6) includes musical notes, and (to borrow a Situationist term) *detournes* 'Living Doll' by Cliff Richard, on whom Hockney had a crush. An etching of 1962 is called 'My Bonnie Lies Over the Ocean'. This is as Pop as Hockney ever got, but it is also very Cubist. Braque, himself a musician, and Picasso, whose *Ma Jolie* (1911-12) refers to a popular tune, incorporated both language and musical symbolism and notation into their examinations of pictorial conventions.

In *Picture Emphasizing Stillness* the words are more of an intervention, into a picture space less eager than the 'Love' paintings to compare its flatness to a wall. They refer to an action that suggests a before – or a number of indeterminable befores, in which the men might have been in the house – and also suggests, more pressingly, an after, perhaps one hundreth of a second away, in which the leopard lands on the unsuspecting men. But the words deny that action, at the same time casually incorporating a distinction between photogra-

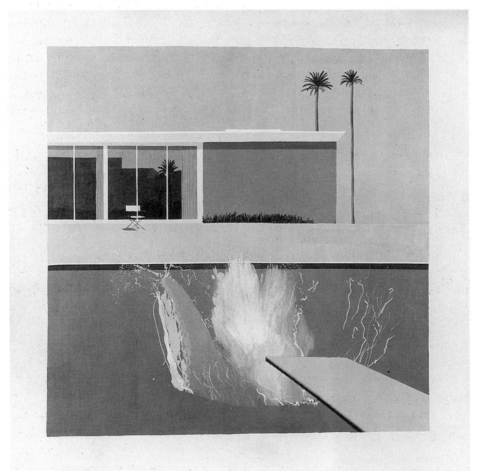

2.7
A Bigger Splash, 1967

42

phy and painting. The word 'still' suggests photography, albeit a transparently fictional photography, referring to cinema, and notionally drawn from it, though stills are rarely in fact individual, isolated frames. But a photograph catches a fraction of a second's action from a real world in which the action 'frozen' doesn't freeze; a photograph of two men being attacked by a leopard wouldn't allow us to say 'they are perfectly safe' (though a still would, not because it was still, but because it was a still, from a film). Hockney's two men are really 'safe' because they are not traces but fictions in a medium which has no real time of its own to organise and fictionalise and manipulate, which has no beginnings or middles or ends, but only static images.

Static images, paintings, suggest actions, or time, in intriguing ways which are very different from photographs; and Hockney has been interested throughout his career in the ways that photographs and paintings can tell time. He does not often paint actions in a narrative sense, though his pictures often offer us relationships, situations, and latterly journeys, through landscapes or houses, journeys perhaps anticipated by *Flight into Italy – Swiss Landscape* (also 1962) (Plate 10). In the sixties he solved the problem of movement, of activity, partly through the complete artificiality of his figures – a single stencil represents the three different runners in *Accident Caused by a Flaw in the Canvas*; in *Cha-Cha* he used quasi-Futurist repetitions of curves which could either be repeated arms or the flapping of a jacket – and partly (though I am not suggesting that the problem was consciously addressed and solved in this way) through using what I have elsewhere described (see Chapter 6) as genre activities. These are activities which have duration but not clearly differentiated stages of action, present participle activities, in which something is going on – showering, or embracing.

He returned to these when he started making his joiners, the collages made from many prints or Polaroids. Although they occasionally complete a coherent, linear action, like walking along a Zen garden, or bringing a cup of tea, his subjects generally talk, or play Scrabble, or take a bath. The order of events is unproblematically unclear; Celia has looked this way, and that, but we cannot tell which she did first, and it matters little.

Apart from *Picture Emphasizing Stillness*, the picture most concerned with time before the joiners so influenced Hockney's painting is *A Bigger Splash* (Figure 2.7), which suggests a human action through its aftermath, and is a meditation upon a whole complex of times and moments, layered and contrasted. *Picture Emphasizing Stillness* is a highly artificial painting, based upon another painting in Berlin; it is a diagram of an action which never existed outside the imaginations firstly of Hockney himself and secondly of the viewer. *A Bigger Splash*, from a far more naturalistic phase of Hockney's career, was based on a photograph. The painting initially presents itself as artificial not through its Modernist devices, but by comparing itself to a Polaroid, with its white 'frame'. There are still games with the picture surface, and there are new plays between Post-Painterly Abstraction and representation, but there is also

an implicit assertion that there once was a real splash, a real event, and that this real event was the basis of the painting, the way a real person is the basis of a portrait. *A Bigger Splash* is a portrait of an event.

The event itself took a split second. It took far less time than the two other real times with which the picture concerns itself: the time it takes us to look at it and the two weeks it took Hockney to paint it. He liked the idea that it is only in a 'still' – in a photograph or a painting – that you can contemplate a splash at all. A real splash is a visible event, but not in the way people or objects are visible. We can see a splash, witness it, but we cannot look at it.

'It is very good advice', David Hockney tells us at the outset of *David Hockney by David Hockney*, 'to believe only what an artist does, rather than what he says about his work... People interested in painting might be fascinated by an artist's statements about his work, but I don't think one can rely on that alone to learn about an artist's work, which is all trial and error' [p. 27].

We have considered so far what Hockney, apparently beginning his picture 'without actually knowing its complete subject', finally regarded as most 'odd and attractive' about it: not its action, but the impossibility of action in a picture. And we have seen how he used language to incorporate his reading of the picture into our reading of it.

Had he not done so, we would simply have read the action as a painted action, in a painting self-conscious about itself as a painting, but an action, the way the cha-cha that was danced in the early hours was an action, or the cruel elephant's crushing of insects (represented by the repeated words 'crawling insects') was an action.

Hockney first used words as substitutes for the figure. '[I] hadn't the nerve to paint figure pictures; the idea of figure pictures was considered really anti-modern, so my solution was to begin using words... when you put a word on a painting, it has a similar effect in a way to a figure; it's a little bit of human thing that you immediately read; it's not just paint' (Hockney 1976: 41). But by 1962 he was clearly a figure painter; and what the words do in *Picture Emphasizing Stillness* – all the more so because they are in Letraset, impersonal – is deflect attention from the figures, from the action. They 'rob you of what you were thinking before'. This is curious because Hockney stressed to Brett at this time that even still life only existed for him as, or through, narrative: 'I cannot paint objectively. A heap of empty cigarette packets, say, has no meaning for me as a combination of shapes, lines and colours. A pile of empty cigarette packets means I've smoked a hundred cigarettes; and then I wonder why, and where, and whether I shared them or smoked them all myself – and from there, with luck, a picture might begin.' In the same way, a picture began with a leopard, before its narratives were overruled by an idea, a line of text.

Yet the action is still there, to be constructed from three elements: the

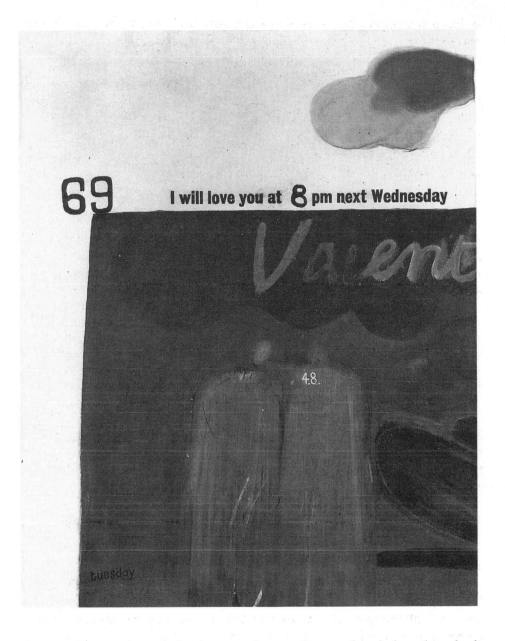

2.8
The Fourth Love Painting,
1961

leopard, the couple and the house. The couple are closed, boxed-in, both because Hockney has painted a couple of straight lines around them, and because they face each other. One of them is speaking. There is a narrative charge between them ambiguous enough to disallow any neutral critical description; so let me simply draw attention to a narrative focus which seems to me less simple than Hockney's 'quiet talk' or 'quiet conversation', a focus from which we are distracted both by the bizarre, whimsical threat of the leaping leopard and by the line of text.

It may be that I call them a couple only because of Hockney's suggestion that they have just walked up from the house. But if that is so, the handshake

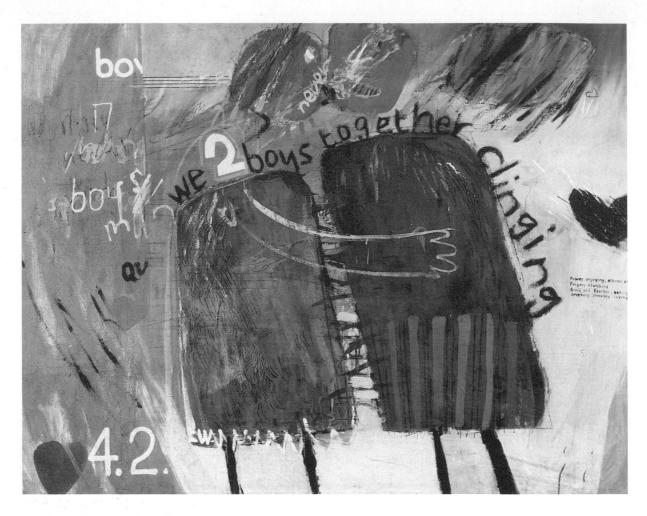

becomes hard to explain, unless they are taking leave of each other. In fact, there is nothing in the picture itself to suggest that there are not, say, introducing themselves, or shaking hands on a deal. If they are indeed a couple, this is almost the first time in Hockney's work that we are shown a gay couple rather than a gay coupling. Before this, or around this time, there are 'marriages', which are marriages of incompatible styles, juxtapostions as much as alliances. There are paintings to do with sexual fantasies rather than sexual partnerships, with crushes on inacessible (heterosexual or famous) men. There are paintings, such as *Adhesiveness* (Figure 4.2), *The Fourth Love Painting* (Figure 2.8), and *We Two Boys Together Clinging* (Figure 2.9) exclusively or primarily to do with casual, anonymous sexual encounters explicitly linked to obscene graffiti, to messages on toilet doors. Even the quote from Auden's *Homage to Clio* adapted within *The Fourth Love Painting* (1961) becomes, in this context, an assignation. (Auden wrote: '"I will love you forever", swears the poet. I find this easy to swear to. *I will love You at 4.15 p.m. next Tuesday*; is that still as easy?'. Hockney removes the context of the second question, changes Tuesday to Wednesday, and 4.15 to 8. More significantly, the 8 is painted into a gap in the text, which is

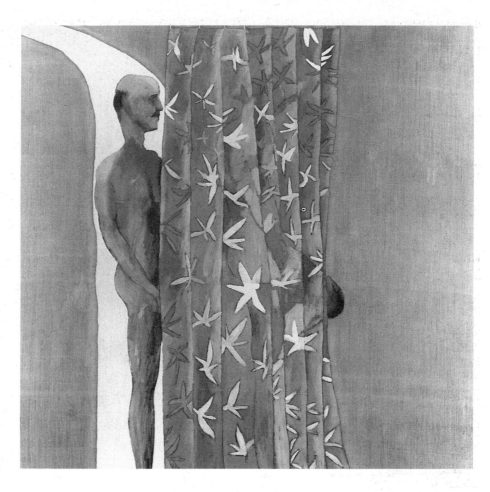

2.10

Two Men in a Shower, 1963

in type, suggesting a regular series of sexual encounters in which only the exact time and the partner are irregular. Another number, 69, is close by.) Before this only Hockney's version of Madox Brown's *The Last of England*, (*The Last of England?* (1961)), in which two boys replaced Brown's emigrating family, showed a couple. Afterwards, in 1963, came another curious picture, *Two Friends (in a Cul-de-sac)*, and the better-known domestic interiors, including the first shower scenes.

I have suggested that Hockney was clearly a figure painter by 1962, but the figures were still far from realist; they were still, as it were, figures first approached through words – and then through Dubuffet. The doll boys were caught within two languages, ironised pop romanticism and the brutal frankness both of graffiti and of prejudice. They are rag dolls also, vulnerable and abused. In pictures such as *Jump* and *Doll Boy*, they are queens. There is a sense of threat, which in *Picture Emphasizing Stillness* is first made fantastic in a leopard's leap, and then denied by the statement that they are perfectly safe. And beneath the leopard there is the house, a vision, hitherto unthinkable, of domesticity. It is tempting to propose a further contrast, almost too pat, between domesticity, the house, and the wilder sexuality routinely linked to

cats in general and the great cats in particular. The sexual act, Bataille suggests in *The Accursed Share*, is to time what the leap of a tiger is to space. In such a reading, the subtext is far less random than the baffling, or at least curious, juxtapositions of the painting might suggest.

The figure on the left is a curious confection, and an early example of the problems Hockney had in painting feet which became increasingly apparent as he approached realism. The head is close enough to the man shown in *Two Men in a Shower* (1963) to suggest a portrait source (Figure 2.10), while the stripes on his eccentric clothing – probably initially derived from playing cards, which allow a simple pun on 'queen' – can be seen in earlier paintings – *Going to be a Queen for Tonight* (1960) and *Boy with a Portable Mirror* (1961). The nude figure on the right is, with a new emphasis on the untanned buttocks, the first indication since *Life Painting for a Diploma* (Figure 1.4) of the characteristic Hockney nudes of the sixties, painted first from photographs in American physique magazines and then from the life in California. The head, however, bears no relation to this source; the figure is absorbed in the painting's ambiguous narrative, rather than turning towards the viewer.

Realism entered into Hockney's work alongside voyeurism.[2] Yet voyeurism is held at bay in this painting, which is transitional, but superior in many respects to what follows, balanced as it is between two strands which were often separated in the later work: sexuality and formalist artifice. The nude figure is far from passive; he speaks, and acts. There are two charged spaces in this picture: the gap between the back of the nude's head and the leopard, in which the text has been placed, and the space between the two men themselves, the space of their ambiguous conversation. They are the most subtle and intriguing couple in Hockney's work before the great double portraits of the late sixties. Hockney is most interesting when he is least charming.

Notes

1
It may be that Hockney picked this idea up from Duchamp, who wrote the title of *Nude Descending A Staircase*, the hookiest and most influential title of the twentieth century, at the bottom of the painting, partly to outrage the Salon Cubists. However quintessentially Modernist Duchamp's strategies now appear, many of them, including his anti-retinal insistence on the importance of language to visual art, were conscious blasphemies against the avant-garde which surrounded him. Modernism, to make the point again, was never coherent, or monolithic. Hockney, in any case, has always been happily 'literary', while abstraction has always looked somehow to music.

2
For Hockney and voyeurism, see Webb's biography. It is fortunate for Hockney that he objectified the male rather than the female body, and thus escaped the criticism long since levelled at Allen Jones.

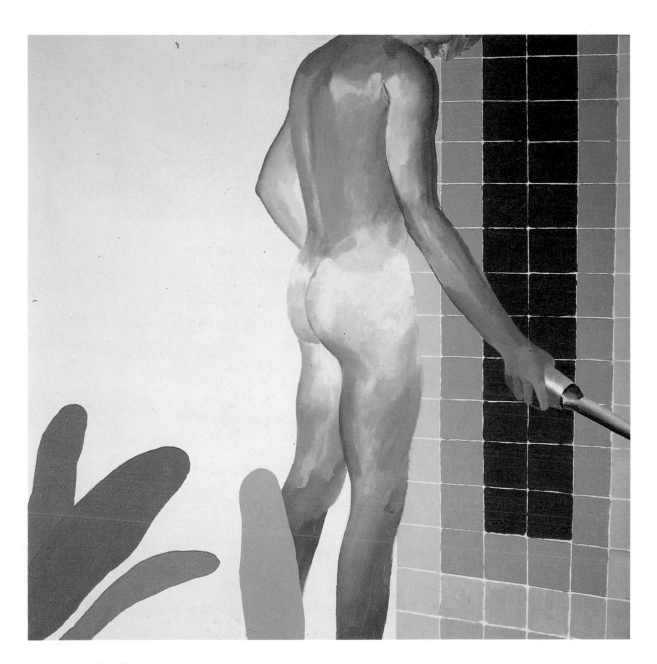

Boy About to Take a Shower,
1964–69

PLATE 3

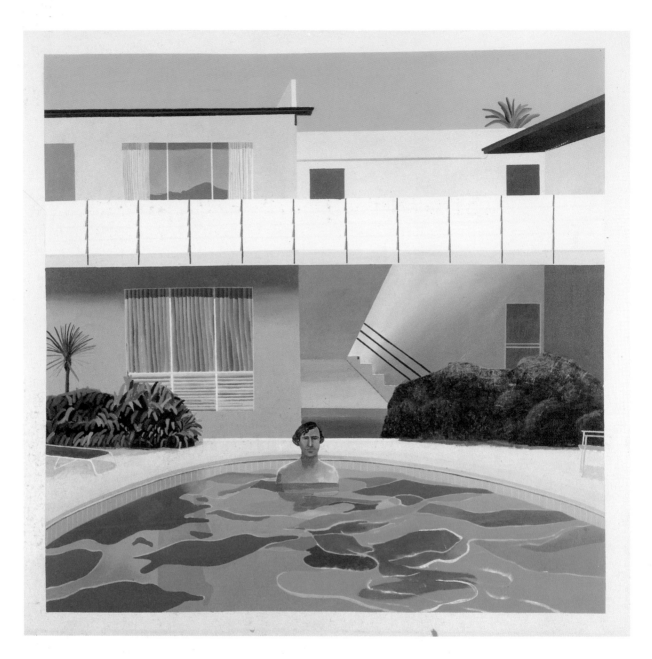

Portrait of Nick Wilder,
1966

PLATE 4

3

Showers, pools and power

PAUL MELIA

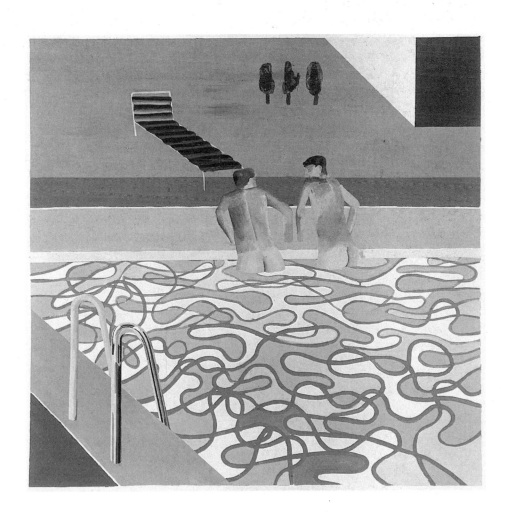

Two Boys in a Pool,
Hollywood, 1965

By December 1963, paintings by Hockney had been acquired by institutions such as the Tate Gallery and The Arts Council of Great Britain. He had his first solo exhibition at the Kasmin Gallery in Bond Street, where eight paintings, along with a number of drawings were shown. Simultaneously, Editions Alecto organised an exhibition of his prints, which included the recently completed *A Rake's Progress.* Both exhibitions received extremely favourable criticism in national newspapers and brought financial success. By the age of 26, Hockney had become a leading figure in London's 'New Generation'.

Despite the publicity from his one-man shows, Hockney, intending to spend a year in America, left London for New York. This must have been perceived as a shrewd move on his part as, by this date, New York was firmly established as the capital of modern art and many ambitious young British artists chose to spend time living and working there. On his arrival, Hockney began to establish himself within the social network of the New York avant-garde. At the Pratt Institute workshop he made two etchings which sold for a $1,000 apiece; he was introduced to Andy Warhol and the culture of the Factory; and he became friendly with Henry Geldzahler, the young and influential curator of contemporary art at the Metropolitan Museum. Kasmin then arranged his second solo exhibition for September 1964 at the Alan Gallery, New York.

Yet, after just a few weeks, Hockney, ignoring the advice of his new-found friends to stay in New York, left for the West Coast – not San Francisco, but Los Angeles. It was not the Los Angeles art scene that attracted him: 'when I arrived I had no idea if there was any kind of artistic life there, and that was the least of my worries. I found out later that there were quite a few good artists in Los Angeles, and I got to know them, but they weren't the main attraction which California had for me' (Webb 1988: 69). That is just as well. Reminiscing about his position as a director of the Ferus Gallery between 1958 and 1966, Irving Blum likened the artist's lot in Los Angeles to 'slowly sinking into a bowl of warm farina' and lamented the decision of the artists he represented to stay in Los Angeles rather than move to New York: 'When you talk about the art establishment, it exists in New York and no where else. Now, if you're going to ignore all that, you certainly can, but you do so at your own peril' (Hopkins 1988: 41, Weschler 1982: 49). 'Omaha with a beach' is how another American art dealer, James Corcoran, described the city at this time (Hopkins 1988: 41).

Given Hockney's ignorance of the Los Angeles's art scene and its underdeveloped state, the decision to move there was a curious one from a professional point of view. That he planned his second solo exhibition to consist of paintings

produced while in Southern California suggests that he felt that a distance from metropolitan centres was necessary for him to evolve a modern practice which would establish a critical difference from the Modernist abstraction dominant at that time. But why Los Angeles? We can begin to formulate an answer by considering several paintings produced during or shortly after his career at the Royal College of Art.

The last of England?

By the early sixties, London enjoyed a network of meeting places for homosexuals: pubs, private clubs, public toilets and parks. During 1959-60, his first year at the Royal College of Art, this variegated subculture provided Hockney with a source of social support and information; during 1960-61, it became a subject for his practice. His emphasis upon codes, secrecy and anonymity in paintings from his second year at the College, however, suggests the burden of potential conflict with the law which is made explicit in a small painting, *The Last of England?* (Figure 3.2). In the spring term of 1961, students at the College were set the task of producing a transcription as part of their coursework. Hockney

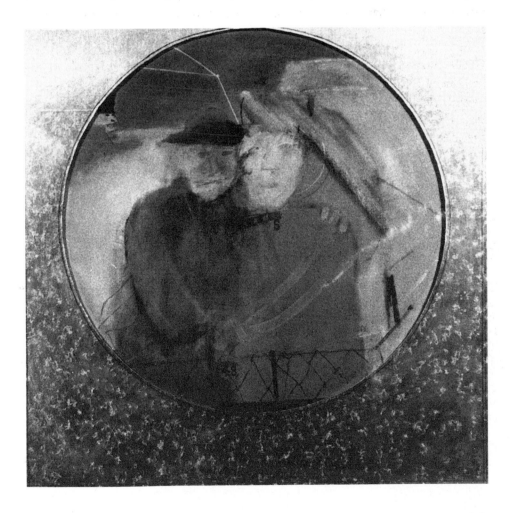

3.2
The Last of England? 1961

chose Ford Madox Brown's *The Last of England* (1855). Brown shows himself and his wife Emma, along with other emigrants, aboard the *Eldorado*. In Hockney's version, Brown's place is taken by a self-portrait, that of Emma by 'D.B.' or Doll Boy – Hockney's perfect lover. Hockney likens his situation to the paupers and remittance men of the mid-nineteenth century who, caught on the margins of British life, were often forced into involuntary exile. The gold mount and frame in both paintings suggest that each couple is an icon of their time, implicating the viewer in a condemnation of poverty and injustice.

Hockney's painting also evokes the two hundred year tradition of educated English homosexuals who, often after social ruin or legal persecution caused by their sexual activities, were forced into exile. The Mediterranean, specifically southern Italy, was a favoured destination; not only did its history satisfy intellectual interests, it also supported a culture hospitable to their desires. As Robert Aldrich has shown, beginning in the 1750s a comprehensive utopian myth of southern Europe as homoerotic was produced and reproduced, which legitimated the type of sexual pleasures northern Europeans came to the region to enjoy. Desire was conceptualised as an aesthetic experience, justified by reference to both 'Greek love' and an idealised image of antiquity.

Had Hockney been born a couple of generations earlier, he would have gone to Capri rather than Los Angeles and have used photographs by Wilhelm von Gloeden rather than the Athletic Model Guild as studies for paintings. Homosexuals of his generation, however, were less drawn to the Latin culture of the Mediterranean. In part, they were no longer as familiar with classical learning or allusions; furthermore, the burgeoning gay identity in London reduced the need to justify desire by reference to antiquity. In any case, the material foundations which had supported the homoerotic South were no longer in place. 'The Italian economy and society changed ... and disparities of income, education and standards of living between northern and southern European narrowed. Shorter or longer-term sexual liaisons between foreigners and Italians increasingly assumed the form of more recognisable hustling and prostitution, or replicated relations in the new gay subcultures which emerged' (Aldrich 1993: 185).

With their flourishing gay subcultures, cities such as New York and West Berlin became favoured destinations; both were places Hockney had visited, in 1961 and 1962. The autobiographical paintings based on his stay in these cities – which include *I'm in the Mood for Love* (1961) and *Berlin: A Souvenir* (1962) – are, unlike the work from his previous year at the College, explicitly concerned with gay identity. The quest for personal liberation through an unfettered sexuality, coupled with the burden of potential conflict with the law, may account for Hockney's decision to leave London in late 1963 (the proceeds from his one-man show had made him financially secure). As for the choice of Los Angeles, we need to consider what that city signified to him in 1963.

Imagining Los Angeles

Although by then [1963] I had made two visits to the United States, I hadn't yet gone further west than Washington, D.C. California in my mind was a sunny land of movie studios and beautiful semi-naked people. (Hockney 1976: 93)

You came here to find the wish fulfilled in 3-D ... The make-believe among the awesome palmtrees ... the invitation of technicolored, gold-laced Movies, of perpetual sun ... the last Frontier of Glorious Libery (go barefoot and shirtless through the streets) ... (Rechy 1964)

Leaving aside the mythology about Los Angeles disseminated through popular culture, Hockney's image of the place was – according to the artist – principally formed by physique magazines and John Rechy's novel, *City of Night*, which the artist read in London during 1963.

The section of Rechy's book that deals with Los Angeles focuses on Pershing Square, a park occupying a block in the centre of downtown Los Angeles. During the interwar period a culture of sorts developed in the area from the east side of the park up to Fifth and Sixth Avenues. Here, hustlers and homosexuals could meet partners for casual or impersonal sex and frequent the nearby bars, cheap hotels and bath-houses when vice-enforcement was not

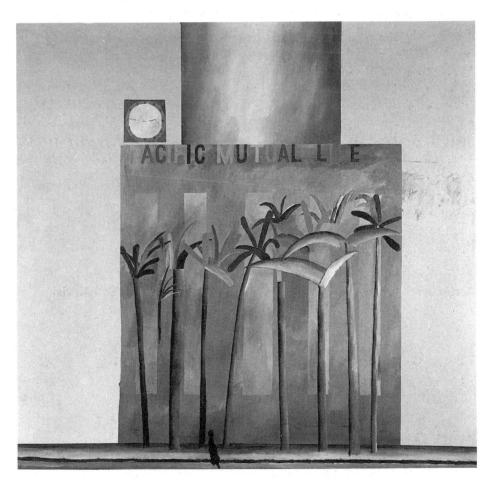

3.3
Building, Pershing Square, Los Angeles, 1964

rict. Rechy's evocation of the gay subculture exerted such a hold on Hockney's imagination that soon after his arrival he cycled the considerable distance from where he was staying in Santa Monica and subsequently painted *Building, Pershing Square, Los Angeles* (1964) (Figure 3.3).

His painting is, however, a misrepresentation. By 1964, Pershing Square was a drab and grey area, a rectangle of waste land, and the gay scene, the object of Hockney's bicycle ride, had moved on (Hockney was to leave the Square alone after a solitary beer). The significance of this work can only be understood by reference to Rechy's novel; the 'awesome' palm trees refer to passages in *City of Night* as does the legend 'PACIFIC MUTUAL LIFE'. (The seemingly arbitrary prominence given to this savings-and-loan company is otherwise hard to explain.) But Rechy's Los Angeles is evoked only to be denied by the solitary figure, more detailed in Hockney's lithograph *Pacific Mutual Life* (1964), walking along the edge of the park. Through evocation and denial, the artist transforms a drab landscape into a powerful metaphor of unrequited expectation. Soon afterwards, however, he was producing drawings of faceless nude males undressing next to motel beds. Pershing Square may not have satisfied his longings but some other area obviously did.

The other significant source of Hockney's image of Los Angeles before he moved there had been visual rather than literary; 'my picture of [Los Angeles] was admittedly strongly coloured by physique magazines published there' (Hockney 1976: 93). While a post-graduate student at the Royal College of Art, Hockney began collecting *Physique Pictorial*, a magazine published in Los Angeles by Bob Mizer. Unlike traditional physique magazines, where photographs illustrated the body-building routines described in the text, *Physique Pictorial* placed emphasis upon the model's appearance. In common with *Body Sculpture, Modern Adonis* and *Physique Artistry*, any routines it might include were recommended not to increase one's physical strength but to help improve one's appearance. A clear outline to a young body was favoured and the archetype of Apollo was evoked, not Hercules.

Physique Pictorial was the most progressive of the new titles since it was directed at homosexual men, although it could not openly proclaim its market. It featured drawings by Tom of Finland, while its photographic studies were inscribed with a code detailing the model's sexual preferences. Shots often showed close contact between the models to suggest a degree of sexual play. Mizer promoted up-to-date gay types – sailors, cowboys and men in uniform – and included experimental photographs of virile young men posed as couples engaged in activities such as washing-up or vacuuming within a domestic scene. To a far greater extent than other magazines it featured male bodies which existed simply to be looked at as objects of desire.

While Hockney put this soft-core homoerotic photography to professional use – in *Life Painting for a Diploma* (1962) (Figure 1.4) he made explicit reference to a cover of *Physique Pictorial* while for other paintings, *Picture Emphasizing Stillness* (1963) (Plate 1), for instance, he simply used photographs as a source of

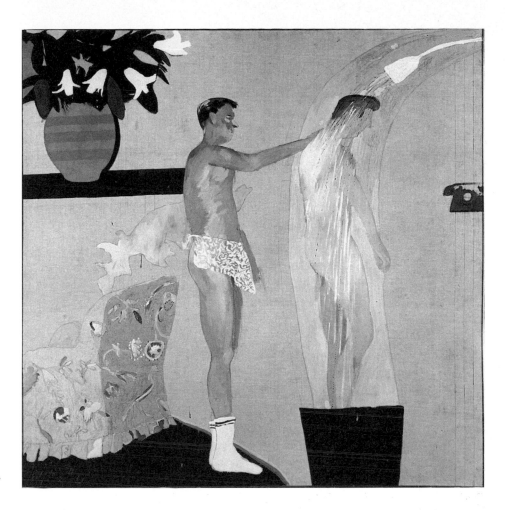

3.4
Domestic Scene, Los Angeles,
1963

imagery – it also satisfied more personal interests. The images of nude men bathing and relaxing served as veracious (because they were photographs) representations of Los Angeles as a modern Mediterranean, an Arcadia where the constraints on one's sexuality could be shed with one's clothing.

Domestic Scene, Los Angeles (1963) derives from photographs of domestic scenes in *Physique Pictorial* as the apron – rather than the customary jockstrap – suggests (Figure 3.4). The white socks signify desire conceptualised by reference to athletics rather than antiquity, one that has been fulfilled (since the painting suggests a narrative) in an ordinary, everyday environment. Although the scene in which the couple are depicted is private, the presence of the telephone suggests a network of friends and even, perhaps, that Hockney's imaginary couple belong to Los Angeles' gay subculture which had developed rapidly since the early fifties (and to which editorial notes in *Physique Pictorial* had often made reference). The painting serves as a useful index to Hockney's conception of the city six months before he visited the place.

What is surprising, however, is not so much the nature of the imagined scene but that the artist found reality corresponded to his image. 'It was only

when I went to live in Los Angeles six months later that I realized my picture was quite close to life' (Hockney 1976: 93). Suggestions to account for this statement will be offered later. But, having situated Hockney within a tradition of expatriate English homosexuals and having indicated that Los Angeles signified, in Hockney's imagination at least, an American incarnation of the utopian myth of an homo-erotic South, it is time to attend to the artist's representations. What themes and motifs circulate in his images of southern California? How does he contain Los Angeles and what does he say on its behalf? I propose to begin by looking at those paintings which depict men bathing in showers or pools. In a later section I will offer notes on others made at the time of the Watts Rebellion.

The L.A. Look

Boy About to Take a Shower, a painting from early 1964, is the first of three paintings showing a young man in a blue, grey and black tiled shower (see Plate 3 and figure 3.5). The figure derives from a photograph of 14-year old Earl Deane printed on page 6 of the April 1961 issue of *Physique Pictorial* (Figure 3.6). (Soon after he arrived in Los Angeles Hockney visited the Athletic Model Guild and acquired many such photographs.) Each emphasises the curvaceousness of the soft, smooth and hairless body. The suntanned torso and legs are contrasted with the pallor of the buttocks, which lends them a spurious mystique, giving rise to the idea that despite the model's nakedness they are still secret, even forbidden territory. But the two images are different in other respects. The harsh contrast of tones visible in the photograph have been softened, while the hard, metallic, shower nozzle which the boy handles is emphasised, enabling it to serve much more obviously as a metaphor for a penis. The absence in the painting of the stream of water cascading down the model's body enables this metaphor to be taken further as the similarity between their forms is accompanied by another – that of their function. The imminent release of a jet of liquid – the boy is about to take a shower – becomes a metaphor for orgasm. The pose of the figure, with the stiffly outstretched arm, suggests an awkwardness that is reinforced by the abrupt contrast between the flat torso and the modelled legs (Hockney omitted the highlights on the torso visible in the photograph) emphasising the image of burgeoning male sexuality.[1]

The subject of this painting was to remain very much the exception to Hockney's normal practice. Much more typical is *Man in Shower in Beverly Hills* (1964), the second of the three shower paintings – the third being *Man Taking Shower* (1965) – where the figure, with enlarged buttocks, is blatantly objectified as an erotic spectacle. However, in 1969, Hockney returned to *Boy About to Take a Shower* and added the leaves of a plant because it was, to quote his only explanation, 'a device I thought necessary'.[2] Whatever his reason for employing this device, its effect, as Nicholas Wilder has noted, is to establish a greater distance between the viewer's space and that of the boy's (Wilder 1985: unpaginated). The main prerequisite for a particularly active form of looking – voyeurism – is now present. The boy becomes objectified, a process augmented

56

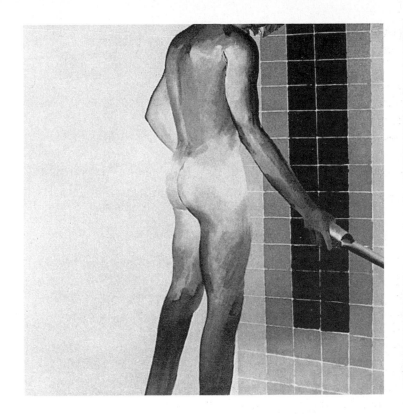

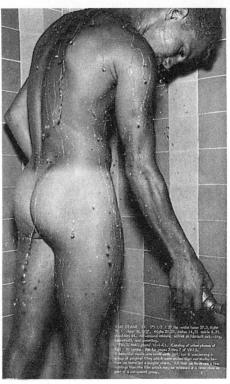

3.5
Boy About to Take a Shower,
1964 (see Plate 4 for
finished painting)

3.6 [*right*]
Athletic Model Guild,
photograph of Earl Deane,
published in *Physique
Pictorial*, April 1961

by the cropping of his face which is clearly visible in the photographic source. The revised painting now draws on a look similar to that invited by *Man in Shower in Beverly Hills*, one characterised by a wish to control and master; here, the male term is appropriate, as this kind of visual dominance comes from a masculine perspective which will be discussed later. One of the phallic-shaped leaves (they are present, obtrusively so, in all three shower paintings) has surely been painted in such a way – climbing up the boy's left leg – as to excite the implied (male) spectator. No longer invoking the passage from a state of innocence to one of experience, the painting retrospectively became typical of Hockney's early subject matter – a European's sexual desire – which continued to preoccupy him. *Two Boys in a Pool, Hollywood* (Figure 3.1) and *California* (Plate 6), paintings from a series begun in 1965 featuring adolescents in or by a swimming pool, are representative examples.

Within the literature on Hockney there is a tendency to regard the formal qualities of these paintings as having greater significance than their figurative concerns. For example, Webb writes, 'with *California* and *Two Boys in a Pool, Hollywood*, he had added the figurative element of suntanned, nude male bodies, but these were subservient to the main concern, which was with Modernist ideas of surface shape and pattern in the rendering of water' (Webb 1988: 81).

The stylisation of *California* and *Two Boys in a Pool, Hollywood* is unquestionably related to the then latest developments in Modernist practice; the

3.7
Savings and Loan Building,
1967

rendering of the water evokes abstract paintings by Bernard Cohen, while the flat, unmodulated paint surface acknowledges the Post-Painterly Abstraction of his American peers. Such references ensured that these works would not only be understandable in terms of current aesthetics and criticism but also that they would be received as 'gambits'. The term is useful because it suggests not only calculation on Hockney's part but also that he was taking a risk.[3] In the Modernist subculture, characterised by individual ambition and often, therefore, competitiveness, an artist's status and thus the value of his or her work depended on the production of paintings which not only deferred to the practice of avant-garde leaders but which also established a significant difference, legible as an advance to critics, dealers and 'serious' collectors. These paintings were part of the artist's on-going bid for recognition and status within the metropolitan art worlds of London and New York since, by simply quoting works whose *raison d'être* was the maintainence of the integrity of the picture plane to render the surface of a swimming pool opaque, Hockney not only embraced his exemplars but also undermined their authority. (In 1968, Guy Brett noted that Hockney's paintings of Los Angeles' buildings (Figure 3.7), in which the same concern is evident, censure Minimalist sculpture.) The artist

has said about his work in the mid-sixties, 'I still consciously wanted to be involved, if only peripherally, with Modernism' (Hockney 1976: 100).

Hockney *is* a figurative painter and has never allowed his dialogue with American Modernism to dominate the 'figurative element' referred to by Webb. Rather, the pleasure to be obtained from the means of representation (after all, he undermines Cohen's practice in way that is highly amusing) augments that obtained from the subject of the representation. The initial pleasure or fore-pleasure afforded by the signifiers in *Two Boys in a Pool, Hollywood*, for example, makes possible the release of a still greater pleasure in the signified, subjecting two boys to a voyeuristic look. As with the shower paintings, the figures are explicitly marked as passive erotic objects for the spectator's gaze; not only have their enlarged buttocks been placed towards the centre of the composition, they have also been rendered in a lighter tone than the remainder of their bodies. The painting draws on a voyeuristic look, one that asserts control, is investigative, and the relatively high viewpoint contributes towards this. The viewpoint also assures the spectator that the boys will continue to be under his surveillance even when they finally emerge from the pool and, one assumes, lie together on the sunbed. The manner in which the three plants have been painted is curious, as though they were intended to appear as an afterthought. Perhaps they perform a function similar to the leaves in the shower paintings (psychoanalysis claims that three is the phallic number).

Physique Pictorial was the source of imagery for *California* (and, one assumes, *Two Boys in a Pool, Hollywood*). A comparison of Figure 3.8 and Plate 6 reveals a number of differences, significant among which is the fact that Hockney decided to paint the boys as sullen – as though they have been subjugated. But this alteration does not contradict the promise of gratification. Rather, it is meant to arouse the spectator's desire. Such meanings – the subject is two *boys* – were very risky. Perhaps this is one reason why Hockney felt

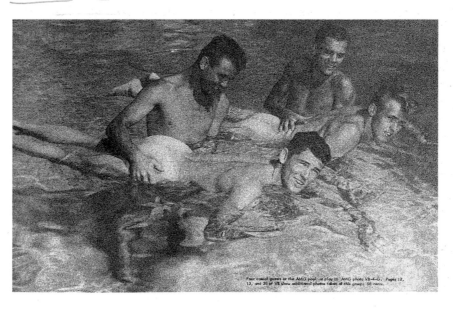

3.8
Athletic Model Guild, photograph of casual guests at the AMG pool at play, published in *Physique Pictorial*, January 1963

impelled to supply a framing device. In his autobiography, Hockney writes that 'The idea of leaving a border of virgin canvas round the image was, in retrospect, a timid one. It makes the picture look more like a painting' (Hockney 1976: 100). The frame, therefore, not only heightens the spectator's pleasure in looking, since it draws attention to the act itself, but can also displace any unease within the spectator by reminding him – the implied spectator is male – that what we are looking at is, after all, only a painting, thereby allowing pleasure in the signified to continue.

The rigid separation of voyeurism and exhibitionism enforced by these paintings suggests the possibility that it functions as a defence; it prevents the spectator from identifying with the objectified nudes. Despite being 'gay' images, they have clearly been executed within the terms of masculinity and do not break, therefore, with the norms of conventional male sexuality. Hockney's paintings share a feature with gay pornography which, as Richard Dyer has argued, 'is always in [a] very ambiguous relationship to male power and privilege, neither fully within it nor fully outside it' (Dyer 1983: 28).

This issue can be explored in relation to two apparently similar paintings by Hockney, *Portrait of Nick Wilder* and *Peter Getting Out of Nick's Pool*, both produced during 1966 (Plates 4 and 5). From June of that year to July 1967, Hockney had a studio on Pico Boulevard and for some of this time lived in Nicholas Wilder's apartment in West Hollywood. (Wilder owned a well-known art gallery on La Cienega Boulevard and was later to represent Hockney in southern California.) Both paintings feature a pool in the foreground, the figure in the middle distance and, behind them, Wilder's apartment. However, despite their similarities, the paintings have two quite different functions.

We may note that Wilder's full name is given in one title – he is an identifiable individual – whereas in the second only the young man's Christian name is supplied. In the portrait of Wilder, much more of the pool and building is shown, presumably to serve as a sign of his wealth. One of the principal pleasures he will have derived from this portrait is that of seeing himself depicted as wealthy – a man of property. However, an absence is significant here: a public sign bearing the notice 'No lifeguard on premises' is present in a study. While there may be a number of reasons why this sign was not included in the finished portrait, the effect of the omission is to establish Wilder as the owner of the building and pool. Neither the entire building nor the whole pool was, in fact, owned by Wilder (it belonged to a condominium) despite the claim to the contrary contained in the title of the other painting.

The curve created by the pool, the horizontal line formed by the intersection of the building and ground, the vertical line created by the building and the diagonal one of the staircase all intersect at the point occupied by Wilder's head. In the other painting, the pool has been straightened out and the viewpoint lowered to make Peter's buttocks the focal point to a far greater extent.

The painting of Wilder *is* a portrait; it documents not only his appearance but also his status and presence (hence the styled reference to a Classical bust).

3.9
The Room, Tarzana, 1967

This is in contrast to the second painting, which is of a semi-anonymous younger man, whose image has been objectified and sexualised. It is *not* a portrait, it constitutes a figure as the passive erotic object of the spectator's gaze. One painting constructs a fantasy around an adolescent who has no identity beyond his existence as sex object; the other is a portrait of a man of wealth and social position. The identity of Peter Dan Schlesinger, an 18-year old then studying world history at the University of California at Santa Cruz and Hockney's partner in 1966, has been erased; unlike Wilder, he is simply represented as a body, as a sign of a European's desire. The majority of works discussed articulate and are, indeed, the product of a power relationship; bodies of young Californians have been colonised by the desires of the visiting European.

Colonised is an apt word, for it emphasises that Los Angeles, like the homo-erotic Mediterranean, is conceived in these paintings as though it were an outpost of the Empire, a conception which embraces not only exile but also expectation. Hockney wrote about his arrival in Los Angeles, 'I got into the motel, very thrilled; really, *really* thrilled, more than in New York the first time. I was so excited ... Los Angeles reminded me of Cavafy; the hot climate's near enough to Alexandria, sensual' (Hockney 1976: 94, 99). For Evelyn Waugh,

who arrived in southern California sixteen years before Hockney, Los Angeles also seemed more like a British colony rather than one of the most successful centres of industry in the world. An entry in his diary for 1948 reads, 'A city ... of palm trees with a warm hazy light ... more like Egypt – the suburbs of Cairo or Alexandria – than anything in Europe' (Davie 1976: 672).

Another painting by Hockney sheds further light on the subject of colonisation. When Hockney's 1967 painting *The Room, Tarzana* (Tarzana is district in the Los Angeles basin) was exhibited at Kasmin's Gallery, London, in January 1968 (Figure 3.9), the example of François Boucher's painting *Reclining Girl (Mademoiselle O'Murphy)* (1751), was cited by critics as a reference for the positioning of the figure, a comparison which continues to be made in the literature today. This comparison is only of limited use, however. Although it may emphasise that the visual pleasure obtained comes from a masculine regime of looking, it precludes too many other meanings. The work *does* evoke a reference: Paul Gauguin's *Manao Tupapau (The Spirit of the Dead Watching)* (1892) (Figure 3.10). At the compositional level, the similarities are striking – the bed across the plane of the painting on which is spread a naked body, subjected to the viewer's gaze, served up to be sodomised.[4] Both paintings also feature an opening on to another space behind the bed.

As in Gauguin's painting, a European spectator is also implied by Hockney's work because of the direction of the figure's gaze. He, since I assume the implied spectator for this painting is also a male, is necessary to the scene since the painting is not only about the maintenance of distance, and therefore visual

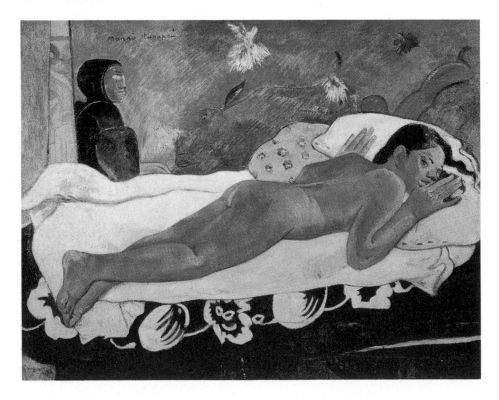

3.10 Paul Gauguin
Manao Tupapau, 1892

62

mastery, but also of difference from non-Europeans. The spectator is installed in a position of control *and* superiority, and the representative of Los Angeles youth – Peter Schlesinger served as the model – is reduced to a sexual stereo-type, as the white tee-shirt and sport socks suggest. Schlesinger's presence is, once again, erased as his painted body becomes a sign not of a particular Californian but of a European's desire. It is more apt to compare the work to Gauguin's rather than that of Boucher since this helps to bring the themes of exploitation and domination present in Hockney's work to the foreground. It also alerts us to the possibility that his practice has its roots in the culture of colo-nialism, a culture to which, intentionally or unintentionally, he is contributing.

'It is striking that so many Los Angelists are English, outcome of whatever mimetic gene that has made them such a race of colonizers and impersonators' (Sorkin 1982: 8). In addition to Hockney and Waugh, the architectural historian Michael Sorkin had in mind Aldous Huxley, Charles Laughton, Christopher Ishwerwood, Reyner Banham and the 'myriad of lesser lights in their wake and thrall'. After invoking Edward Said's *Orientalism*, Sorkin coins the term 'Occidentalism' to refer to the representations of Los Angeles produced by these expatriates. The analogy has appeal.[5] About Banham's book, *Los Angeles: The Architecture of Four Ecologies* (Figure 3.11) Sorkin notes that the author's 'exultant celebration of learning to drive a car in order to attain one of the pillars of wisdom as a prerequisite to writing about the city might a hundred years earlier have involved a camel' (Sorkin 1982: 8). The most prominent of all the images of Los Angeles used by Banham to illustrate his arguments are by Hockney (*A Bigger Splash* (1967), is reproduced twice, on the cover and in the final chapter, and the 1965 drawing *Hollywood Garden* appears on the title page). But this should come as no surprise; Occidentalism depends upon a communal language forged from the accounts of expatriates.

Just as earlier generations of European artists perceived the homoerotic South through the the ideological baggage of Winckelmann and Pater, or the Middle East and 'tropics' via Orientalism, so Hockney perceived California through *Physique Pictorial* and John Rechy's *City of Night*. But, as has been noted, what should surprise us is that he found that reality corresponded to the image. In order to account for this we need to come to some understanding of Los Angeles; of what it was in the mid-sixties and why it was represented by Hockney, Waugh and and other Englishmen as an outpost of the Empire rather than one of the most profitable centres of industry in the world. To establish how their image was supported, we need to make reference both to the city's history and to the manner in which it has been represented.[6]

Los Angeles, myth and reality

In 1888, following the collapse of the Los Angeles real estate boom (a stagger-ing one thousand people a month were leaving the region after its population had increased from 11,000 in 1883 to 50,000 in 1888), the owner of the *Los*

Angeles Times, Harrison Gray Otis, and his son-in-law, Harry Chandler, spear-headed the creation of the Los Angeles Chamber of Commerce. The new organisation embarked on a continuous promotion of the region by investing in an industry which promised immediate returns – tourism mixed with real estate speculation. Millions of brochures and hundreds of illustrated monthlies were distributed nationwide advertising Los Angeles as the golden land of promise. Exhibitions, which portrayed Los Angeles as fertile and exotic, toured the country – often on special trains – visiting state (and even world) fairs. For more than a quarter of a century, the Los Angeles propaganda machine was successful in attracting not only movie producers but newcomers from towns in the Midwest, all of whom transferred their savings into southern California real estate. (It also attracted cheap labour from all quarters of America, a point which will be developed later.)

Through the efforts of the Chamber and with the provision of an artificial harbour and secure supplies of water and electricity, Los Angeles had become a city of 1,238,000 by 1930, with another million surburbanites living in the country – a rate of population increase that outstripped that of any other metropolitan centre in the United States. Between 1949 and 1965, the population doubled to 11 million.

The promotion and transformation of Los Angeles depended as much on the successful fostering of an all-encompassing fiction as on the crude promotion of land values: hence the integral role played by tourism in the Los Angeles economy. In the 1880s, tourism already accounted for over a quarter of all business revenues. During the interwar period, the tourist industry became more profitable with the founding of the All-Year Round Club, another initiative of Harry Chandler, which received funding not only from county government but also from local businesses. According to Henstell, 'The All-Year Round Club was no sedate public relations office ... it functioned like a ministry of information' (Henstell 1984: 19). With advertisements in daily and Sunday newspapers and more than 2,000 copies of *Pictorial California* sent out each month to travel agents, the Club estimated that it had contacted 12 million people in 1926 alone. By the early 1930s, tourism had grown to be southern California's second largest industry. In 1981, 123.1 million visitors spent $8.8 billion in the Los Angeles area.

Prominent among the many fictions produced and reproduced by the tourist industry was that of Los Angeles as a second Eden, a Mediterranean-like idyll, claims about whose moderate climate, for example, were often at odds with fact. In a series of travel books on southern California written by the journalist Charles Nordhoff during the 1870s and 1880s, Los Angeles was already being described as a 'magical, lotus-land of sleepy adobes and Mediterranean, semi-arid grandeur' (Klein 1990: 5). Over the next quarter of a century, the Chamber of Commerce and the All-Year Round Club embellished such claims, going so far as to promise that the climate would perform miracle cures and that trees could grow without being watered. To support this myth, the first of many

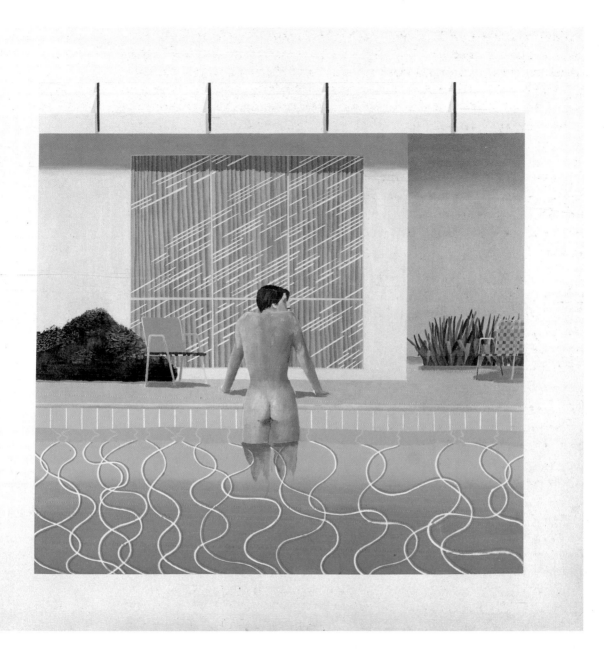

Peter Getting Out of Nick's Pool, 1966

PLATE 5

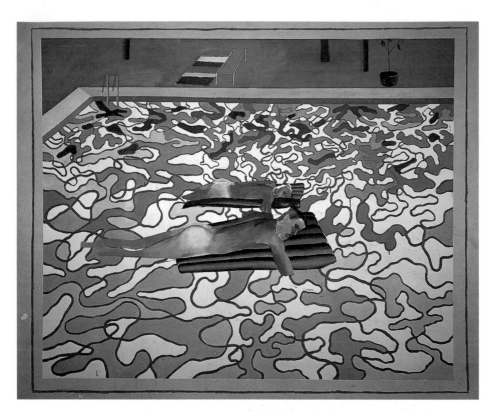

California, 1965

*American Collectors
(Fred and Marcia
Weisman), 1968*

SCAW

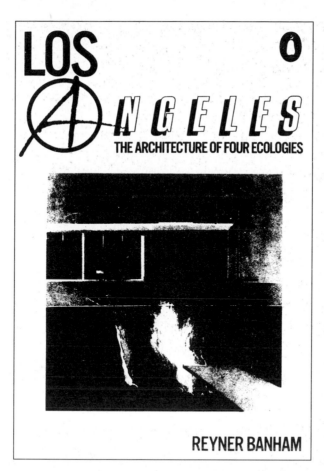

3.11
Cover of Reyner Banham's
*Los Angeles: The
Architecture of Four
Ecologies* (featuring the
artist's 1967 painting, *A
Bigger Splash*; see Figure
2.7)

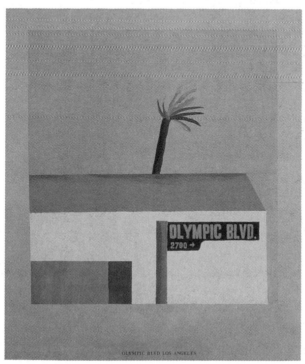

3.12
Olympic Blvd., 1964

material transformations of the southern Californian landscape had already taken place as long ago as 1905, with the opening of Abott Kinney's Venice-by-the-Sea. Kinney, a tobacco tycoon, speculator and developer, modelled its hotels on Italian precedents, and, as in the other Venice, houses were organised around canals (complete with imported gondoliers), a Grand Lagoon and, at the city's heart, the pier. (That the landscape could prove resistant to the myth can be seen by the fact that during the 1920s Venice's canals were filled in after they had turned into swamps.) A variety of other practices also attempted to transform southern California into a Mediterranean-like idyll. They ranged from the importation of palm trees to the colourful advertising of the exotic Valencia orange, introduced from the Azores, in which it served as a symbol for the region. The tourist industry can therefore be understood at two related levels. It was, and is, an integral part of the economy of Los Angeles and also a product of new economic, social and ideological structures ('boosterism') from which were produced a range of representations.

While Hockney's images of the city cannot be accused of reproducing tourist images uncritically (see Figure 3.12), their embrace of Los Angeles as a Mediterranean idyll is stronger than any criticisms. This point can also be made by contrast. In order to construct Los Angeles as an object for tourist experience, the industry had to exclude, more than anything else, that corpus of critical representations, generally referred to as *noir*, in which the city is a dystopia. As the conclusion to this chapter suggests, not only is the Californian sky in Hockney's paintings devoid of '*noir*' clouds, but the social realities of the city are negated so that it serves as a *spectacle*.

Hockney's comparison of Los Angeles to Cavafy's Alexandria is meaningful in several ways. Like the Middle East, the city is a geographical and cultural borderland, lying between the Far East and Europe and between Anglo and Hispanic America. With access to cheap labour supplies, southern California drew upon one group after another to perpetuate a plantation style of landowning. In every era of California's history, non-whites have performed the community's manual labour. For example, figures for 1970 show that three-quarters of California's farm workers spoke only Spanish; most earned less than $1,000 a year and, because of pesticide spraying, they had the highest rate of occupational disease in any Californian industry. Throughout the sixties, the millions of acres on which non-whites worked were owned by the Bank of America, the Los Angeles Times, savings-and-loan companies, and the major oil and utility companies (see Figures 3.3 and 3.7).

While middle-class whites moved out to the burgeoning suburbs in the post-war era (the subject of paintings such as *American Collectors (Fred and Marcia Weisman)*, *A Bigger Splash*, *Mulholland Drive* – see Plate 7, Figure 2.7, Plate 12), a rapidly growing population of blacks and less prosperous whites competed for space in the inner area (no plates can be referred to as there are no representations by Hockney of this area). Blacks moved to Southcentral Los Angeles, amid the surrounding antipathy of neighbourhoods that were determined to stay white.

In August 1965 – the year Hockney painted two naked boys in a sun-drenched pool and titled his picture so as to serve as a synecdoche for the region (Plate 6) – racial hostility turned an incident into a riot which lasted for six days. In the Watts Rebellion – as it became known – 34 people were killed, and another 1,032 were wounded or injured. White-owned businesses over an area of eleven square miles were burnt, causing property damage of more than $40 million. One outcome of the Rebellion was further economic distress in Black Los Angeles.

While Hockney need not be criticised for avoiding these issues – he has never claimed to be a social realist – the ends to which his images have been put do give rise for concern. Mike Davis has argued that in recent years 'the largest land developers and bankers [in Los Angeles] have coordinated a major cultural offensive ... to support the sale of the city to overseas investors and affluent immigrants ... with a promotional budget so large that it could afford to buy the international celebrity achitects, painters and designers – Meier, Graves, Hockney, and so on – capable of giving cultural prestige and a happy "Pop" veneer to the emergence of the "world city"' (Davis 1990: 22).

If this is the case, then Hockney's paintings of showers, pools and other motifs in Los Angeles, have achieved a significance which is dangerously unrepresentative. While the 1988 retrospective exhibition and its scholarly catalogue appear to have established Hockney's work as being of continuing importance to the history of art, and the artist himself as above all *serious* (*pace* Chapter 1), a problem does occur when it is claimed that his images represent a whole region. It is this claim that Earl A. Powell III, Director of the Los Angeles County Museum of Art, makes in the foreword to the retrospective catalogue: 'It is through Hockney's work that many people derive their impression of life in Southern California, a landscape redolent with sunshine, swimming pools and palm trees.'

Notes

1
This discussion owes much to Marco Livingstone's comments on an earlier discussion of this painting by me. See also his commentary on the painting in the catalogue to accompany the exhibition *David Hockney*. April/May 1989, Odakyu Grand Gallery, Tokyo.

2
This explanation is given in a letter dated 19 Nov. 1970 to A. Plunkett, reprinted in the catalogue to accompany the sale of contemporary art at Christie's, London, 29 June 1983. See entry for lot 467.

3
Both the term 'gambit' and the trilogy 'reference, deference and difference' are taken from Pollock (1992: 12-16, 28-35).

4
My references to Gauguin's painting owe much to Pollock (1992).

5
Although is should be noted that the fantasy around Los Angeles – unlike that around the Orient – was created not so much by Europeans as by local businessmen. See the next section of this chapter for a discussion of this point.

6
The following section draws freely on the work of Clark (1983), Davis (1990), Fine (1990), Henstell (1984), Klein (1990), Marchand (1986) and Nelson and Clark (1976).

4

Figure paintings
and double portraits

NANNETTE ALDRED

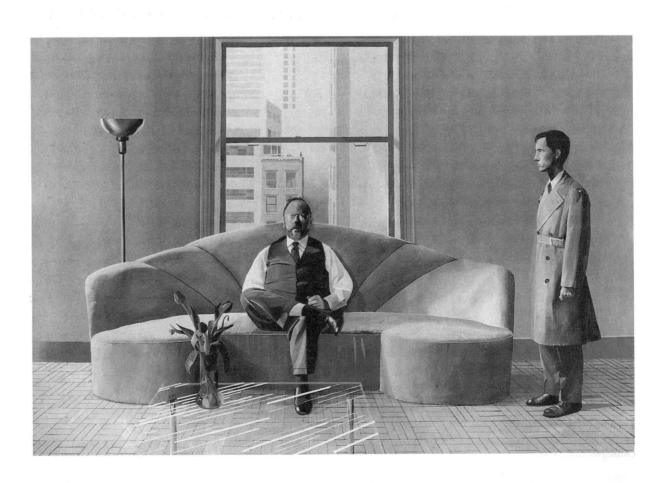

In 1955, when he was half way through his course at the Bradford School of Art (1953–57), David Hockney sold his first painting, *Portrait of my Father* (1955). The picture combined a naturalistic depiction of the figure with an attention to technique evident in the surface of the work, as he had been taught at Bradford. By 1975, when he painted his father again, he had explored a range of possible uses for the figure within a Modernist paradigm. He had briefly explored abstraction; he had used the figure to make personal and political statements; and he had investigated post-Cubist and perspectival articulations of space. This chapter focuses on the way in which Hockney explored these possibilities through a discussion of the double figure paintings and double portraits that he produced between 1955 and 1977. I begin by looking at his reincorporation of the figure through the influence of R. B. Kitaj and Francis Bacon; the relationship of figure to ground and the re-emergence of space; and his expansion of the discourse of sexuality. I then consider his move from painting two figures to painting double portraits and making an explicit depiction of a relationship.

When Hockney arrived at the Royal College of Art in the autumn of 1959 he began to use the language of abstraction in his paintings. Before long, however, he returned to the figure, only now with innovative subject matter and a self-conscious awareness of style. One of the painterly issues that had been raised by that time at the RCA was the relationship between abstraction as epitomised by the 'new' American painting and a commitment to modern figure painting as practised by established figure painters like Bacon (who had occasionally taught at the RCA) and 'second' wave Pop Artists like Peter Blake. The Pop movement, with which Hockney became associated for a short but significant time in his career, was largely identified by its subject matter (rather than by a style or manifesto), and its subject matter was largely figurative.

Hockney's declared influences, and the artists he admired, tend to stand outside Modernist accounts of twentieth-century art. They include artists such as Edward Hopper, Balthus, Stanley Spencer and Walter Sickert, who also wanted to retain the figure within a Modernist paradigm. Like Sickert and Bacon, Hockney has used photographs as source material for his paintings. Initially he relied on available images – the work of Eadweard Muybridge, for example, (whose photographs were also influential on Bacon) – but later he used his own photographic studies.

It is well documented in other sources that Hockney was personally encouraged to retain the figure in his painting by his association with Kitaj, his older fellow student at the RCA. By the second half of the twentieth century, film appeared to have become the dominant medium representing the human figure;

4.1 *[facing]*
Henry Geldzahler and Christopher Scott, 1969

69

and Kitaj and Richard Hamilton referred to the body in paintings based on quotations from films or reconstructed stills. Hockney later spoke of being influenced by the scale and light of film but in his use of cinematic images he seems to be nostalgic for that sense of scale and for the use of the close-up as an erotic encounter rather than seeking to appropriate existing images. Moreover, he does not invest the figure with the traditional notion of humanist truth, as is apparent in the way that he uses it to flirt with different styles. His first major public work was a series of four paintings called *Demonstrations of Versatility* (1962).

Hockney had seen the 1960 retrospective exhibition of Picasso's work at the Tate Gallery and that had freed him from the repression of a single stylistic identity and allowed him to explore both abstraction and figuration. A Bacon exhibition of the same year had encouraged him to use the male body whilst exploring the relation of figure to space. A third exhibition, of the work of Dubuffet, had confirmed his use of the schematic language of graffiti. Hockey's earliest non-naturalistic figure paintings contained passages of abstract framing, letters, numbers and musical notation within which figurative elements appear, at first almost indistinguishable.

In his series of 'Love' paintings of 1960 Hockney began to frame the figurative elements. In *Adhesiveness* (Figure 4.2) of the same year, he reintroduced a figure/ground relationship by the use of a dark, flat area on the left and along the lower part of the image on, or in which two figurative elements are ambiguously placed, so that the viewer is bound to gain a sense of recessive space. Even in his more naturalistic representations of the figure in the later double portraits this playful use of spatial ambiguity provokes a double-take. In the 1960–62 paintings Hockney relates the figures to specific human individuals conceptually through the use of numbering rather than literally through resemblance. In addition, the flat denotative signs in *Adhesiveness* (the numbers) confuse the viewer's understanding of space as the 23.23 of Walt Whitman's initials[1] straddle the two different areas. The colour field framing and the areas of gestural abstraction, encourage a Modernist reading of the overall flatness of the image whilst at the same time emphasising the difference between the parts of the figures and their ground. The 4.8 of Hockney's coded name is contained within the flat colour field. Indeed, all the elements are depicted as flat. However, the relationship between the upper and lower parts of the 4.8 figure becomes ambiguous because we read the upper part of the figure as being *in front of* the abstraction. In addition, the abstract area of the painting contains a figurative element in the black 'bowler' hat placed above the Whitman figure, which challenges the viewer to ask in which space is it placed. The black hat connects with the second figure through a black calligraphic gesture. *The Cha-Cha that was Danced in the Early Hours of 24th March* (1961) (Figure 2.5) also played with these elements of doubling, spatial ambiguity and flatness, in this case through the mirrored reflection within the painting. By *Doll Boy* (1960–61) (Figure 2.6), *The Most Beautiful Boy in the World* (1961) and *Peter C.* (1961) the figure had become increasingly dominant.

A young contemporary

R. B. Kitaj had argued for a reclamation of the figure for radical politics after the liberal espousal of abstraction as a safe haven from overt propaganda. In his RCA figure paintings, Hockney had painted about his own fantasies. At a time when sexual acts between men were illegal, he articulated a language which could speak of those acts and feelings. His references were to 'cottages',[2] to graffiti as it had been accepted within high Modernism in the *art brut* of Dubuffet, and to the explicit sexual imagery of Picasso's work. With the encouragement of his friend Kitaj to paint what he believed in, Hockney's early paintings were overtly propagandistic on behalf of homosexuality and implicitly

reformist of the existing laws. By 1960 in works like *Adhesiveness*, he had not only begun to explore a formal relationship between two figures, but also to depict a sexual one. In the first three 'Love' paintings he combined a naive style in the scratched surfaces, with the accepted reference to graffiti, and the popular and 'sexy' imagery associated with the new Pop Art. He also used visual puns and other forms of humour in the paintings and their titles.

In addition, Hockney was to project himself in the new form of artist as performer or superstar unabashed about his class and sexuality; and the support of new dealers created a cultural environment in which the works were not only acceptable but also immediately integrated into the range of possibilities that 'Swinging London' held. Derek Jarman noted that during this period Hockney's significance extended both to the man and his paintings:

David was honest to the point of naivete ... [depicting] ordinary young men in bed together ... David was a 'star', not just a good painter, but – like Warhol – at the cutting edge of a new lifestyle, which was the most enduring legacy of the sixties ... visual statements like David's golden hair – he said 'Blondes have more fun' – gave all of us hope, opened new horizons. (Jarman 1987: 42–7)

The early figurative paintings were important for the explicit way in which Hockney employed those elements of the new art as sexy, glamorous, witty. Like Peter Blake in works such as *Girlie Door* (1959), he took the pin-up as the new visual paradigm but increased the vocabulary of desire in images like *Doll Boy* (1960–61) and *We Two Boys Together Clinging* (1961) (Figure 2.9). Richard Hamilton, too, questioned the construction of a gendered identity in works like *Adonis in Y-Fronts* (1962–63) which challenged the language, codes and assumptions of representations of gender in popular culture, in this case popular music. He reworked the song, *Venus in Blue Jeans*, as Hockney had reworked Cliff Richard's *Living Doll*.

If a David Hockney could be a luminary of the 'swinging London' scene, how to explain his (homo)sexual lifestyle? For most homosexual media stars of the period, the question was evaded, either in an ostensibly shining virginity and a glowing religiosity, or in nervous breakdown. But if sexual pleasure was a desirable goal, how could homosexuals be excluded? Especially when the Kinsey 'heterosexual homosexual rating' told everyone that most people had had some homosexual experiences at certain periods of their lives. (Weeks 1983: 158)

Weeks draws attention to the fact that sexual 'liberation' in the 1960s assumed the existence of a 'normal' male sexuality and thus excluded a range of sexual identities and experiences. Gay men, like women, formed no part of dominant liberationist discussion. In his catalogue for *The Sixties Art Scene in London* exhibition, David Mellor drew attention to Pauline Boty's paintings entitled *Its a Man's World* (1963–65) and their concern with the 'problem' of female sexuality during the decade. Hockney's radical gesture was not to consider homosexual identity as a problem but to expand the discourse of sexuality itself. In this he was encouraged by the example of Francis Bacon. Hockney was also aware of the work of Keith Vaughan and John Minton, two other figurative artists associated with the

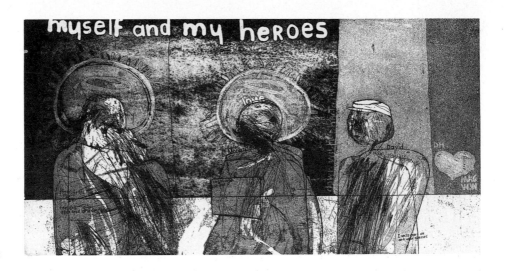

4.3
Myself and My Heroes, 1961

relatively small 'out' homosexual world of the 1950s cultural scene in London (see Jarman 1987). Minton had been a tutor at the RCA until his suicide in 1957.

Hockney had 'come out' in his paintings and to his friends in 1960. The following year he visited New York for the first time and later produced his first etchings. *A Rake's Progress* was published in 1963, and, like Hogarth's original, was about social mobility. Hockney took his humour and subject matter from Hogarth but his work is a semi-autobiographical tale describing a homosexual – rather than a heterosexual – discovery of life in the big city. Anecdotal and ironical in its reference to the original, Hockney's set of etchings made a

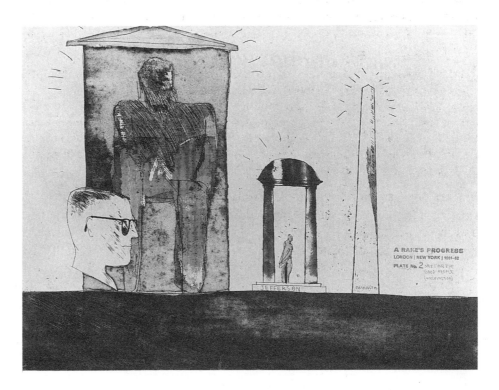

4.4
'Meeting the Good People (Washington)', 1961–63

personal and political language out of a familiar tale. Attention has been drawn to the liberating effect on the artist of this first trip New York. It is also worth nothing that there had been a rapidly expanding market in figurative painting for a gay audience on the American art scene since the fifties (see Silver 1992).

At the same time as he was producing the heavily coded RCA fantasy figure paintings in which he often placed himself as 4.8, Hockney was more openly autobiographical in his etchings. His first work in that medium, *Myself and My Heroes* (Figure 4.3), dates from 1961. In the light of the later double portraits, as we shall see, it is significant that Hockney has painted himself as onlooker of the two figures. The 'heroes' (Gandhi and Whitman) represent different aspects of love, with 'David' standing in a separate space, outside the main composition. Although the picture is triptych in form, the space occupied by the artist is made to appear more confined than that of the heroes by the use of light and tone and by the way in which the schematic (love)heart and the letters DH encroach upon it. The figures of Whitman and Gandhi are connected by their gaze; the artist's gaze is outside their visual field. This positioning of the artist as both viewer of the scene and participant recurs in the later double portraits. *A Rake's Progress* included self-portraits of the artist as protagonist in, and viewer of, his own mythologised life. Etchings like 'Meeting the Good People (Washington)' (Figure 4.4) and 'Viewing a Prison Scene' depict Hockney as spectator of his new visual experience. 'The 7-Stone Weakling' directly addresses the artist's voyeuristic pleasure in the idealised and eroticised figures of the muscular runners.

By 1966 when his series of etchings based on the poems of C. P. Cavafy were published, Hockney had already produced a large number of 'lifestyle' figure paintings – domestic, leisure scenes of men showering, swimming, sunbathing. In this case he chose not to set the more intimate scenes of the poems in the Middle East (the poems were set in Alexandria) but in London, with recognisable figures (Jarman 1993: 47).

As Paul Overy wrote in *The Listener*, in August of that year, 'Hockney concentrates on presenting homosexual liaisons as something completely normal and acceptable. To do this requires a certain amount of courage one must admire' – particularly at a time when these 'liaisons' were against the law. The painting establishment backed Hockney as propagandist the following year, when homosexual acts between men were partially decriminalised. He was given the prestigious John Moore's prize for his painting *Peter Getting Out of Nick's Pool* (Plate 5), one of his recent L.A. paintings, despite (or because of) its explicit reference to homoeroticism. Hockney denies the concept of 'gay art', but his work has extended the visualisation of sexuality.

As we have seen, Hockney's early subjects were an articulation of his own lifestyle and that of his friends. The figure paintings were constructed like a collage of visual pleasure. He took images from physique magazines and studies of friends for a 1963 series of domestic scenes set in friends' homes, his home and a fantasy Los Angeles. The most significant of these works were double figure paintings, including *Domestic Scene, Broadchalke, Wilts.*, with Joe

Tilson and Peter Phillips as two seated figures on the sofa. In *Domestic Scene, Notting Hill* (Figure 4.5), he juxtaposed a life drawing of his model Mo McDermott with a portrayal of Ossie Clark (the subject of a later double portrait) sitting in his armchair. The 'Notting Hill' figures represented an experiential visual relationship rather than a depiction of figures in space. The painting records the motif's visual impact on the artist's perception; the objects are noted not composed. Hockney's eye lingers for a moment over the curtain behind the seated figure of Clark. The two elements form a single visual mass, the configuration of the curtain echoed by the arrested movement of the figure, and they have a common light source. Behind is the naked figure of the model. Even this early work contains the vase of tulips, a metonym for Hockney himself. This motif enters into his lexicon and he continues to employ it in his subsequent work. In *Domestic Scene, Los Angeles* (Figure 3.4), the empty armchair, recognisably from Hockney's Notting Hill flat, also stands as a representation of the artist in the scene, whilst the schematised bathing figures are taken from a contemporary physique magazine.[3] These paintings are exploring the relationship of figures in space; but, although they suggest a third presence within the format of the painting itself, that of the artist, they are not attempts to paint an intimate emotional relationship in the way that the double portraits are.

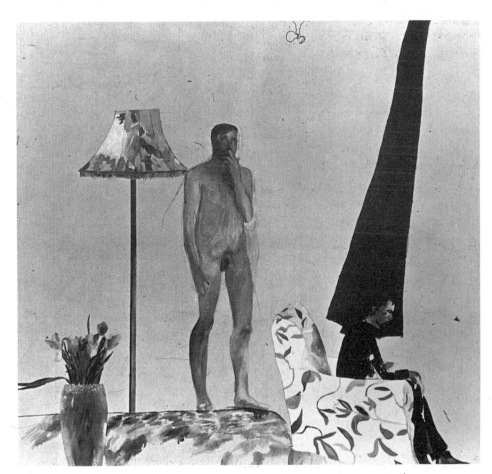

4.5
Domestic Scene, Notting Hill, 1963

David Hockney's interest in figuration developed through portraiture in many of his paintings, from *Peter C.* (1961–62) to *My Parents* (1977). Portraits played an increasingly dominant role in his work and were mainly images of his friends, their relationship and a common life style.

Given the liberationist aspirations of the 1960s, Hockney was employing the genre to describe his contemporary life. Whereas the earlier paintings of his lifestyle in London took a polemical tone in their advocacy of homosexual desire, by the later 1960s, in California at the intersection of a gay culture and a leisured elite,[4] that campaigning urgency has disappeared in favour of a more naturalistic depiction of modern life. It may be useful to think of another transatlantic potraitist in this context: Cecil Beaton's work consisted almost entirely of his evocation of the attractive, desirable and leisured lifestyle enjoyed by a particular group of people. It is perhaps no coincidence that Beaton was one of the first people to buy Hockney's work.

Hockney's interest lay as much in achieving a formal and evocative representation of relationships between people, especially between intimate couples, as in creating an accurate description of their physical appearance. For these works he developed a static, formalised mode of depiction. As serial imagery the

4.6
Christopher Isherwood and Don Bachardy, 1968

double portraits continue to draw attention to the ambiguity between the painting of a specific person or people in a specific sort of relationship and the status of the painting as an artwork in its own right. In choosing the formal portrait as a format, Hockney can both legitimately depict the figure, and create a continuing set of elements (similar size, style, iconography) which evoke the artist's own presence and describe others through their difference.

Christopher Isherwood and Don Bachardy (1968) (Figure 4.6) was the first work in which Hockney had deliberately set out to paint a 'double portrait'. The artist made studies of the subjects' domestic environment and separate studies of their heads to 'get to know their faces and what they're like' (Hockney 1976: 152), but the information he really sought concerned, not their appearance but their relationship. Once he had noted a set of gestures that seemed to him to epitomise the relationship, the way in which one subject deferred to the other, he could start painting this established dyad not simply as a formal portrait but also as a picture of two individuals in a relationship.

In his *Picture Emphasizing Stillness* of 1962 (Plate 1), Hockney had dismissed the traditional depiction of two or more figures by effectively rejecting narrative. In that painting, considered more fully in Chapter 2, two male figures engaged in a dialogue are apparently about to be attacked by a leopard. Adopting the Modernist denial of the place of narrative in painting, and, in addition, emphasising the flatness of the picture plane, Hockney wittily inserts the motto, 'They are perfectly safe. This is a still.' He self-consciously locates twentieth-century visual narrative in the cinema, referring to a typical high dramatic moment in the popular narrative form. So, to depict two people, without recourse to narrative, presents a problem in *Christopher Isherwood and Don Bachardy*, as Hockney himself realised. He overcame this difficulty by the use of the gaze (the visual relationship between the figures) to create an infinite cycle of desire. Hockney has painted Isherwood as the object to-be-looked-at, the traditional focus of fascination for the viewer. But Isherwood refuses to accept the power of our gaze. He is actively looking at Bachardy who, in profile to him, is in the same visual relationship to him as Isherwood is to us, the viewer. Hockney had noted that Isherwood's automatic response when addressed would be to look at Bachardy, so he has painted this aspect of their relationship, thereby allowing the artist/viewer to engage directly with and enter into the relationship. Bachardy takes the place of the object to-be-looked-at for Isherwood, but also actively returns the gaze of the viewer. (Historically it has been the image of the woman who is in the passive role of the desired, held by the active male gaze.)

The significance of the gaze in the Isherwood/Bachardy painting is the way in which it constructs a relationship between the two figures portrayed and also between the portrayed and the viewer. Through the gaze and through the position of Isherwood's crossed leg and right elbow our attention is then directed to Bachardy. (Even the banana and the corn point us in the right direction). By very economical means, Hockney has represented a relationship between these two figures,[5] a relationship that also acknowledges the absent presence of the artist

in an eroticised *mise en scène*. Other elements help to construct a unified emotional space. The two figures are connected by the continuous plane of the closed shutters, which serves to push them to the front of the picture plane; while the immediate foreground is taken up by a table that, like the shutters, unifies the space occupied by the two chairs and their sitters. The minimal details include two piles of books which balance the composition, visually unifying the figures and suggesting shared intellectual pursuits, and a bowl of fruit and a corncob which carry erotic and sensual meanings. The window-seat to the right of the figure of Isherwood encourages the viewer initially to look towards that mass, and this promotes a specific way of reading the constructed scene. Without the seat the scene would be symmetrical and our attention would be divided between the two figures, with the bowl of fruit visually acting to separate them. As it is, we are drawn to the image of Isherwood through the use of colour, the white shirt and the white gym sock (connoting leisure and the physique culture of gay Californian life, as in the Los Angeles shower scenes); and the light source from the right catches our attention. In his description of his working method on this painting, Hockney admitted that Bachardy was painted less substantially than Isherwood because he was away during most of the time that Hockney was working on it. Bachardy's direct address discourages us from lingering too long on his body so, in that sense, the painterly style adds to to the compositional and informational imperatives of this portrait of a relationship.

It is interesting to compare this with another double portrait of the same year, *American Collectors (Fred and Marcia Weisman)* (1968) (Plate 7). The Weismans were not amongst Hockney's intimate circle of friends, and as significant collectors of contemporary art their double portrait represents the more traditional portrait of the patron. As in the Isherwood/Bachardy portrait there is one frontal and one profile figure,[6] both positioned in front of a continuous architectural feature (exterior and interior respectively). But there are significant differences between the two paintings. The source of light is different since one is set outside, the other in a domestic space. In one the gaze, the gestures and the address all act to pull the composition apart, in the other they are unifying devices. Isherwood and Bachardy are portrayed at home in an intimate and essentially private scene and within an enclosed but not enclosing space. The composition articulates the relationship. By contrast, the painting of the *American Collectors* is a less intimate and less focused work. The subjects are shown outside the building, as is appropriate for a more formal, public portrait and we have no sense of their relationship with each other. Since this is a portrait of collectors, the prominence given to their art is understandable. However, Hockney paints them in such a way that they become the visual equivalent of their collection, figures which seem to exist to be displayed.

One perceptual problem that needs to be addressed in the depiction of two figures is how composition relates to hierarchy. In the Weisman portrait it is the figure of Marcia Weisman who first attracts the viewer's attention, but the light source and her gesture lead us out of the painting to something on the right. If

we start viewing again, this time from left to right, with the male figure, his gaze and shadow also lead us beyond the picture into the far right, by way of the Turnbull sculpture, the Moore sculpture, the tree, and then the totem. The circularity of the composition then takes our gaze back to Fred Weisman by following the expanse of blue sky. Finally we focus on the sculpture by Henry Moore in the centre of the house. We can see its visual equivalent in the head and shoulders of Marcia Weisman, whose right hand gestures towards the totem pole on the right. This, in turn, leads back to her with its reference to her grinning smile. Hockney seems to have constructed this figure from an amalgam of visual referents within the image itself, in an almost surreal combination of the *cadavre exquis* and the use of the *objet trouvé*. He offers us no depth to these characters: the windows of their house reflect flat abstract patterning. Space is articulated in the relationship between the Moore seated figure and the spectator who is perspectively constructed as being seated in front of the *tableau* of the figures, in the same spatial relationship in front of the painting as the Moore sculpture is behind. The painting depicts separate spatial fields, divided by the strong verticals of the Moore and its framing. Tension is also suggested by Fred Weisman's clenched right hand, the fist literally squeezing paint. There is no relationship depicted in this image but an implicit tension which seems to be the actual relationship that Hockney intended to convey.

Another interesting aspect of this work is that, apart from the totem which is outside the immediate space of the two collectors, their collection is seen to be of contemporary British art. By buying the work by Hockney they are extending that collection by incorporating his own work into it. Hockney's double portrait, therefore, forms the missing object from the painting, as if the picture plane were a screen exhibiting the work, the third term of reference beyond and embodied by the painting. As if to demonstrate the materiality of the painting as art object, Hockney has left paint dripping from Fred Weisman's hand (as signifier of Modernist painting).

Modern life subjects

We may compare the Weisman portrait of a married couple with another of the same period, *Mr and Mrs Clark and Percy* (1970–71) (Figure 4.7). This is Hockney's most straightforward quotation from the history of English painting; and derives from the eighteenth-century portrait tradition as exemplified in such works as Gainsborough's *Mr and Mrs Andrews* (c. 1752). In a near contemporary essay, John Berger considered the painting of Mr and Mrs Andrews, asking questions about its construction of gendered identities and economic relations as a typical portrait of eighteenth-century land-owning gentry. His analysis of the Gainsborough argued that it was a double portrait in two senses: on the one hand it was a painting of a married couple, on the other a portrait of a man and his property (including the woman). Berger drew attention to the standing figure of the man, the 'correct' place of the woman sitting dutifully at his side and the vast

tract of England he owned, which dominates the right-hand side of the image (Berger 1972).

In *Mr and Mrs Clark and Percy* Hockney reversed those conventions. In Hockney's painting she is standing, and looks out at the viewer/artist as confidently as 'Mr Clark'. Whereas Gainsborough depicted the land and livestock owned by Mr Andrews, Hockney subverts the idea of an ongoing, unchanging tradition of power and ownership in favour of the idea of the 'now' of a particular section of sixties' culture. The Clarks' identity is constructed through clothes and a tasteful interior design. In this image Hockney also portrayed the contemporary life(style) of members of the meritocracy whose interest in interior design and fashion was often displayed as visual imagery in the new colour supplements and glossy magazines. (Celia, a fabric designer, and Ossie, a fashion designer, were both celebrated figures in London's fashion world during the sixties.)

A further model for the double portrait of the Clarks was 'modern life painting' as practised by Hogarth[7] and revitalised by artists associated with the Pre-Raphaelites, a group of nineteenth-century artists whose revival was well underway by 1970, particularly in fashion and fabric design. Hockney had transcribed the image of Ford Madox Brown's *The Last of England* (1855) when he painted himself and his Doll Boy huddled together leaving repressed, homophobic England in 1961 (Figure 3.2). By 1970, Hockney was exploring the limits of naturalism and a painting like William Holman Hunt's *The Awakening Conscience* (1853–54), which depicts a couple in an enclosed and newly furnished environment with an exterior view of London visible through a window, could also serve as a model for this particular work. As in the nineteenth century version, Hockney has given equal weight both to the objects included in the scene and to the figures. Here, however, he has depicted objects as objects, visual forms in their own right without the heavy overlay of symbolic meaning that was part of the Pre-Raphaelite programme. In his work the flowers, lamp, cat and book appear as phenomenological things which, in addition, are used to say something about the people portrayed, rather than clues to be interpreted (and so give moral meaning to the narrative of the scene). Like the figures, they are objects which Hockney uses to depict against the light.[8] This essay in the *contre-jour* effects of light was one that seemed to revive an interest in his earlier influence, Walter Sickert, who explored the implications of the device in some of his modern life paintings of London domestic interiors in the early part of the century.[9]

The image, like the room, is divided by the central light source into two parts, each containing a figure. In addition, the gazes of the protagonists are directed out of the picture space towards the artist/viewer rather than towards each other. Hockney's declared aim was 'to paint the relationship of these two people' (Hockney 1976: 204), but he seems to have painted their separate and real relationships with him rather than with one another. Like all of his double portraits, this is a large painting intended to evoke the actual presence of the subjects in the real space of the viewer. In its scale, in the naturalistic depiction of the figures and in its use of perspective, this double portrait becomes an analogue

*Self-Portrait with Blue
Guitar*, 1977

PLATE 8

Model with Unfinished
Self-Portrait, 1977

PLATE 9

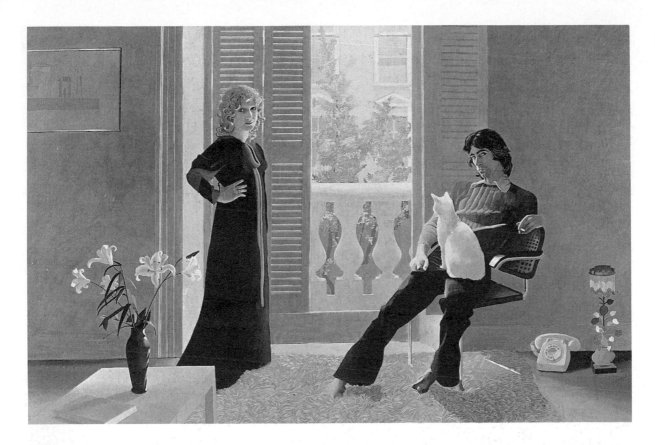

4.7
*Mr and Mrs Clark and
Percy*, 1970-71

of the actual presence of the sitters and, by implication, that of the artist.

However, despite its mimetic rhetoric there are several disquieting
elements. The figure of Celia appears to hover weightlessly above the carpet into
which Ossie is sensuously rubbing his feet. The lamp is placed in a curious relation
to the floor and wall; and, despite its pictorial function as an anchor, the reces-
sion of the coffee table does not fit the perspective of the rest of the room. The
confrontational gaze of both subjects problematises the viewer's relation to the
image, through Hockney's deployment of point-of-view. On the other hand, the
subversion of naturalism through the self-conscious pictorial devices empha-
sises the artificial construction. Hockney's work, like, for instance, van Eyck's
Giovanni Arnolfini and his Bride (1434) or Velazquez's *Las Meninas* (1656), makes
self-conscious use of the authorial presence. He does not offer us a voyeuristic
view into a private domestic space, but a scene in which the artist acts as protag-
onist. This seems to be one attraction of portraiture for Hockney, in that it is a
genre of figurative painting that includes a possible space for the inclusion of
the artist. With one exception,[10] he only paints people he already knows but the
real subject of the work is the relation of Hockney himself to the figures.

This relationship is similarly addressed in another double figure painting
of 1970, *Le Parc des sources, Vichy* (Figure 4.8). Here Ossie Clark is shown seated
next to Peter Schlesinger, with a third chair on his left.[11] The artist has self-
consciously indicated his absence, and thus implied his presence, by the empty

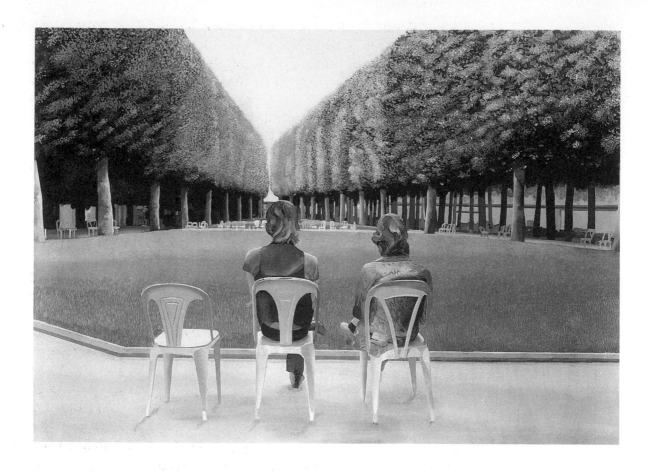

chair of the triad. Here the figures, with their backs to us, are placed right up against the picture plane with space opening out in front of them, unlike the *tableaux* of the earlier portraits where deep space is not depicted, but suggested, in front of the painting and occupied by the artist. The Vichy painting shows the artificial construction of 'real' space in its depiction of depth using perspective. The park has been made to appear longer than it actually is by the triangular planting of the trees to construct an artificially long perspective, rather than relying on the artist's use of geometry to create a sense of depth. Playing with perception, Hockney deliberately evokes Magritte in his naturalism of this period.[12]

A near contemporary double portrait to be compared with *American Collectors* is *Henry Geldzahler and Christopher Scott* (Figure 4.1). Geldzahler was a significant figure in the New York art scene and was the curator of the Metropolitan Museum in New York when Hockney first met him. An art historian and collector, he had met Hockney at Warhol's Factory in 1963 and Hockney has portrayed him on a number of occasions in different media. *Henry Geldzahler and Christopher Scott* (1969) is significant because it is the first double portrait, rather than figure painting, to confirm the artist's presence by the use of metonym as well as point of view. Hockney has included himself in this scene through the transposition of his glass-topped table from his studio in

London to Geldzahler's New York apartment and his use of tulips (Hockney's favourite flower) as in the earlier domestic scenes. In addition the flowers, signifiers of Hockney, are prominently placed on one side of Geldzahler, the figure of Christopher Scott on the other side, beyond the edge of the sofa which gives presence to the central figure. That Geldzahler is the subject of the portrait cannot be in doubt, even though it is included in the series of double portraits. The relationship depicted here is surely that between Geldzahler and Hockney, with Scott as outsider. (Hockney was later to paint his parents in a similar way, with he and his mother exchanging looks and his father's attention elsewhere; see Figure 4.10 below.) Hockney has declared his presence in the scene as clearly as he was to do when he included his own feet at the base of the photo-collages. The two suggested figures are linked through composition and motif, rather than naturalistic depiction. The cityscape through the window recalls Edward Hopper's paintings in the depiction of the smallest building, and the atmosphere of this bare domestic interior likewise evokes Hopper's estranged figures within their privatised space in small town apartment blocks in the USA. An etching of 1967, *Henry and Christopher*, had shown a more relaxed couple. In one version of the etching[13] Hockney had given both figures haloes, an attribute that has led some commentators to interpret this painting and its composition as a traditional annunciation.

In the later portrait of Henry Geldzahler, *Looking at Pictures on a Screen* (1977), Hockney places him in profile, looking at a series of pictures. Traditionally the format connotes the collector, the connoisseur viewing examples of the history of Western art. We are invited to look at and recognise the same history. The object of Geldzahler's scrutiny, though, is Hockney's collection of reproductions in his studio – this is not a gallery. Discussing this painting, Hockney has pointed out that Geldzahler is engaged in the same activity that we, the viewers of the image, are engaged in – that of looking at pictures. In addition, these particular paintings have been significant in Hockney's own work, and in his then recent double portrait, *My Parents* (1977), discussed in detail below. It was particularly significant that Hockney should present his influences from the history of art in 1977, for this was the year in which he and Kitaj had taken a stand on the continuing importance of the figure: 'And remember this: it is always figures that look at pictures: It's nothing else. There's always a little mirror there' ('David Hockney in conversation with Kitaj', *New Review*, January/February 1977).

Self-portraits

In addition to those paintings in which the artist's presence is implied but not stated he also made a number of self-portraits, including *Self-Portrait with Blue Guitar* (Plate 8) and the *Model with Unfinished Self-Portrait* (Plate 9), both of 1977. The 'Blue Guitar' of the first painting refers to a number of coloured drawings and *The Blue Guitar*, a suite of etchings that Hockney produced during 1976–7 which continued a project of self-inscription into the history of

twentieth-century art, specifically in relation to the 'father', Picasso.[14] Hockney produced two etchings picturing himself and Picasso, one in 1973 – the year that Picasso died – the other in 1974. *The Blue Guitar* was the result of Hockney's reading of Wallace Stevens's poem based on a Picasso painting of 1903, a poem shown to Hockney by Henry Geldzahler in the summer of 1976. So in *Self-Portrait with Blue Guitar* a collage of styles and motifs is appropriated with specific references to Picasso. It is no longer a simple 'marriage' of styles as in *The First Marriage* of 1962 or *Portrait Surrounded by Artistic Devices* of 1965 (Figure 0.4).

4.9
My Parents and Myself,
1975, unfinished

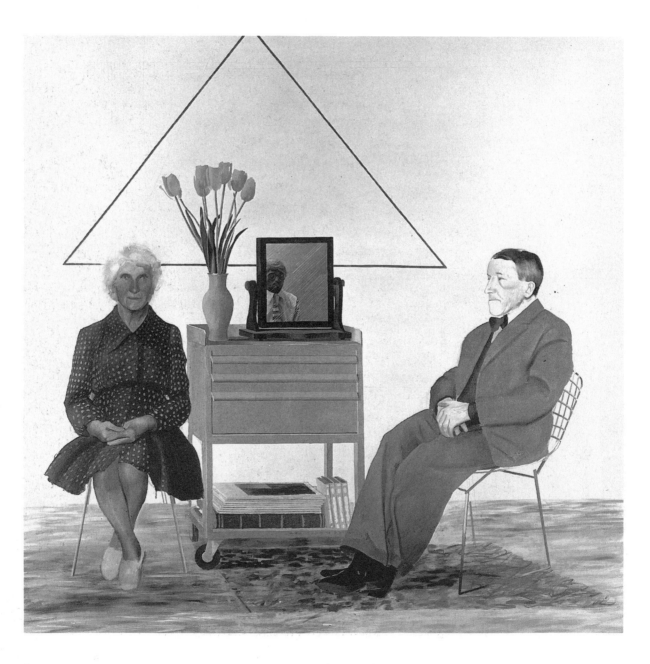

Model with Unfinished Self-Portrait contains a figure, the 'model', and is another double portrait of a relationship. In this case it is Hockney's own relationship which is shown but, perhaps significantly, he has chosen to depict the two figures (himself as the artist and his then lover, Gregory Evans, as the model) on different visual planes. The portrait of the artist takes the form of an unfinished canvas propped up behind the model. Hockney has, however, unified the image and the double articulation of space through the use of geometry and perspectival recession. The sides of a triangle above the head of the self-portrait can be extended downwards into the 'real' space of the studio so

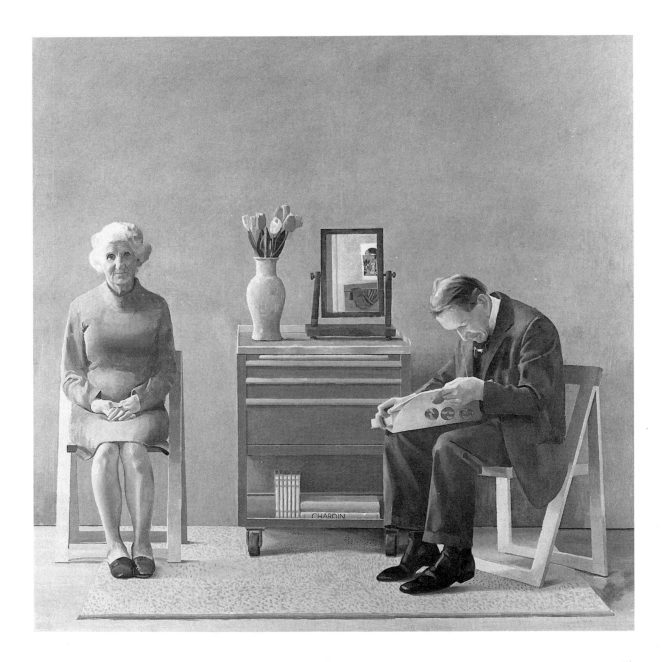

that the prostrate figure of the model forms the base of an expanded triangle and the figure of Hockney is at the vanishing point of the unified space. The self-portrait is shown as a visual pun, as a representation within a representation. Its painted curtain is reflected on the glass table top in the studio.

The significance of the model is emphasised by the difference between the 'unfinished' parts of the *Model with Unfinished Self-Portrait* and the reference to Picasso's model in the finished *Self-Portrait with Blue Guitar*. Although overtly a depiction of Hockney as the author of *The Blue Guitar* etchings at work in his studio, in fact the real subject seems to be the depiction of the figure as the object of desire. Hockney had not yet included the image of Picasso's model, Dora Maar, in *Model with Unfinished Self-Portrait* but painted *his* model, surrounded by blue, supporting his head with an outstretched hand, on a perspectively described flat plane. Hockney then worked the decorative design of the bedspread in that painting into the flat, abstracted geometric patterning in the finished self-portrait. In the finished self-portrait, Evans has become Dora Maar, Hockney having rendered Picasso's 1937 portrait of her as though it were a sculpture to aid this displacement. He has expanded the 'real' world of his own desire and his established artistic practice to incorporate Picasso's range of styles as shown in the part of *Self-Portrait with Blue Guitar* that relates to the depiction of Dora Maar. The two works also comment on the relationship of model to motif which was the subject of the *Blue Guitar* series. This is a play on the promiscuous use of style in the work of both Hockney and his 'model' (in both senses of the word), Picasso. It refers back directly to *Artist and Model* (1974), his self-portrait with Picasso which similarly plays with the pun. Is Hockney the artist and Picasso the ideal model? Or is Picasso *the* artist and the nude Hockney his model?

The ambiguity of the position of the artist in *My Parents and Myself* and *Model with Unfinished Self-Portrait* is interesting in relation to the earlier double portraits, where the artist's presence is implied as coexisting with the viewer's. Here the viewer either shares the artist's point-of-view, as in a mirror, or becomes the motif in front of the artist, whose sheet of paper is still significantly blank. When he came to complete the self-portrait, Hockney chose to depict himself in the act of drawing the 'Blue Guitar', thereby identifying himself with Picasso – the subject of Stevens's poem – just as he had decided to equate his model/lover with the Spaniard's.

An earlier work that includes a portrait of the artist is *My Parents and Myself* (1975) (Figure 4.9), a painting that he subsequently abandoned. He then painted *My Parents* in 1977 (Figure 4.10), the same year as the self-portraits. The first of these paintings also contains a schematic reference to geometric space in the triangle that takes up most of the top part of the picture, a device he used around his own image in *Model with Unfinished Self-Portrait*. Here, it seems to refer to the mother/father/child triad, emphasised by the inclusion of Hockney as a reflected image between the figures of his two parents, existing literally in a triangulated spatial relation to them.

Hockney's work has consistently been concerned with composition and the elimination of all superfluous information. *My Parents and Myself* contains an abundance of signifiers in the metonymic still-life: the reference to personal memory in the edition of Marcel Proust's *A la Recherche du temps perdu*, the books of paintings and the vase of tulips. In *My Parents* the artist removes himself as figure from the primal scene, leaving in his place the image in the mirror of the artist's studio with its reproduction of 'models', significant artists for Hockney (Piero della Francesca and Fra Angelico).[15]

Double figures have featured consistently in Hockney's work. In their similarity they have constituted a continuous theme which demonstrates his ongoing concerns; in their difference they have indicated his exploration of possible solutions to the pictorial problems he has set himself. The figures in his early paintings embodied visual pleasure in order to make a polemical statement; later they stood on the edge of naturalism. In both cases, Hockney has used the figure to explore the languages of visual representation, both real and fantastical.

Hockney's portraits have constructed an intimate relationship between the subject and the artist, at first conceptually through the numerical 'secret' code, later through the use of point-of-view, and finally through metonym. By use of a complicated perspectival system, they have created a spatial continuity between the artist and the scene and, as such, have implicated the viewer within that process. Hockney explicitly drew attention to the subjective relationship between the viewer and the artist in the works of 1977, the original version of *My Parents and Myself* and *Model with Unfinished Self-Portrait*; in each of the paintings, he places himself as viewer of the scene at the vanishing point, drawing attention to the viewpoint in front of the painting that we are occupying. In the later photographic collages we are invited to enter his world, literally to stand in his shoes. Through scale, point of view and, often, the deployment of part of an object that projects into the foreground, the paintings become the stage in front of which the viewer is made aware of his or her status as viewer. Many works which do not contain actual portraits of the artist imply his presence through the gaze and through his use of metonym. This concern also runs through the single figure paintings, the sunbathers and swimmers, the men lying face down on beds in hotel rooms. In all of them we are invited to share the erotic visual experience with Hockney but not to forget his presence there.

Notes

1

Hockney employed Whitman's coding device for the discreet and playful naming of individuals.

2

Public lavatories.

3

In a conversation with the author, Elaine Coghlan has pointed out the second figure being baptised in Piero's *Baptism* as an additional model for these figures. Hockney: 'For an artist the interest of showers is obvious: the whole body is always in view and in movement, usually gracefully, as the bather is caressing his own body. There is a three hundred-year tradition of the bather as a subject in painting' (Hockney 1976: 99).

4

Cooper has noticed that after Stonewall artists were 'finding a more open acceptance of their homosexuality and, wanting to put this into their work, could either look creatively at past traditions and archetypes and reform them for themselves or reject them in favour of relating only to contemporary life and attitudes' (1986: 86). Hockney had already begun to move into this new subject matter. He had reworked traditional voyeuristic themes like Susannah and the Elders for his Californian swimmers and bathers, and by 1969 was painting established gay relationships in his series of double portraits.

5

In an etching that he made of the couple in 1976, Hockney reversed the position of the figures and their gaze, drawing attention to the automatic reversal of the image in a print by also reversing the depicted relationship. Hockney had only just met Isherwood shortly before he began the painting. By 1976 he knew both men and more about their relationship.

6

Meyer Shapiro has argued for the use of linguistics in the theorisation of a grammer of visual language. He suggests that the frontal figure in visual representation stands for the 'I' of grammer and that the figure in profile stands for the 'you' who is being addressed (Shapiro 1973).

7

As if to emphasise the connection there is a print from Hockney's *A Rake's Progress*, 'Meeting the Good People (Washington)' (Figure 4.4), on the wall to the left of the figures in Hockney's painting of the Clarks' apartment.

8

Three years later, Hockney would achieve the same painterly effect, without recourse to figures to justify the work, in his two French paintings, *Contre-jour in the French Style – Against the Day dans le style français* and *Two Vases in the Louvre*.

9

For example, Sickert's *Mornington Crescent Nude: Contre-Jour* (1907).

10

Portrait of Sir David Webster (1971). Webster was general administrator of the Royal Opera House, Covent Garden. The portrait was commissioned on the occasion of his retirement.

11

This work seems to prefigure *Portrait of an Artist (Pool with Two Figures)* (1972), in which, after the end of their relationship, Hockney finally depicted Peter Schlesinger with his own point of view. Until 1970 he is shown as the object of Hockney's gaze. *Portrait of an Artist* was started in the autumn of 1971. Livingstone (1981), however, demonstrates that there was tension in the relationship even in 1970 and argues that this tension is expressed through the false perspective of the scene.

12

There was a major exhibition of Magritte's paintings in London in 1969. It included *Not to be Reproduced*, Magritte's back-view portrait of Edward James.

13

Reproduced in Hockney (1976), illustration 224.

14

It is interesting to note that 1977 was the year that Hockney's father died.

15

Before abandoning it in February 1976, Hockney depicted two curtains looped over a rail in the foreground of *My Parents and Myself*, a detail from which is shown in the mirror of *My Parents*. The form of the curtain was appropriated from Fra Angelico's *The Dream of the Deacon Justinian* (*c*. 1438–45). See Geelhaar (1978) for Hockney's comments on the mirror in *My Parents*.

5

Mapping and representing

ANDREW CAUSEY

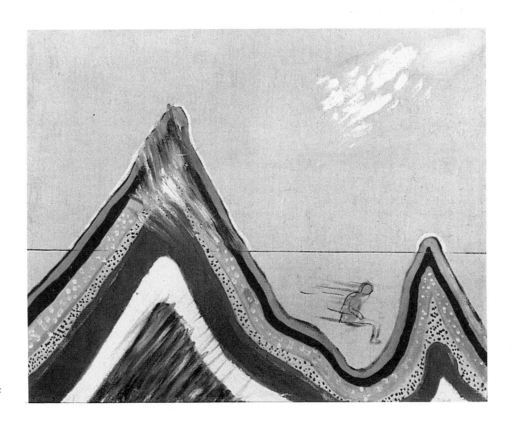

*Swiss Landscape in a Scenic
Style*, 1962

Hockney has quoted lines from Auden's *Letter to Lord Byron*: 'To me art's subject is the human clay/Landscape but a background to a torso' (Hockney 1976: 195). His Californian paintings, with their figures by pools, on patios, in sitting rooms, bedrooms and showers, most clearly reflect this, but all his work, back to the early 'Love' paintings, is about human life in one way or another. It is too simple, however, to see him just as a realistic figure painter laying out his own and his friends' lives in paint. On his travels Hockney draws and photographs what he sees, but when he paints he introduces evidence from a wider field than experience alone. Similarly, as a figure painter he uses techniques and devices that suggest a highly personal outlook and create a sense that the figures in his paintings belong both to an everyday world and to the world of his imagination.

Hockney's designs, after the early work, are economical to the point of austerity; his settings are often sparsely furnished, impersonal and lacking domesticity; couples tend to be silent, individuals self-absorbed; and gesture of any kind is uncommon. This may be first and foremost a description of the 1960s' Californian paintings, but Hockney's presentation of people has often been marked by a certain unease which is deliberate and not a question of technical competence. He is not an urban scene painter or a genre artist; he is the opposite of the Dutch seventeenth-century tavern painters whose figures, relaxed with drink, gesture and communicate with ease.

Similarly his evocation of places has produced its own ambiguities, with dissonances in his settings between things actually seen and pre-existing images brought in from elsewhere. Advertising, brochures, postcards, art books and other artists' work, maps, geography books and playing cards, typography, photographs and teenage and soft porn magazines have all provided ready-made sources of imagery for Hockney. His work is complex and subtle in the way it switches from real life to invented or appropriated imagery and back again within a single canvas. In looking at figures and settings in certain of Hockney's works, this chapter is concerned with the kinds of meaning that emerge from these elisions of the experienced and the appropriated.

Flight into Italy – Swiss Landscape (1962) (Plate 10) is a record from memory of a trip to Italy made by Hockney in December 1961 in the back of a minivan. Landscape is represented in different ways. It is shown in part diagrammatically, by means of the coloured bands along the back that stand for the Alps and perhaps also for the line of the road itself, since city names with small arrows are attached at intervals. These are juxtaposed, by contrast, with the *trompe l'œil* realism of the mountain detail, slipped in on the right, which Hockney said was taken

from a postcard. A third kind of representation, somewhere between the other two in degree of lifelikeness, is used for the minivan and the chalet-style house.

The diagrammatic form of representation used for the mountains is described by Hockney in one place as being inspired by the abstract painting of Harold and Bernard Cohen, and in another as being taken from a 'geography book' (Hockney 1976: 87). The first is an appropriation from contemporary art in which the mountain range is represented by a form derived from non-figurative painting to which Hockney's images have no relation of meaning. The geography book is a different kind of source because it, like Hockney's subject, is connected with representation of landscape. If the comparison is assumed to be with the introductory pages of an atlas, where sectional drawings tabulate information about rainfall, vegetation and geological strata, it becomes obvious that of Hockney's alternatives the geography book is the more plausible. It is only when Hockney's mountain view has already been conceived sectionally that the likeness to a Cohen painting is apparent at all. Hockney entertains as well as informs; and, in imagining on the basis of this painting what kind of geography book he might have been looking at, one thinks of the association of diagrammatic and scenic found in a pictorial, educational magazine like the *National Geographic*, in which the use of diagrams is less austerely didactic than in an atlas and is intended, like Hockney's painting, both to please and inform.

An article in the *National Geographic* of June 1962, contemporary with *Flight into Italy*, describes the destruction caused by an avalanche in the Peruvian Andes. The scene-setting plate is purely descriptive, a photograph of the mountain where the dislodgement of ice occurred (Figure 5.2), while the pictorial climax of the article is a double-page diagram mapping times and distances and tracking the course of the disaster by means of lettering overlaid on a model of the location (Figure 5.3). An earlier article, in the December 1960 issue, was closer to Hockney's painting in subject. It described the introduction of a new cableway across the Alps and showed close-ups of the cable cars in use together with a diagram in the form of red line overlaid on a model of the Alps (Figure 5.4). A characteristic style of the *National Geographic* was to contrast the individual scenic photograph, representing one point in space on a journey at one point in time, with a diagram that plots the whole journey spatially, and in the case of the avalanche, in time as well.

Hockney is working in parallel when he evokes his own journey both scenically, by recording the van at one place and moment in time, and diagrammatically by laying out the whole journey and delimiting it with the words Paris and Berne inscribed at either end of the mountain range. The obvious difference in the two methods of representation lies in the way the magazine uses the diagram simply as an explanatory tool, while Hockney in part parodies the idea of a diagram by imposing his personal style as much upon the diagrammatic element as upon the scenic part. The obviously manual draughtsmanship in the bands of colour that constitute the mountains subverts the essential objectivity of maps and diagrams.

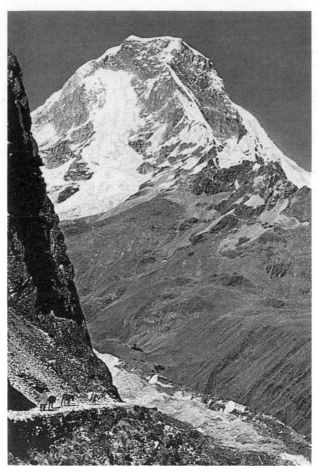

5.2, 5.3 [facing]
'Nevado Huascaran' and
'Nine-Mile Avalanche
Minute by Minute',
National Geographic, June
1962

Hockney's chalet-type house, though it appears more natural than the mountain range, is also a cultural representation. Whether based on a real building or not, it suggests the kind of house one might expect to see in Switzerland, the sort of image that represents a place on a postcard. In 1969 the painting was shown¹ with a different title, *Souvenir of Switzerland*, which recalls the commemorative function of a postcard and represents a place to someone who is not there. The irony is that Hockney – stuck in the back of a van – was to all intents and purposes not there himself, so that emblematic representation, designed to satisfy convention as well as reality, seems appropriate. The paradox of *Flight into Italy* is that the painting is autobiographical and easily recognised stylistically as Hockney's, while at the same time it appears, on account of the prefigured imagery derived from a geography book, to be objective or disinterested. Although authorship is evident and important for Hockney at the level of style, his feeling for representation by means of appropriated imagery tends towards impersonality.

A related but simpler first version of *Flight into Italy*, entitled *Swiss Landscape in a Scenic Style* (Figure 5.1) was exhibited at the Young Contemporaries in February 1962, where it was one of four canvases with separate subtitles but

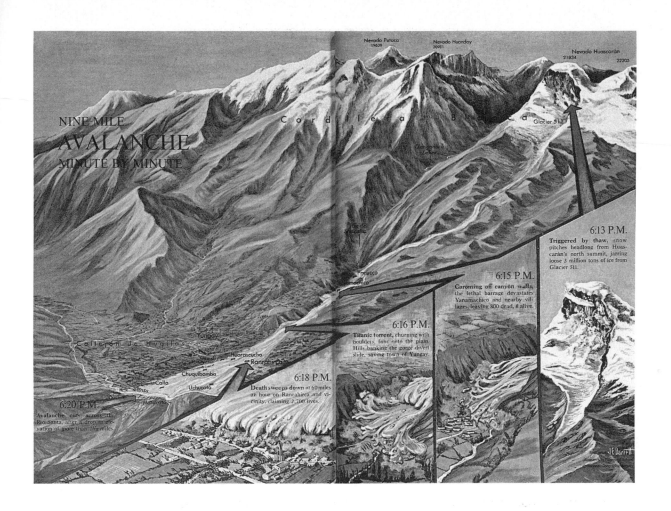

NINE-MILE
AVALANCHE
MINUTE BY MINUTE

Cordillera Blanca

Nevado Putaca
19639

Nevado Huandoy
20981

Nevado Huascarán
21834 22205

Glacier 511

6:13 P.M.
Triggered by thaw, snow
pitches headlong from Huas-
carán's north summit, jarring
loose 3 million tons of ice from
Glacier 511.

6:15 P.M.
Caroming off canyon walls,
the lethal barrage devastates
Yanamachico and nearby vil-
lages, leaving 800 dead, 8 alive.

6:16 P.M.
Titanic torrent, churning with
boulders, fans onto the plain.
Hills banking the gorge divert
slide, saving town of Yungay.

6:18 P.M.
Death sweeps down at 60 miles
an hour on Ranrahirca and vi-
cinity, claiming 2,700 lives.

6:20 P.M.
Avalanche cuts across the
Río Santa, after a drop in ele-
vation of more than 2¼ miles.

Yungay
Ranrahirca
Huarascucho
Chuquibamba
Calla
Uchucoto
Santa
Matacoto

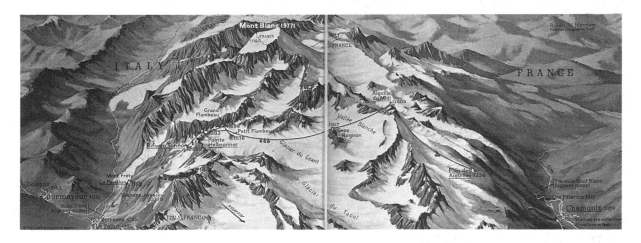

Mont Blanc 15771

ITALY FRANCE

FRANCE

Robert W. Nicholson
National Geographic Staff

Aiguille
du Midi
12605

Grand
Flambeau

Petit Flambeau
11178

Rifugio Torino
10899

Pointe
Helbronner

Glacier du Géant

Vallée Blanche

Gros
Rognon

Plan de l'
Aiguilles 7350

Mont Fréty
Le Pavillon

Glacier du Tacul

7½-mile Mont Blanc
highway tunnel

Courmayeur 4016
Dolonne 3963

Grandes Jorasses
13799

Les Pèlerins 3461

Chamonix 3329

Mont Blanc
highway tunnel

Entrèves 4285
La Palud 4459

ITALY FRANCE

Stations are underlined
Elevations in feet

5·4
'Across the Ridgepole of
the Alps', *National
Geographic*, December
1960

with the generic title *Demonstrations of Versatility.* The word 'scenic' evokes the theatrical, which characterises much of Hockney's painting at the time, and expresses the artifice with which Hockney approaches the, for him, untypical subject of landscape. Scenic also has overtones of the Picturesque of *c.* 1800 – a way of viewing landscape that depended, like the more conceptual of Hockney's images here, on pre-existing notions of what a landscape should look like. (In the case of the true Picturesque, however, the approved exemplars, paintings of Claude and Salvator Rosa, were very different from Hockney's forays into geography books.) Neither *Flight into Italy* nor its precursor consciously refers to the Picturesque, but elements in them parody the Picturesque way of seeing. Hockney's chalet-type house is a tongue in cheek equivalent of the thatched cottage of the Picturesque: it is there less to represent the real Switzerland than to satisfy an expectation.

The young avant-garde of 1960 had excluded landscape from the canon of possible subjects for painting. The exclusion was most emphatic on the part of the Situation Group round Robyn Denny; and though Hockney was not a member of the group, which was committed to complete non-figuration, his painting, like theirs, obviously belongs to an urban culture. Even when Hockney looks at landscape he does not see it in terms of nature. A 'geography book' uses diagrammatic forms of expression because diagrams are objective and the same for everyone. An atlas does not demand personal experience or empathy as a prerequisite for recognising a place. Nor would the diagrammatic part of *Flight into Italy*, had Hockney not personalised it by the individuality of his technique.

Hockney linked *Flight into Italy* with his 1965 work *Rocky Mountains and Tired Indians* (Plate 11) (Hockney 1976: 101). The two paintings are different in certain respects, the later one being much larger, painted in acrylic not oil, and surrounded by a large unpainted canvas border and a line frame. In other ways they are similar, particularly in the colour-banded treatment of mountains. In 1965 Hockney was teaching at the University of Colorado at Boulder where, he tells us, his studio had no window, so there was no view of the Rockies (Hockney 1976: 101). Equally there were no Indians in that part of Colorado. Like *Flight into Italy*, *Rocky Mountains and Tired Indians* is an unseen landscape. The line frame surrounding the picture is a graphic designer's device, used in postcards and reproductions as pictorial inverted commas to define the sense that something is worth recording, and to make it available as a souvenir or memento for those who are not there.

The emblematic wooden bird and Indian figures in *Rocky Mountains and Tired Indians* are clichéd images that satisfy expectation in the same way as the chalet in the earlier painting. Together these images comment upon the desensitising of the average person's experience of the foreign or unfamiliar. Instead of looking for a new experience the tourist looks to a guide book to discover the approved reaction. The Indians and the wooden bird are emblems of foreign travel and substitutes for actual experience. The process of change from the personal to the cliché parallels a shift in the modern world in general from travel

to tourism. Paradoxically, however, Hockney the traveller does not, on account of his love of cliché, become Hockney the tourist. While the distinction between travel as original, and tourism as recycled, experience appears to place Hockney, with his interest in appropriated imagery, in the second category, his teasing, ironical approach raises him above supposed attachment to either the original or the second-hand. His paintings are comments on a changing way of seeing rather than being themselves part of the change.

Compared with the contemporary landscapes of a St Ives painter like Peter Lanyon, for whom only actual experience could trigger artistic production, Hockney, drawing on imagery from outside the personal, is testing the need for original experience and measuring the value of what is seen against what is received. The issue was central to the Pop Art movement's absorbing of popular, easily recognised non-fine art graphic material into painting, and it is in this area that Hockney's affinity to Pop – a very limited relationship in the artist's view – would need to be considered.[2]

The value of experience as compared with appropriation is an established debate in twentieth-century art, and has its origins in Cubist collage. In describing the way his art diverged from his predecessors, the Cubist Juan Gris had, in 1923, challenged the role of experience alone in representing the outside world. In general in the history of painting, Gris suggested, 'the elements of a concrete reality have been rendered pictorial, a given subject made into a picture ... my method of work is exactly the opposite ... It is not picture X which manages to correspond with my subject, but subject X which manages to correspond with my picture' (Kahnweiler 1947: 138). He starts with elements of design, he is saying, and ends up with a picture that is also a representation. The shift from an art founded in the real world to one that starts from elements of design and moves *towards* the real world is not in fact as straightforward for either Gris or Hockney as Gris's succinct distinction suggests. For both painters representation and abstraction work in tandem, though Gris's cooler, more classical approach points towards synthesis while Hockney's narratives remain like juxtaposed fragments. There is no question here of direct influence: Hockney appears not to have looked at Gris's work in detail until 1974, and spoke of him even then with nowhere near the enthusiasm he felt within the Cubist movement for Picasso (see Hockney 1976: 104, 123). Gris is too naturally abstract a painter to expose himself to the explicit suggestion that the banded curvy lines in the background of a painting like *The View Across the Bay* (Figure 5.5) have their point of origin in a 'geography book'; but equally there is nothing to say that they do not. Appropriation is too specific a word to apply to Gris, but in this picture clouds, sky, water and hills are a synthesis of observation and forms of artistic shorthand. As neither Hockney nor Gris was centrally a landscape painter, they were able to see landscape abstractly, as a subject for painting on a par with other subjects, and were therefore not deflected by questions of spiritual commitment to nature from the problem of how to represent it.

The diagrammatic presentation of landscape was taken up later in the 1960s by artists such as Richard Long and Robert Smithson, who are in most respects quite unlike Hockney and were, by contrast, motivated by a deep commitment to nature. With these artists the distinction is typically between the diagrammatic representation of a journey by means of a map and the evocation of a place by literally bringing examples of it into an art gallery. One part of Smithson's *Six Stops on a Section* (1968) (Figure 5.6) is a diagrammatic representation of a journey across New Jersey from New York to the Connecticut River by means of maps of the region's geology. This representation is complemented by six bins, the lips shaped to match the contours of the maps, filled with stone removed from Smithson's stopping point *en route*. This form of expression is, of course, only available to a sculptor, though the work of both Long and Smithson has strong pictorial qualities.

Smithson's gathered stones reflect an interest in what is ready-made but freshly discovered. Within the limits of what is available to a painter, the images in the bottom part of *Flight into Italy* are similarly representations of personal presence. The van and its occupants are individualised and distinctive. To the extent, however, that the chalet is a clichéd image Hockney's concern is with the ready-made or received image but not in the same way with the newly discovered. The materials, stone or anything else, which Smithson removed from a site and displays in a bin, is, in a different aspect, original because he has excavated from the site something nobody has ever seen before. Hockney, by contrast, adopts in the cliché what is already well used. This distinguishes Hockney from the sculptors, whose work is essentially tied to real experience. But there is nonetheless a parallel between these artists, all of whom wanted a certain objectivity, the freedom from the local, arbitrary, and indeed natural, in landscape that is made possible by a map or diagram. In other respects

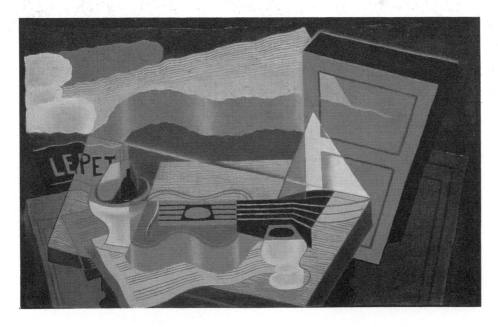

5.5 Juan Gris
The View Across the Bay,
1921

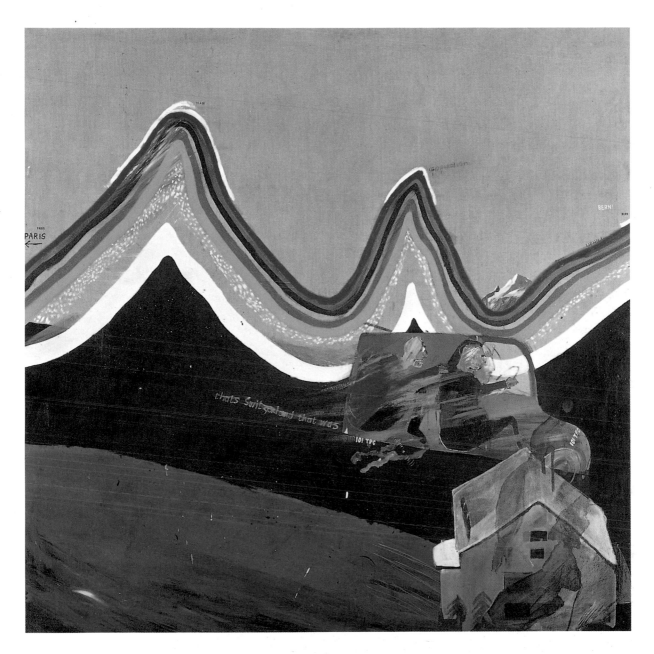

*Flight into Italy – Swiss
Landscape*, 1962

PLATE 10

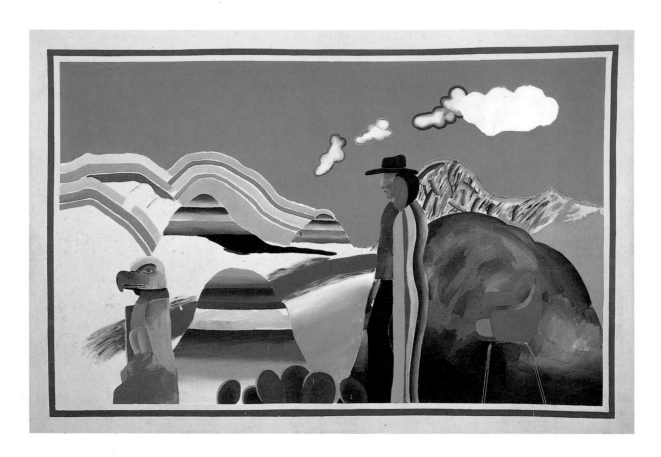

Rocky Mountains and Tired Indians, 1965

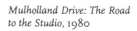

Mulholland Drive: The Road to the Studio, 1980

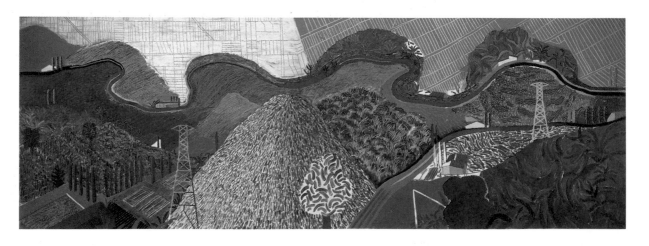

PLATES 11 & 12

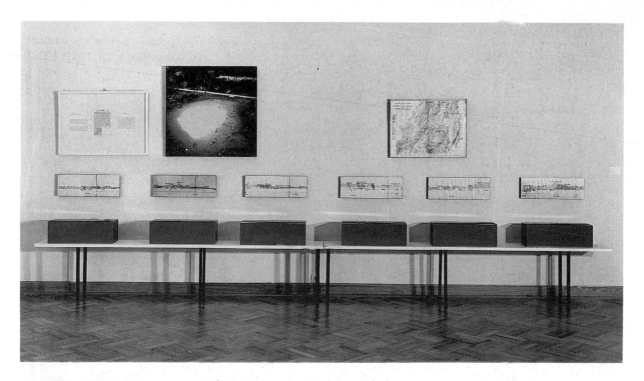

5.6 Robert Smithson
Six Stops on a Section, 1968

Hockney's ironical detachment, his lack of contact with the real experience of landscape, allows him to value cliché as highly as experience and means that by the standards of a Smithson or a Long he is not a landscape artist at all.

The problem all these artists face is how to make a place personal and yet avoid the subjective response to landscape which values that quasi-magical character of a particular site enshrined in the idea of the *genius loci*. Landscape as anti-Romantic subject needs the map and the geography book. The precedent from early in the century for the artist who wanted his art to have the hallmarks of a strong individuality while remaining cool and objective, was Marcel Duchamp. As inventor of the ready-made, Duchamp was the artist who brought to the fore the problem of appropriation, not in the manner Hockney was to adopt – though graphic images – but by bringing real objects from life to art. In doing this Duchamp was affecting impersonality by transferring the subjective element away from the thing made into the act of choosing it. It is not surprising therefore, to find that Duchamp's search for ways of concealing personality – or, at least, of appearing in his ironical way to do so – had led him, as it was later to lead Hockney, in the direction of diagrammatic representation.

Duchamp's oil painting *Network of Stoppages* (1914) (Figure 5.7) shows a series of numbered radiating lines resembling the map of a rail network. In fact it is nothing to do with landscape, urban or rural, but corresponds to the pattern of threads linking the so-called malic moulds to the sieves in the *Large Glass*, and its form was arrived at by Duchamp dropping threads from a specified height and recording how they fell. The impersonality of the process and the cartographical character of the result, combined with the distinctiveness of

Duchamp's presence behind everything he did, within whatever apparently objective parameters, is relevant to Hockney. Not only did Duchamp open up the possibilities of the map as a contribution to art, but there is implied in the *Network of Stoppages* the same contrast of diagrammatic and scenic that exists in *Flight into Italy*.

The proof of this is that Duchamp painted his austere design over an enlarged but unfinished version (turned clockwise through ninety degrees) of one of his most romantic paintings, *Young Man and Girl in Spring* (1911). It is a version of a familiar symbolist subject, naked youth reaching to pick fruit; and the contrast between it and the cool objectivity of the *Network of Stoppages* could hardly be more marked. The earlier design has been painted over, but enough hints remain of what is going on underneath to draw attention to the original painting. There is no direct reference to Duchamp in Hockney, but *Network of Stoppages* does provide an earlier solution to Hockney's problem of evoking individual experience without its temporal effects, of making a picture that refers to a specific moment in time – in Hockney's case to a journey through Switzerland – while being enough of a diagram to be valid whoever's experience is related to it.

Hockney treats the physical fabric of Los Angeles in a similar way to the landscapes shown in these paintings. He describes his arrival in the city at the beginning of 1964 in terms of John Rechy's scabrous novel *City of Night* about gay life and prostitution. Rechy directs those looking for gay company to Pershing Square, but when Hockney went there on his first evening, he found it empty, the clubs and bars having moved away. He nonetheless made buildings in Pershing Square and downtown Los Angeles the subjects of early pictures (see Figure 3.3), taking advantage of an apparent error to paint something else, the flat, melancholy facades of office buildings. But that, the obvious account, is not the only possible one: Hockney was not a painter of street life or bars, and it was not for subjects to paint that he had gone there. He *had* in fact found what he wanted in Pershing Square; its vacant passivity suited him.

The bleak vision of Los Angeles that Hockney typically shows is also a theme of *City of Night*, expressed in Rechy's subjective reference to 'America at night fusing its dark cities into the unmistakable shape of loneliness' (Rechy 1964: 11). Hockney quotes another passage which becomes the subject of *Building, Pershing Square, Los Angeles* (1964): 'Remember Pershing Square and the apathetic palm trees' (Rechy 1964: 11). Emptiness rather than the life of the bars attracted Hockney as he started to paint a city which he was never to show as bustling or populous but only as building fronts and street signs. The boulevard paintings (see, for example, Figure 3.12) combine a street name with palm trees – Hockney's favourite emblem of Los Angeles – and sketchy references to architecture. These dry, witty clusters of images work as emblems rather than representations, drawing together a minimum of visual references to define, in this case, Olympic Boulevard. The designs are all much the same, and Hockney appears to be saying that one street is barely distinguishable from another. A

street sign, seen against the background of anonymous building and palm trees in several designs, becomes like a logo, the same representative emblem surrounding each street name.

Behind Hockney's coolly sceptical response to Los Angeles, however, is a continuing interest in ways of representing places. As with *Flight into Italy*, there is both engagement and detachment here – with the emphasis moving towards detachment. Hockney is still concerned with the balance between mapping and representing. He introduces a fresh element into the debate already set up between the diagrammatic and the scenic in the form of a street name which is represented twice: pictorially, within the painted design, and verbally as a Letraset caption. The caption develops the earlier reference to 'geography book', printed article or – to give the problem its broadest definition – the exchange between graphic and 'original' art. Hockney continually pulls graphic ideas back into the fine art domain by means of the distinctive painterly handwriting which clearly registers everything that comes from his studio as fine art. Hockney uses the objectivity of the Letraset caption and the wide unpainted border to the painting to create resemblance to a printed page, while impressing his individuality firmly enough to maintain the idea of uniqueness.

Hockney's architectural facades make no pretence to volume and their grid-like surfaces refer to Minimalism, which also achieved purity by rigorous exclusion. There is parody in Hockney's adoption of elements of abstraction in his painting, as there had been with his appropriating the Cohens' work earlier – as if abstraction was a set of devices rather than a principle. Hockney's claim that Modernism remained a serious issue for him in the 1960s is to be seen in this

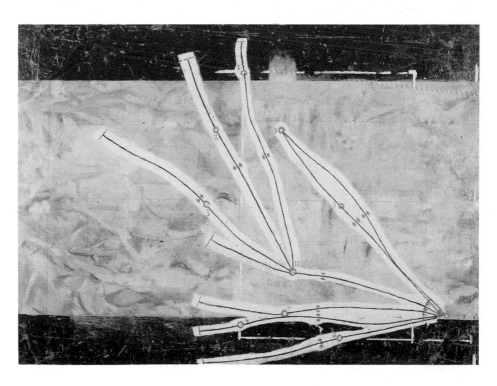

5.7 Marcel Duchamp
Network of Stoppages, 1914

light (Hockney 1976: 100). At their most austere, Hockney's office block facades are unlike contemporary Minimalist painting mainly because they do not cover the whole canvas, and are revealed as what they are by what surrounds them, trees or sky. Hockney discovered in the building facade the thing which has all the grid-like objectivity of a map while actually being out of real life. The narrative content of the designs is less than in earlier work because the principal representational element, the building front, takes on the role of the real-life, scenic elements of the earlier paintings, but lacks their lifelikeness.

Hockney's claim that Modernism was important is borne out, and it is hardly surprising that it was in 1964, with his adoption of America as a second domicile, that it comes into the open. The grid as the emblem of a certain kind of twentieth-century art has been described by Rosalind Krauss as 'modern art's will to silence'; and if there is one quality that distinguishes Hockney's Californian paintings of the 1960s from his earlier British ones it is their silence. For Krauss the grid is 'what art looks like when it turns its back on nature'; the grid belongs to a world apart, it is 'both prior and final' (Krauss 1978: 9). Hockney's Californian art is concerned with the rejection of nature (*Flight into Italy* having already been in part about how to paint landscape without being naturalistic). It is also concerned with the removal of art from temporality – the way representational images, as well as abstract ones, can be made to seem, at least, both 'prior and final'.

In another sense, however, Hockney is quite different from this. The grid is invariably compromised, with Hockney's almost ubiquitous means for doing this being the palm tree. The palm is the element which represents nature, even if by English standards of naturalism it does so by the narrowest margin. As Hockney introduces it in front of a spare, rhythmical facade, it is like a flag being waved, telling us not to read the facade as a grid after all. Hockney never loses sight of narrative, but his claim that Modernism was a real concern is borne out (though Minimalism might be a more precise word). The silence, stillness and apparent timelessness of his Californian paintings – the elements that create much of the distinctiveness of these canvases – is the evidence of this.

The vision of Hockney as the north European artist who finds in California a new equivalent for the relaxed Latin culture of the Mediterranean, to which northerners have traditionally been drawn, is a seductive half truth. Hockney is a natural radical coming to Los Angeles full of optimism to enjoy the leisure and ease of an open, prejudice-free city. His painting, nonetheless, is full of lonely and disturbing images.

Uninterested in painting people and locations he did not know, Hockney turned from public spaces to the pools, lawns and patios of private houses. He has acknowledged the use of pre-existing imagery drawn from real estate brochures, swimming pool sales material and mail order store catalogues (Hockney 1976: 100), as well as painterly devices drawn from abstraction which he could translate back into representational imagery. (Hockney himself initi-

ated the much repeated comparison between the ripples on his pools and Bernard Cohen's – in Hockney's phrase – 'spaghetti paintings'.) The artist's practice remains that of *Flight into Italy*, with images born of experience set against others appropriated ready-made.

New graphic conventions particular to the Californian paintings of the 1960s are wide white borders and line frames (see, for example, Plates 4, 5, 6). Hockney has spoken of the white edges as part of his internal debate with abstraction; and though the result is certainly abstract in the sense that the designs become less lifelike, the immediate effect of both white borders and line frames is to bring the designs into line with the conventions of reproductions, postcards or photographs. This effect is increased by the fact that most viewers see Hockney's paintings more often as reproductions than as paintings, so that the canvases' mainly large size, which is the feature that more than anything else identifies them as paintings, is lost. The flat, unmodulated surface of the acrylic paint Hockney started to use in California, which leaves no trace of brush or hand, enhances the viewer's sense of looking at a non-original design.

Assessment of authenticity in modern painting often uses Impressionism as a yardstick because it is painting of outdoor subjects using marks that seem to reflect momentary changes. Hockney's Californian painting is largely of the outdoors, but uses opposite techniques to Impressionism. Still, silent and unchanging, his pictures relate to 'true' open-air painting, such as that of St Ives, as Seurat's works relate to Impressionism. Seurat questioned naturalism in the representation of landscape by using the device of painted frames round designs, equivalents of Hockney's line frames. These create the same sense as with Hockney that the enclosed designs are not the result of immediate perception but are distilled experience, with the built-in frame acting as a mediator between experience and image. Both artists use 'indoor' effects, enclosing frames and highly regulated paint surfaces, for 'outdoor' subjects.

Seurat created a different effect from Hockney's unmodulated flatness by the use of his dot technique which, whatever its significance in terms of colour theory, confirmed for a work of art of that date (before half-tone printing introduced dots to reproductions) that what is being looked at is a painting. Hockney's flat unmodulated colour surrounded by white is more ambivalent in this respect than anything in Seurat. The similarity of his handling of acrylic paint to reproduction and the framing devices he adopts are less reassuring that what we are looking at is something we immediately recognise as art.

Hockney's white borders also have the effect of windows, giving the viewer the sense of looking through something in order to read the design. The result is to distance the subject because the border blocks off the space between the looker and the thing seen, creating remoteness within the frame. While the views Hockney painted in this way are real ones, the effect of the way he does it is to question their reality. Framing memorialises, and the images are trapped and held in suspension, withdrawn from the passage of time and thus protected

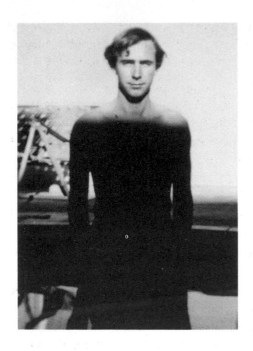 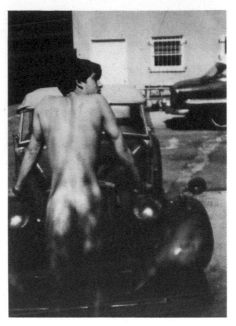

5.8 [*left*] Mark Lancaster
Photograph of Nick
Wilder, 1966

5.9
Polaroid photograph of
Peter Schlesinger, 1966

from change. A paradox emerges in these Californian paintings. Identifiable people, friends and art collectors who generally own the places where they are painted, are shown in situations that seem strangely impersonal, objectified as if belonging to no-one. The patios and pools are private places, but are unmarked by the signs of casual possession one might expect with private ownership. There are no used glasses or teacups, no towels or even wet foot-prints on the pool's edge to suggest either that a swimmer was anywhere before being in the pool or that he will ever come out.

Hockney particularly liked to memorialise or extract from time things which in reality are the least amenable to this effect: water flowing from pipes and lawn sprinklers, splashes, the restless rippling surface of a pool, or reflections on plate glass. Representing these is a technical challenge which Hockney needs to engage with in order to arrest the living world and make it into a still world of objects under the artist's control. The sense that everything is an object is increased by the opaqueness of surfaces. He resists transparency, whether of water or glass, in order to create equivalence between things, to make everything solid and object-like.

This process of objectification is strange when applied to the world of things, and stranger still when applied to people. Hockney explains how for the image in *Portrait of Nick Wilder* (1966) (Plate 4) he got his friend the painter Mark Lancaster to stand in the pool to photograph Wilder (Hockney 1976: 104). The photograph just visible pinned to the studio wall in Hockney's photo-collage *George Lawson and Wayne Sleep, Pembroke Studios, London w.8, 2 May 1982* (Plate 13) appears to be the one used in the painting; and another, similar one (Figure 5.8), shows Wilder standing close to where he is in the painting, but

on the edge of the pool not in it. In copying the photograph into the painting almost exactly, Hockney has used the effect of collage, the impression, true or not, that he has cut the image from one context and slotted it into another.

The apparent – and actual – dislocation is more radical in *Peter Getting Out of Nick's Pool* (1966) (Plate 5). Hockney photographed Schlesinger nude from the back, in exactly the pose he wanted in the composition, but in a quite different place – not near the pool at all, but against the radiator of Schlesinger's sports car (Figure 5.9). The actual displacement from car to pool ensures the effect of dislocation, makes quite certain that Hockney does not end up with a natural seeming result. He emphasises here, as he had not with Nick Wilder, that the key image, the figure, must be brought in from a strange environment in order to achieve the sense Hockney wanted of Schlesinger's not belonging.

What Hockney was doing both with landscape and with objects, culling diagrams from geography books and swimming pool images from newspaper advertisements, he was doing in parallel with people: photographing them in one place, lifting them out and setting them down in another location. The power to transfer something from one place to another at will is a form of control or possession; and there is an inference in the Californian paintings that everything is a thing, and that each of Hockney's Californian paintings, with or without figures, can be considered a 'still life'. The implication of the phrase, of a live thing becoming still, is suggestive of Hockney's strategy, but the French equivalent, *nature morte,* is even apter for the way it expresses the sense of living things becoming *dead* as they come under the artist's control.

This treatment of the human figure compares with that of Seurat, who spoke to the critic Gustave Kahn of the seemingly lifeless figures in *Un Dimanche à la Grande Jatte* (1884–86); 'I wanted to make modern people, in their essential traits, move about as they do on those friezes [the Panathenaean friezes of Phidias]' (Herbert 1991: 174). Seurat's critics used words such as 'Egyptian' and 'primitive' and made comparisons with popular objects and wooden toys to evoke the stiffness of Seurat's figures and the strangeness of their relationship to their surroundings (Herbert 1991: 174–5). Hockney also avoids naturalism and achieves a separation not just of person from environment but of thing from thing.

The Californian paintings are like re-assembled fragments which, in the process of rehabilitation, have just failed to regain their wholeness. The distinction is between Hockney's realism and the naturalism he avoids. Realism here refers to Hockney's powerful, pared down, flat and frontal images; naturalism to images that would have to surrender the power that Hockney's have in order to relate naturally to one another within the frame. Hockney's realism, his preference for the first approach over the second, leads to such effects as the sharp, highlighted head and shoulders of Wilder, half isolated from his surroundings. For the way the paintings memorialise moments in time they can be thought of as like photographs in an album, which are themselves memorials of a private

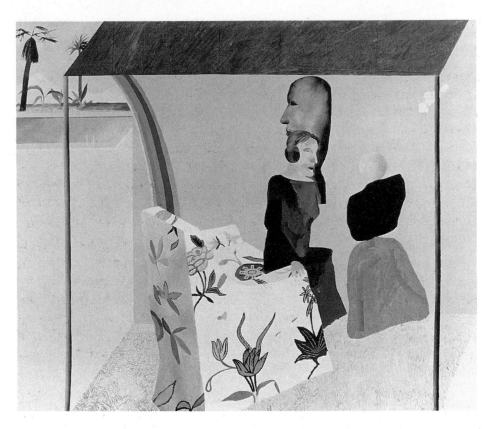

5.10
California Art Collector,
1964

and personal kind. A second analogy would be with museum exhibits for the unimpeachable way they enshrine something that would otherwise be lost.

The most significant absence from Hockney's Californian painting is any image of decay. The museum as a site of preservation and permanence in contrast to the changing real world has always interested Hockney, to the extent that people and artworks, the living and the dead, have sometimes shaded into one another. In 1962 he visited the Pergamon Museum in Berlin with an American friend Jeff Goodman, and having become separated from Goodman, suddenly caught sight of him from a distance facing an Egyptian head, as if the two were in some way partners (Hockney 1976: 89). This pairing off was the source of *Man in a Museum* (1962), which was followed by two 'Marriage' paintings, the second of which shows an Armana princess, copied from a book on Egyptian art, sitting on a couch with a mafioso-type businessman. Beneath Hockney's jocular comparisons between human beings and ancient artworks is a recognition of death-in-life, or, from the viewpoint of the Egyptian head, life-in-death. A little of the life of one creeps into the other, and some of the rigor mortis of ancient Egypt enters living people. Wilder and Schlesinger are presented ambivalently, as real friends but also like objects preserved as museum objects are.

This kind of interpretation helps to explain why Hockney liked to paint people with the artworks they collect, and sometimes to search for likenesses

between them. The woman in *California Art Collector* (1964) (Figure 5.10) is engaged in dialogue with what Hockney describes as a William Turnbull sculpture, but a Turnbull made, in actuality, sufficiently anthropomorphic for dialogue between the incongruous couple to seem plausible. For *American Collectors (Fred and Marcia Weisman)* (1968) (Plate 7) Hockney did not paint the Weismans from life because he saw it as a painting, as the title indicates, of collectors and their collection. Equality between people and things is illustrated in the way Marcia Weisman's face is treated as equivalent to that of the North West Coast Indian totem pole in their collection. The painting is really of a museum, of which the statuesque Weismans are both the living owners but also part of the contents, with Hockney using the skills of the embalmer to take control of the whole scene and blur the distinction between owner and object.

In an interview with Peter Webb in December 1980, Hockney described the 1960s' Californian paintings as belonging to a particular period in his career, and one that he did not want to return to. 'I know everyone wants me to paint pictures like *Mr and Mrs Clark and Percy* and *A Bigger Splash*, but they are not the mainstream of my work. I think they were good pictures, but in retrospect it will be seen that they were an aberration in my career. The true line of development leads from the Royal College and early sixties paintings to *Mulholland Drive'* (Webb 1988: 192).

In 1978 Hockney had become interested for the first time in painting unpeopled landscapes, working on the series which was to lead to the twenty-foot canvas *Mulholland Drive: The Road to the Studio* (1980) (Plate 12). The interview with Webb followed on the abandonment, in October, of Hockney's only attempt at a multi-figure composition, *Santa Monica Blvd.* (1978–80) (Figure 5.11). Conceived from the viewpoint of someone looking from a moving car, *Santa Monica Blvd.* was Hockney's attempt to create a kind of living city, a theatre of the everyday. To gather material for it he used a miniature camera so that he could take photographs in the street unnoticed. *Santa Monica Blvd.* is

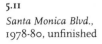

5.11
Santa Monica Blvd.,
1978-80, unfinished

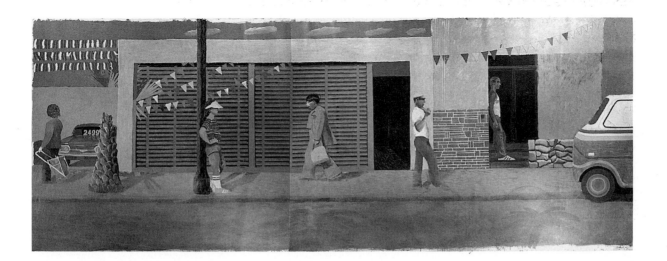

not about the shared life of the street so much as figures on their own in doorways, against architectural backgrounds. Hockney was discovering, as he had in Pershing Square in 1964, that he was not interested in groups or crowds but, as in the 1960s, in isolated figures. Abandoning *Santa Monica Blvd.*, he tacked over it on the wall of the studio the canvas that was to become *Mulholland Drive*, replacing an urban scene with figures by a semi-rural one with none. The force of his statement to Webb, that the Californian paintings of the 1960s were not the mainstream, is unusual in Hockney's discussion of his work, but the decision to abandon *Santa Monica Blvd.* was logical. Isolated figures in architectural settings were what Hockney did not want to return to, and landscape seemed to present a way forward.

Hockney is not a traditional landscapist searching for spiritual affinity with nature, and the group of paintings he made between his home off Mulholland Drive and the downtown area should be seen as part of his world in a more physical sense, of terrain that he was constantly passing. The word 'drive' in the title *Mulholland Drive: The Road to the Studio* was intended to evoke not the name of the road – even though that is synonymous – but the idea of driving in a car (Hockney 1993: 67).

Hockney's claim that the new paintings would look back to his early work is confirmed by likenesses between *Mulholland Drive* and *Flight into Italy*. The new landscapes are motorists' experiences, and share with the earlier painting the sense of being real combined with the impression that each picture is also a kind of map, with different colours and types of handling for different areas, and – in the case of one canvas, *Nichols Canyon* (1980) – a road sign guiding one between them. Hockney used different perspectives within *Mulholland Drive* to vary the degree with which a viewer feels either close to the ground – and therefore in Hockney's company – or high above the scene, in the more objective position of a person looking down at a wide swathe of landscape as one would look at a map.

At the top of the canvas, where the road pattern from a Los Angeles street map appears as the sky, the presentation seems entirely diagrammatic. In reality, however, Mulholland Drive is on a ridge with views down on both sides. The street map, which at first seems to occupy the space of the sky, could be read quite differently by someone who is not in the viewing position for the picture but actually standing on Mulholland Drive. For such a person the 'map' becomes the street pattern of Burbank, beyond the ridge, seen from the vantage point of Mulholland Drive. Hockney has created a device for showing the viewer an overall, semi-aerial view of the layout of a journey, and has then asked such a person to imagine themselves inside the picture, on Mulholland Drive, looking down over a street pattern that is not, in reality, visible to someone looking at the view in the painting.

To escape what he saw, when talking to Webb, as the dead effect of the 1960s paintings, Hockney has created a design that cannot be understood from

a single viewpoint outside the picture but assumes that viewers can project themselves into the picture. Choosing a different shape from the 1960s paintings, whose stillness relates to the fact that they are often square, Hockney has painted an extremely long canvas, which itself suggests a preoccupation with temporality. Temporality was to be a theme of his painting as he put the earlier Californian canvases behind him. In inviting the spectator into the painting with him, Hockney commented: 'You drive around the painting, or your eye does, and the speed it goes at is about the speed of the car going along the road' (Livingstone 1981: 240).

Hockney's return to strong colour also bears out his claim that he is reaching back over the dry colouring of many 1960s' Californian paintings to his Royal College work. He had found, he tells us, in the course of his work in the theatre a new kind of acrylic paint that offered a richer range of colours (Webb 1988: 190). These richer colours are not really, of course, those of the Hollywood Hills, which are parched and can only be represented in the way Hockney does if the lush vegetation of individual well-watered gardens is made to stand for the whole. Rather than simply representing what he sees, Hockney appropriates the palette of Matisse and keys into an art historical tradition of landscape. The desire to get back beyond the dry bright colouring of the pool and patio canvases to an early love of Matisse and the Fauves is part of his strategy, while the other part is satisfying an audience which likes to associate landscape painting from Post-Impressionism onwards with the intense colours of the Fauves and their love of the Mediterranean.

In relating his new art to his earliest, Hockney also recovers a degree of painterliness after the flatness of the later 1960s' work. Since Impressionism painterliness in landscape art has generally signified naturalism, even though in actuality the Impressionist painters improved their work in the studio. The whole history of modern landscape painting has been one of different degrees of artifice designed to create a 'spontaneous' effect. But in his new landscape paintings Hockney goes further than earlier painters in recognising that spontaneity can be constructed. Reviewing the course of Hockney's work in a book makes it easy to ignore his rapid switches between activities around 1980 and so observe the unexpected continuity between the rich colouring of his stage work and the landscapes. Doing this enables one to understand, better than looking at the landscapes by themselves does, how theatrical all of Hockney's work is, and to caution oneself against expecting naturalism even when looking at his landscapes.

Hockney mistrusts nature and, since *Flight into Italy*, he has sometimes liked to have a windscreen between himself and the outside world. The automobile is a theme of Hockney's autobiography: buying a car, passing the driving test, making an immediate trip to Las Vegas, are all part of his introduction to Los Angeles (Hockney 1976: 97). As with the minivan in the 1962 painting, the car is the essential context of *Mulholland Drive*, whose subtitle is *The Road to the Studio*. The experience of landscape in this and other pictures is mediated by the car as the sign of an urban culture that restricts real experience

of nature by confining what we know to what we see from a moving vehicle.

Early in 1982 Hockney discussed with Alain Sayag, a curator from the Centre Pompidou, an exhibition of his documentary photographs. On Sayag's departure Hockney, his mind firmly fixed on photography, started making collages of photographs. He began by using Polaroids arranged symmetrically edge to edge with their white borders uncut, and then moved to borderless prints from 35 mm negatives used in a quite different way, with the prints overlapping and the sequence of prints therefore able to turn corners, making curving forms and lead the eye in whatever direction the artist wanted.

The completion of the landscape paintings and the start of the photocollages are not normally connected as events, but the two practices have much in common. Photography, developing in Hockney's work away from documentary beginnings where it was subsidiary to the main business of painting, became an independent medium of expression and picked up the implications of temporality which Hockney had started to explore in the landscapes.

The limitation of the still photograph, Hockney believed, is that it does not have any life in time (Hockney 1985: 9-11). The time, as he put it, is the same in one corner of a photograph as in another because the image is made all at once. A painting is different because it takes time to make and marks an accumulation of decisions over time. Hockney had a second criticism of the photograph:

Influenced by the camera's eye … we always feel we are looking through a window: the foreground of the photo or painting abruptly ends at a point some distance from you and you know you are not there, you are not connected with what is seen, even though it's seen from one point representing the viewer. There is actually a void between where you would be standing to see it this way, and the bottom of the picture … The problem with a window on the world is that there must be a wall around the window, and this wall is cutting us off from what is seen. You cannot actually walk towards it. (Hockney 1985: 9-11)

This passage is a true description both of the effect that the bottom edge of a photograph can have, but equally of Hockney's 1960s' Californian paintings with their wide white borders. These borders act in the same way as the wall round the window as Hockney describes it, cutting the viewer off from the view, and from the effect of life, movement and the passing of time. The distinction is between the timelessness and inertia of the Californian paintings, which seem almost infinitely distant from us and untouchable, and the group of landscapes that includes *Mulholland Drive*. What Hockney wanted was not just to get closer, but to be in the landscape. The effect of their depth of colour, he pointed out, was to make everything seem nearer because there is no aerial perspective creating the illusion of distance (Hockney 1985: 98, 124), none of the blanching so evident in the pool paintings.

As Hockney took photographs for photo-collages he directed the camera on one point, then on each adjacent point until he had marked out and recorded an area of real space. He may himself have moved when doing this or he may not, but in either case the passing of time was registered, and a relationship exists

5.12 [facing]
Blue Lines, Los Angeles,
Sept. 1982, 1982,

between the time taken in creating the individual rectangular images and the spaces that these rectangles mark out. In *Blue Lines, Los Angeles, Sept. 1982* (Figure 5.12) Hockney has made a continuous line, each component of which represents one exposure and a step to be taken by the body whose feet are visible at the bottom, while the whole is equivalent of the path the body walks on. Each square can now be thought of as a unit of time, as a click of the camera's shutter, or as a unit of space, a paving stone within the path that the feet will walk. Hockney is, therefore, by implication, fully in the picture, but not, as in *Mulholland Drive*, as motorist. The photo-collages put particular emphasis on that which best defines physical contact with the world but is previously absent: feet.

Blue Lines is uniquely shaped in Hockney's work and, despite its apparent abstraction, is highly anthropomorphic. Turning the feet at its base the other way round in the mind assists perception of the tall thin form as a human figure. At the same time it is both easy to read it as a figure and hard to read it as what it ostensibly is, a landscape. Its narrow verticality is unnatural in terms of the customary way of presenting outdoor scenes, which is panoramically and in terms of a breadth of visual field that is markedly absent here. The narrow view is evidence that, alongside the anthropomorphic character of the work there is a parallel diagrammatic function: the photo-collage is a representation but also a diagram of the steps the feet will take.

Hockney's photo-collages were a historically important development in his art, answering a problem that could not be fully resolved in paint. They eliminated the 'window' in the 1960s' paintings, the gap which distanced the content of a picture from the viewer. The absence of life and of contact with place and reality in the earlier paintings was an effect Hockney wanted to escape from. The photo-collages were a solution because the artist is always there and can be read back into the work as a presence; the gulf has disappeared.

As his photo-collages developed, Hockney introduced more than the two people that his work up to that point had rarely exceeded. At the same time he avoided the dead, enclosing space that had been a hindrance in the Californian paintings by letting the photo-collages take on organically whatever shape emerged, as Hockney led the viewer across the squares of photographic paper which came to act like stepping stones over a void. The window effect of the 1960s' painting is gone because the photo-collages do not have fixed bounding edges. The memorialising aspect of the earlier work is still an available device, however, because a single rectangle of photographic paper could be used as a frame within a design without becoming a framing edge for the complete photo-collage. Hockney could still frame a face, enclose an image, within a design that unfolds according to the needs of the scene it shows and has no preordained shape (Figure 5.13).

Hockney's art raises the question of painting's continuity with the world. It is realistic and about everyday life, but its relationship with outside space is ambiguous. Hockney remains close to experience, but uses appropriated

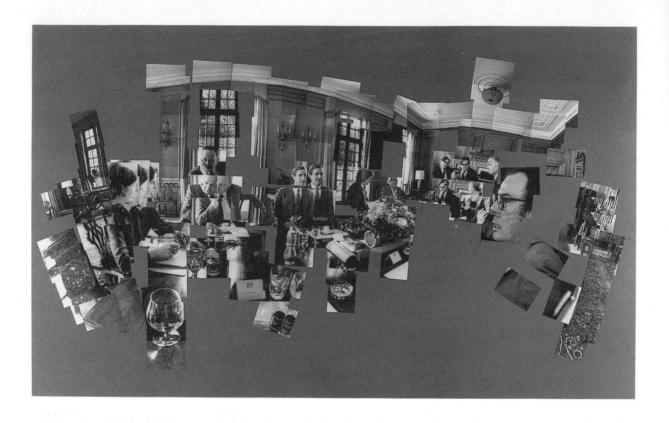

5.13

Luncheon at the British Embassy, Tokyo, Feb. 16 '83, 1983

imagery, window and border effects, and mapping, which are impersonal and distancing. Between the map and the specific example there is always a gap, a caesura on the canvas separating one type of representation from another.

Hockney is post-Cubist in the sense that all his works are like collages, juxtapositions across a surface rather than explorations into depth. The result is a well-defined identity based on style – Hockney is an easy artist to recognise – but also the detachment from self that a collage technique engenders. Perspective, which measures things backwards into space from the eye, creates an accurate visual picture of the world at a particular moment, while collage allows multiplicity of reference and memory as well as description. Hockney wants elements of both these things. His is an ironical position because the tension in his art arises from it being neither autobiography alone nor a map of modern life unmediated by self.

Notes

1
In Hockney's first retrospective exhibition in a public art gallery at the Whitworth Art Gallery, University of Manchester, Feb. 1969.

2
See Hockney (1976: 64), where, referring to the 1961 'Tea' paintings, he writes that they were 'as close to Pop Art as I ever came'. This, and supporting opinions of, for example Henry Geldzahler (in Tuchman 1988: 18-19), are based on a narrow definition of Pop Art, confining it to a direct relationship with printed labels and the like.

6.1 [facing]

Place Fürstenberg, Paris, August 7, 8, 9, 1985, 1985

6

Photo-collage

ALAN WOODS

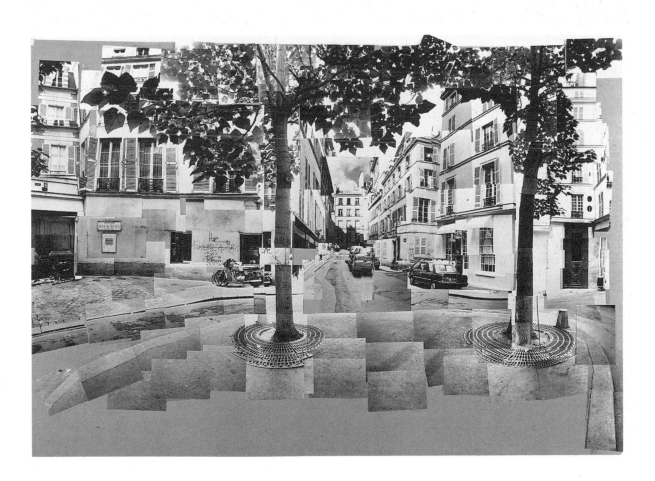

David Hockney's work is at once stylistically eclectic and thematically consistent. His favourite motifs and models are constantly reappraised, rediscovered in different modes and techniques; the subject is always as much the means of representation chosen as it is the object or person represented. Often he has mixed different styles within a single image, for example in *The First Marriage (A Marriage of Styles I)* (1962); in *Mount Fuji* (1972), which fuses a distant view of the mountain, realised in a stain technique borrowed from abstraction, with a hard-edged, glossy, precise still-life in a spectacular unity; and in *Invented Man Revealing Still-Life* (1975) and the related *The Blue Guitar* etchings (1977), which revert to the patchwork accumulations of style of Hockney's paintings of the early 1960s. What contemporary painters inherit from Modernism is not tradition, but a choice of traditions. There is no longer a convention of painting so well established as to appear natural. All paintings are artificial.

One consequence of this inheritance is that representational painting has for much of this century defined and asserted itself against both abstraction and photography; the one denying the point of drawing things or people in a world which the other records so easily and so apparently completely. Abstraction, by restricting itself to what is real in the painting itself as a physical object, to paint, to canvas, seeks an escape from this artificiality. Photography, which can only record what is there, appears to provide a natural, direct image. Photographs were once called sun pictures; light was not drawn, but itself drew. Here was a way of making pictures which obeyed the convention of perspective but which was not conventional. Photography was therefore seen by artists and critics as the death of painting, a replacement which fulfilled all the artist's ambitions but more quickly and accurately; or as an aid to painting which was also its conscience and arbiter; or as the liberator of painting freeing it from the 'mechanical realism' which was (and to some extent still is) popularly assumed to be the natural purpose of art. Released from slavery, painters could explore symbolical or fantastical imagery, pursue musical analogies into abstraction or, while remaining committed to representation (like Picasso, who thanked the camera for its order of release) they could 'distort' appearances for expressive or formal ends, working towards a realism no longer conceived, as nineteenth century theory tended to conceive it, as purely optical.

As part of his general interest in style, in alternative means of picture making, Hockney's work has consistently acknowledged the presence – and the challenge – of both abstraction and photography; often within the confines of a single painting. Several paintings of Los Angeles from 1966 and 1967 – *A Bigger Splash* (Figure 2.7) and *A Lawn Sprinkler* (Figure 0.5), for example – are

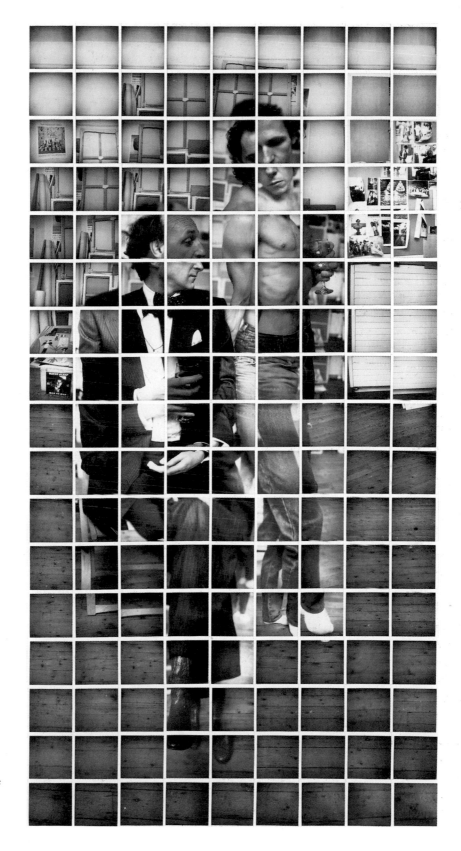

*George Lawson and Wayne
Sleep, Pembroke Studios,
London W.8, 2 May 1982,*
1982

PLATE 13

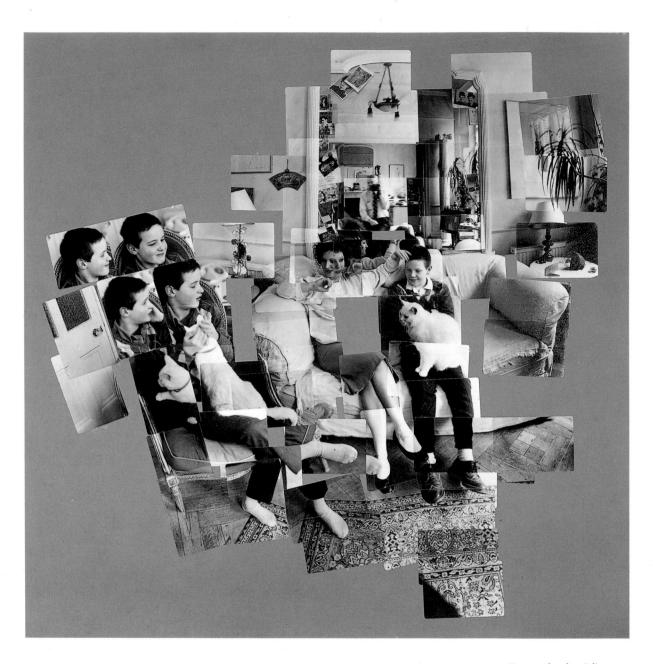

George, Blanche, Celia,
Albert and Percy. London,
1983, 1983

PLATE 14

square with white borders, like Polaroid photographs. In their compositions and markings – the striped bland bands of colour which stand for water, sky, walls, the patient strokes which make up the sprinkled lawns – they depict through abstract devices; and not even schematically, like the stripes of colour which mimic both abstraction and geological diagrams to represent the Alps or the Rocky Mountains in *Flight into Italy – Swiss Landscape* (1962) (Plate 10) and *Rocky Mountains and Tired Indians* (1965) (Plate 11), but in a 'naturalistic' image. The flatness of these pictures is related both to the flatness of the canvas itself – that two-dimensionality so precious to Modernist theory – and to the flatness of a photograph. Until the early nineties, the closest he came to an abstract painting turns out to be not merely representational, but closely based on a photograph; *Rubber Ring Floating in a Swimming Pool* (1971).

Hockney has also maintained a running battle against both these extremes. The freedom with which he now criticises abstraction was hard-earned:

In the 1960s the subject had been completely played down; abstraction had begun to dominate everything, and people firmly believed that this was the way painting had to go. There was no other way out, people thought. Even I felt that, and I still felt it even when I began to reject it in action; in theory I still couldn't reject it at all. (Hockney 1976: 61)

He felt this even as late as 1966, despite the encouragement of R. B. Kitaj, his fellow student, at the start of the decade. Kitaj had told him to paint about things that interested him, and he had. The escape route he found in the mid-1960s was to use abstraction 'as my subject, commenting on it – I felt the need to use it as a subject'. 'Some artists need subjects more than others, but you can play down the subject too much; there is an importance in it' (Hockney 1976: 62, 61). This is especially true of the human subject. Even if neither a human interest nor the discipline of depiction can still be held essential to a painting, both remain valid and exciting. The figure can never be exhausted as a subject, whereas abstract motifs tend to be effectively restricted to a single *œuvre*.

Photography ceased to be the artist's friend once the need was felt to reassert the value of representation, of (to put it at its simplest) painting or drawing from a model, of a description which is neither (to repeat an opposition suggested by Hockney) a snapshot nor 'naive' or 'primitive' but is based upon observation. Its authenticity, its authority as definitive image of the real, was long established as tyrannical. Appearances had to be reclaimed for the eye, for the human lens. Hockney consistently used photography the way in which most people use it; unaesthetically, to record holidays, weddings, family, friends, lovers. Frequently he used it as an aid to painting, even as a stimulus. (The Tate Gallery owns photographs used for the portrait of *Mr and Mrs Clark and Percy* (Figure 4.7), a painting in which the view through the window is 'over-exposed'. Several paintings from the mid-sixties to the early seventies, such as *Peter Getting out of Nick's Pool* (Plate 5) and *Le Parc des sources, Vichy* (Figure 4.8), were based on photographs. *Portrait of an Artist (Pool with Two Figures)* (1972) was inspired by a chance meeting on Hockney's studio floor of photographs of a boy

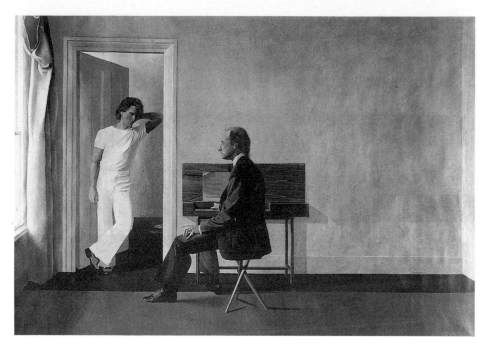

6.2

George Lawson and Wayne Sleep, 1972–75, unfinished

swimming underwater and of a boy gazing at something on the ground.) But he also grumbled about photography, and even questioned its realism. Photographs were too quick, too casual, too indiscriminate; they did not relate, as a drawing or a painting relates, to the act of looking. Hockney might well have taken the argument one stage further and suggested that for many people the act of photography has not distorted so much as replaced the process of looking. A place will be visited, an event attended in order that it may be photographed; once the image is safely captured – as it is immediately – there is no need to study it further.

photography ...has caused confusion ...when people say painting is dying, I think it's the other way round; I think photography is. I think photography has let us down in that it's not what we thought it was. It is something good, but it is not the answer, it's not a totally acceptable method of making pictures, and certainly it must never be allowed to be the only one; it's a view that's too mechanical, too devoid of life.

This weakness in photography is becoming clearer to me ... If you go to an exhibition of photographs, there are certain things about the photographs that dull you in the end. They always have the same texture; somehow, the sense of scale is always the same; there's a monotony ... that you wouldn't get in an exhibition of paintings ... Certainly photography is an interesting art, or can be, but I think it's been – not over-praised, but relied on too much, so that in painting and drawing people have used photographs and abandoned actually looking at the world. (Hockney 1976: 130, 149)

Even the information photography offers is insufficient, suspect:

I use photographs for reference; it's difficult to paint from photographs. If you haven't taken the photograph yourself, you can only do something imaginative with it. If you took it, at least you can remember, you're only using it to jog your memory, make a note of a shape. To draw from photographs is impossible, I think. They don't have enough information. If you look at any photograph of a face, there's no real information.

We tend to think the information a photographer provides is true. Just as you can make a drawing of somebody and then the friends of the person say It's not like him, you can take a photograph and you can eventually say You know, it's not like him, he doesn't look like that. So the information in a photograph is not always true. (Hockney 1976: 99-100, 149)

During the early eighties, Hockney was enthusiastic about his collage or 'joiner' composite photographs – in which a single image is assembled from successions of prints – all of which show a small detail of the subject: 'I love new mediums ... I think mediums can turn you on, they can excite you: they always let you do something in a different way, even if you take the same subject' (Hockney 1980: 10). It is evident that his photo-collages evolved within a context of experiments suggested by the technique itself. Nevertheless, his enthusiasm for it differed from his previous excitements over sugar-lift etching or paper-making. Despite an earlier warning that 'to theorize about it [work] beforehand could be disastrous' (Hockney 1976: 27), there is a theoretical element in the joiners coexisting with the 'trial and error' which, as he stresses, is the inevitable basis of the work as it progresses. Hockney is quite consciously trying to transcend

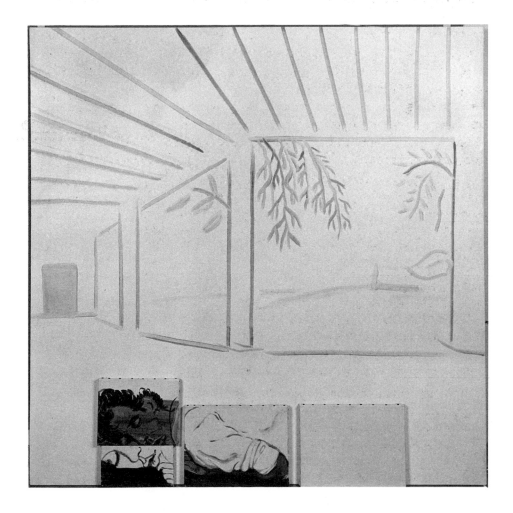

6.3
Gregory Sleeping, 1984

certain limitations of photography, to grant it some of the privileges and responsi-bilities of drawing. Before dealing with the theoretical aspects of the joiners, however, some attempt should be made to offer a more general critical account.

The cover of the second Talking Heads LP, *More Songs about Buildings and Food*, reproduced a life-size group portrait assembled from 529 close-up Polaroids. These were organised on a grid system comparable to that used by Hockney in the works first exhibited at André Emmerich Gallery, New York, four years later in 1982. The difference in atmosphere is striking. In David Byrne's image the four members of the group, spread out across the surface in a repeated pose, with their arms hanging at their sides as they confront the viewer, are trapped between the flat red background and the white grid of the Polaroid borders. The caged figures are at once menaced and menacing, suspi-cious and under suspicion. Brilliant and neurotic, the cover is one of the hand-ful of visually compelling rock images.

Hockney's Polaroids, on the other hand, are amused, touched, affectionate, involved. The grid – eventually abandoned as 'too predictable', offering 'insuf-ficient expansiveness and surprise' (Haworth-Booth 1983: 7) – is never an alien-ating device. His famous double portraits are often sharp, insistent on the distances between partners, as if he painted the gaps and not the solids within relationships. The photographs, however, are more closely related to the draw-ings, more intimate in scale, in pose and in mood (though a similar relaxation may be seen in the second version of his portrait of his parents, painted in 1977 (Figure 4.10)). The most direct possible comparison is between the portrait of George Lawson and Wayne Sleep (Figure 6.2), left unfinished in 1975, and the Polaroid portrait of 2 May 1982 (Plate 13). The painting plays on contrasts; between dark and light, formal and casual clothing, between the intellectualised pose of Lawson, static in its action (his right hand plays a keyboard, though his pose and profile are at right angles to the instrument) and the more fluid, easy, relaxed pose of the dancer. Neither of the figures is entirely present in the room. Lawson, although physically present, gazes out of the window shown in the extreme left of the painting; he is thinking, unaware of either the space in which he sits or of Sleep. Sleep leans against the door frame, as likely to turn back to the room behind him as to enter the room in which Lawson is sitting. The only intimacy (and there are far less intimate portraits by Hockney; in *Gregory Masurovsky and Shirley Goldfarb* (1974), for example, his subjects are shown in different rooms, completely separated) is the one-sided intimacy of observation. Sleep watches Lawson thinking as Hockney himself was later to watch, and then paint, Gregory Evans sleeping (Figure 6.3). The Polaroid, amongst the best of the photographic works, shows the couple physically close – Sleep is leaning on Lawson's chair – and turning towards each other. Both are holding a glass of wine. The contrast in dress is repeated, but also exaggerated and given an erotic charge. Lawson is still in a suit and bow-tie (and a pair of splendid boots), while Sleep wears jeans but no shirt (or shoes). The pose is of an amused (Lawson's brow is crinkled by a raised eyebrow) and parodic seduction. The shifts of

outline from photograph to photograph are not mere dislocations; they indicate movements, both actual and apparent (that is to say, both the movements which Lawson, Sleep and Hockney made as the photographs were taken, and the created movements which result from the technique itself). There is a tender sequence, for example, from Sleep's right shoulder downwards. The line of the arm retreats from Lawson only to advance again; flesh finally touches sleeve.

Other familiar motifs and models appear in the photographs, as they do in the snapshots. Hockney's life and work have always been openly and disarmingly related. (Where his themes are traditional, they inhabit a precise location – his bathers bathe in particular swimming pools – and he has yet to tackle, as Marco Livingstone has pointed out, a 'big' subject.) The new medium offered a new way of describing swimmers, water, rain on water and favourite models, such as Gregory, the artist's mother, Celia. Hockney's continuing interest in theatricality, in multiple layers of symbols and realities, is revealed in titles such as *Unfinished Painting in Finished Photograph(s) April 2nd 1982* (1982) and *You Make the Picture* (1982), which enjoys a condescending piece of advice on a beauty spot notice board in Zion Canyon, Utah. The joiners frequently – repetitively – comment on photography. When photography is not itself the subject of the collage (as in *You Make the Picture, Photographing Annie Leibovitz While She Photographs Me, Mojave Desert, Feb. 1983* (Figure 6.4) and *Gregory Loading his Camera, Kyoto, Feb. 1983* (1983)) the necessary presence of the photographer is signalled by rolls of discarded film at the foot of the image.

The foot of the image is also where we find the feet of Hockney. In the collages, which often recall the spherical space recorded by a fish-eye lens, Hockney usually includes his own feet. The device is variously witty, whimsical or distracting. It is witty in *Walking in the Zen Garden at the Ryoanji Temple, Kyoto, Feb. 21st 1983* (Figure 6.5), in which Hockney's (odd) socks provide not only the most striking colours across the grey stone and gravel of the garden,

6.4

Photographing Annie Leibovitz While She Photographs Me, Mojave Desert, Feb. 1983, 1983

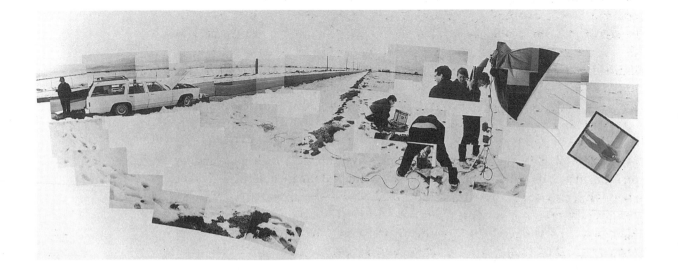

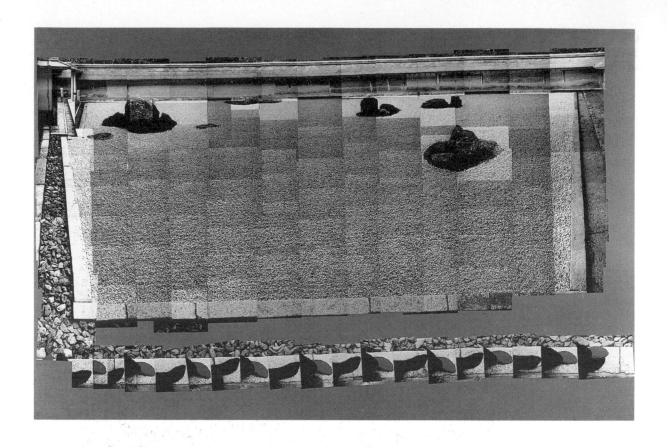

6.5
*Walking in the Zen Garden
at the Ryoanji Temple,
Kyoto, Feb. 21st 1983, 1983*

but also the only obvious temporal element as they travel beneath a static image. It is whimsical often; in the tall thin *Blue Lines, Los Angeles, Sept. 1982* (Figure 5.12) which follows, in mock homage to Barnett Newman, the lines between planks on a wooden floor as they lead to a couple of chairs, a brief view, and the planks of a wooden roof; in *David Graves looking at Bayswater, London, Nov. 1982* (1982), or in *The Brooklyn Bridge, Nov. 28, 1982* (1982) (Figure 6.6). It is distracting above all in *My Mother, Bolton Abbey, Yorkshire, Nov. '82* (Figure 6.7), a lovely, touching portrait of Hockney's mother, wearing blue waterproofs, sitting on a gravestone with her hands in her pockets in a grey drizzly day, the abbey behind her across the graveyard. The snapshot simplicity of the image heightens but does not labour the theme of age and mortality. In this combination of the universal and the everyday Hockney reaches deeper than usual. In such a context, with his mother's frail ankle the only flesh tint in the picture besides the face, the contrast between the mother's blue shoes and the sharp patterned brown tips of Hockney's shoes adds nothing, and takes a little away.

An alternative means of asserting the artist's presence, sanctioned by a tradition of Western painting (seen, for example, in the Arnolfini marriage), is used in *Sunday Morning, Mayflower Hotel, New York Nov. 28th 1982* (1982) and in *George, Blanche, Celia, Albert and Percy. London 1983* (Plate 14). The use of a mirrored self-portrait in a photographic work, however, seeking out an effect which most photographers would try to avoid, is again a little too self-conscious

6.6
The Brooklyn Bridge, Nov.
28 1982, 1982

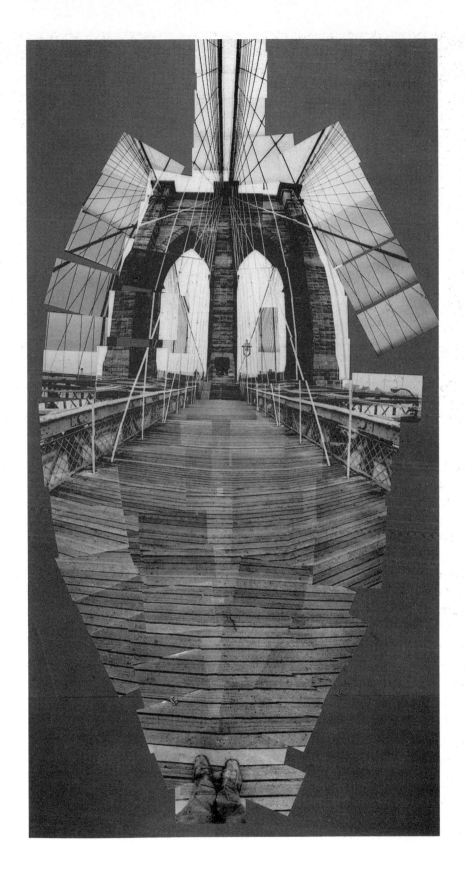

a device. Moreover, it can only show Hockney static, distracted from the action with which he is so involved in the rest of the image. He pauses to look at himself, either holding the camera blind so that his face can be shown, or caught in the act of looking through the viewfinder at himself looking through the viewfinder. The dynamic sense of the artist's presence which is everywhere felt in the links, jumps, joins and gaps, in the choices of detail and in the composition of the whole is strangely qualified, dampened by the images and tokens of his physical presence. The problem is resolved more successfully in two other works. *Luncheon at the British Embassy, Tokyo, Feb. 16 '83* (1983) (Figure 5.13), has a printed place-card for Mr D. Hockney and the impact of the face on the right of the picture, startlingly nearer to the viewer than the figures behind it, establishes the photographer's presence and position implicitly rather than explicitly, and therefore more powerfully. In *Fredda bringing Ann and Me a Cup of Tea, April 16, 1983* (1983) (Figure 6.8), Hockney is a participant as well as an observer. The movement described is towards him, his presence in the foreground completes the action.

Vision is selective; it scans, skips, pauses. It can neither be totally identified with nor separated totally from the consciousness it serves. Vision is at once directed by and directive of attention; it follows and suggests priorities. Hockney is insistent that this selectivity should influence the presentation of a paintings's subject. It is a lesson he learned from his master, Picasso, and applied in such early works as *Domestic Scene, Notting Hill* (Figure 4.5):

When you walk into a room you don't notice everything at once and, depending on your taste, there is a descending order in which you observe things. I assume alcoholics notice the booze first, or claustrophobics the height of the ceiling, and so on. Consequently, I deliberately ignored the walls and I didn't paint the floor or anything I considered wasn't important. What I considered important were two figures, the chair, a bed, a lamp, a vase of flowers, curtains and some light bulbs; anything else was irrelevant. (Hockney 1976: 92-93)

Hockney finds painting and drawing to be 'far more interesting' than a photograph because 'the selection is even better'. Photographers select what they want to record, and they can take certain decisions about how they record it (in colour or black and white, in sharp or soft focus, with a short or long exposure time); but even if they have constructed a complete and artificial world in front of their camera, they will still be recording something – some detail, some effect of light – not consciously selected. In a painting or drawing, everything is chosen because everything is described.

This criticism is related to a complaint that a reliance upon mechanical means of recording an image is to accept an impoverished, de-humanised imagery, and also 'a certain monotony'; photographs resemble each other more than paintings do. It is also related to a more subtle, and highly revealing, contrast between photography and painting. The photograph's time is frozen; the time recorded is the time which it took to record it. The painting's time is

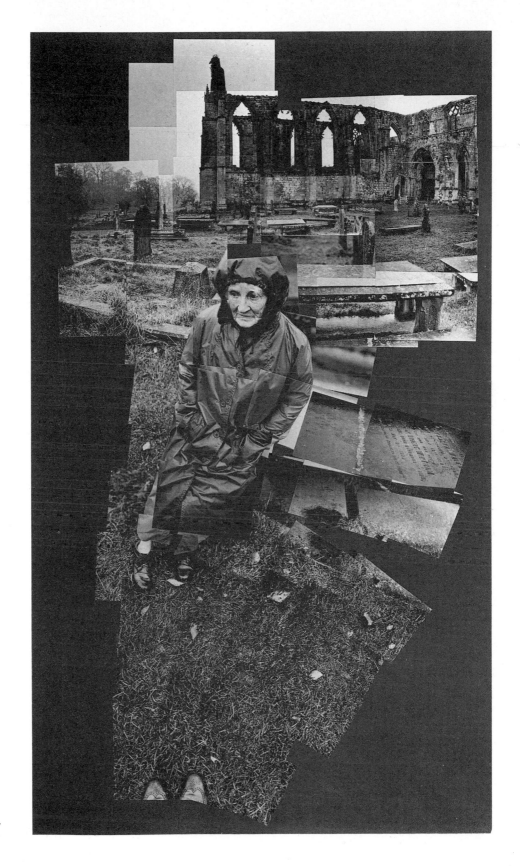

6.7
My Mother, Bolton Abbey,
Yorkshire, Nov. '82, 1982.

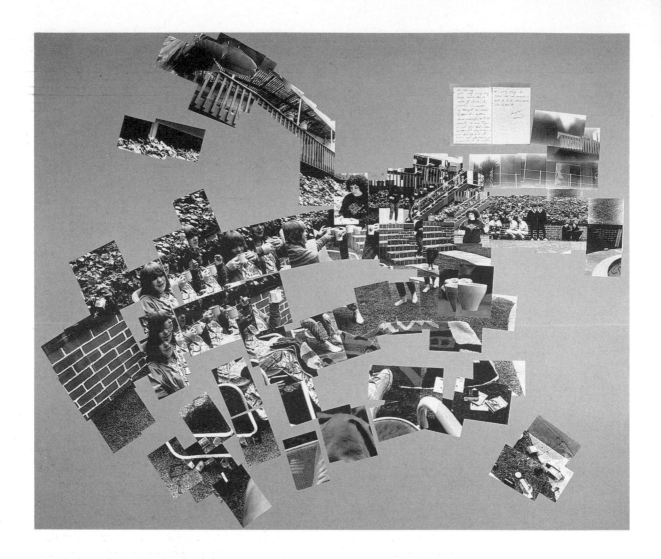

static – the image does not move – but the time taken to make the image is present by implication in the work. One reason for rejecting Photo-Realism (which Hockney approached in a work of 1968-69, *Early Morning, Sainte-Maxime*, painted from his own photograph) was that 'the subject is not really the water or whatever, it becomes the fraction of a second you're looking at it. This is the problem with photography ... its inherent weakness. A photograph cannot really have layers of time in it the way a painting can, which is why drawn and painted portraits are much more interesting' (Livingstone 1981: 118).

'Layers of time' is a useful phrase. Painting is a spatial rather than a temporal art; 'movement' in a painting is a fiction. Nevertheless, time is involved in its making; and it takes time to look at it. Our awareness of the time (one might say: effort) involved in the creation of the image influences our response; part of the criticism once levelled at 'sketchiness' in art was derived from a puritanical rebuke of a labour insufficiently painstaking, while a highly detailed painting still inspires admiration for the artist's patience. We cannot admire a

6.8
Fredda bringing Ann and Me a Cup of Tea, April 16, 1983, 1983

photograph in the same way; at the most we can admire the patience which waited for Cartier-Bresson's 'decisive moment', for an image which a reflex captured in an instant, an instant which is so much shorter than the time it takes to view the photograph.

A Bigger Splash (Figure 2.7) consciously plays on this contrast:

I loved the idea of painting this thing that lasts for two seconds; it takes me two weeks to paint this event that lasts for two seconds... everybody knows a splash can't be frozen in time, it doesn't exist, so when you see it like that in a painting it's even more striking than in a photograph, because you know a photograph took a second to take, or less. In fact if it's a splash and there's no blur in it, you know it took a sixtieth of a second, less time than the splash existed for. The painting took much longer to make than the splash existed for, so it has a very different effect on the viewer. (Hockney 1976: 124-5)

The splash – which 'doesn't exist' because it is only motion, a pure duration – represents an extreme case of a movement in the subject for which a static fiction is found; the movement is the subject, together with the stillness that describes it. With its 'Polaroid' border and references to abstraction, *A Bigger Splash* is the most complex, most successful and (incidentally) the least theatrical of Hockney's meditations on the problems and possibilities of representational art.

However, a painted description generally derives from a period of observation of a subject which is either inanimate or posing. Although photography does not distort, it does replace the extended effort of looking with a casual act of possession.

Hockney, then, seeks to select, to discriminate, to describe as a painter does, to add layers of time to the photographic moment. His joiners obviously take time to assemble. (Many of the Polaroid portraits took 'four or five hours' to make (Hockney 1985: 16); a time scale closer to a drawing than a painting.[1] Unlike a drawing, however, the activity was split into two phases. In the second of these, the arrangement of the individual prints, Hockney was a collagist looking at the photographs and not his model, at his material and not the world he was describing). They also delay, complicate the way in which the image is 'read', the eye takes in an impression of a single coherent image at first glance, but must then explore the complexities with which it is assembled, the felicities of expression which one expects to seek out and find in a painting but not in a photograph. Hockney has managed to fictionalise the photographic moment.

In the joiners, photography's major and unique glory, its capacity to seize the decisive moment is lost; there could be no collage of a (single) splash. Hockney's interest is not in the moment, but in movement; in process. Marey's chronophotographs, which influenced the Futurists as well as the Duchamp of *Nude Descending a Staircase*, spread the stages of an action across the surface of a single print. The influence of Muybridge on artists has proved longer-lasting. Hockney himself bought *The Human Figure in Motion* at the beginning of his career and used it, for example, in his illustrations for the *Oxford Illustrated Bible* in 1966 as well as in a painting of 1963, inspired by the title it borrowed, *Seated Woman Drinking Tea, Being Served by Standing Companion* (Figure 2.4).

Muybridge relied on a sequence of photographs to describe his subjects, each frame conceived as a contribution to an understanding of the movement derived from the sequence as a whole. Hockney's collages achieve a synthesis of the two approaches, combining individual prints to create an impression of a single image. We move from frame to frame, but freely; no logic of succession is enforced. (This is true even in *Walking in the Zen Garden*. The decorative effect turns sequence into pattern, the frieze of red and black socks presenting a movement which is simple enough to be immediately understood as a whole).

In Hockney's photographs movement serves, even suggests his subjects, but is never the exclusive interest. It is rather an enabling device which re-presents domestic and working life, as the snapshot does. We are charmed by the portraits of children who fidget in their poses, amused comments on the way models are expected to surrender temporality, to mimic the static image for which they pose. More complex are the collages which show (not actions but) activities; games, conversations. Celia does not only sit between her two sons (Plate 14), she also turns from one to the other; her hand is on her chin in a gesture of attention, and at the same time it reaches out to affectionately ruffle Albert's hair. The effect, inspired perhaps by a late Picasso such as *Sleeper Turning* (1960), which shows a woman sleeping at once on her left and on her right side, is very different from Bacon's two-profiled head of Dyer in *Portrait of George Dyer and Lucien Freud* (1967), a violent, active blur (which, unlike the effects of the joiners, a single photograph could easily achieve).

There is no sense of suddenness or strain in Hockney's works, which present temporal elements with unprecedented ease, perhaps because he does not get excited about energy, about movement in itself (in contrast to the Futurists), but rather uses time as a *psychological* device. Time, in a portrait, is a way of getting a likeness. In *Luncheon at the British Embassy* (Figure 5.13), for example, Hockney expressed the confidence of a fellow guest's manner by showing him leaning on his own shoulder, a friend to himself. Such doubled, trebled images – far more fragmentary than the portrait of Celia, though hardly more so than that of her son George – remain as unities. Even when the heads pile up on top of one another, as in *Christopher Isherwood Talking to Bob Holman, Santa Monica, March 14 1983* (1983), 'you believe it's one', as Hockney wrote to Mark Haworth-Booth (Haworth-Booth 1983: 30); and to an extent which was surely unpredictable when the process of trial and error began.

For the most part, then, the activities shown in the portrait joiners are (so to speak) present participle activities, such as talking, eating, looking out of a window, playing Scrabble, doing a crossword; activities whose temporal element has never been so well expressed. The figures do not cross the space they energise; they move within an activity, a pose. If there is no way of decid-ing a fixed sequence or priority amongst the alternative expressions and shifts in positions, there is also no need to look for such sequences. (Similarly, in genre painting the pose does not need to carry a sense of previous and future actions, the narrative load which a figure in a history painting might bear.)

Furthermore, the layer of time in a joiner may be restricted to the time the artist – and then the viewer – spends in looking. The joiners, then, look back to the paintings of Cézanne, the Cubists and Delaunay. The massive *The Brooklyn Bridge*, which forces the viewers to raise their head, not just their glance, so that they look up and down the image as they would look at the bridge itself, is Hockney's equivalent of and homage to Delaunay's 'Eiffel Tower' paintings, which record the journey of the eye from street level, up the facades of buildings, to the tower itself. The joiners also look back to Hockney's own, painted solutions to temporal problems; the gaps recall the absences in the 'Domestic Scenes', the emphasis on the selectivity of vision. *Steering Wheel, October 1982* (1982), for example, shows only the driver's priorites – the road ahead, his mirror, and the wheel itself, with the dashboard's dials and switches behind it. (The feet, seen through the wheel, are on the pedals, and belong to the image for once.)

However, while exploring the possibilities of his new technique Hockney has attempted to represent more complex actions. *Gregory Swimming, Los Angeles, March 31st 1982*, a Polaroid collage of 1982, retained its unity by means of formal devices – the structure of the grid and the use of continuous and indistinguishable elements such as light, water and the blueness of the bottom of the pool – but also by repcating the figure of Gregory in a circular movement around the pool which lacks either a beginning or an end. The figure moves across space, it has direction, but it lacks sequence. *Photographing Annie Leibovitz While She Photographs Me* is one of the most complex of Hockney's photographs. Its construction teases both spatial and temporal unities. The footsteps which lead through the snow from Leibovitz as she stands beside her car bring us to a point most easily related to Hockney's own position as photographer. From here we see Leibovitz once more, this time preparing the huge lamp whose four (drawn) light rays shine on to Hockney in the photograph which Leibovitz is shown setting up. Tensions are established between where Hockney is – outside the action, beside the viewer, behind his lens – and where he is shown to be; and between the moments of Hockney's photographs and the moment of Leibovitz's photograph. (Despite the characteristically self-referential title, neither Leibovitz nor Hockney is shown actually holding a camera; although the final portrait does not reveal or incorporate the time it took to set it up, Leibovitz's single print required perhaps as much time, and certainly a great deal more equipment, to produce than did Hockney's joiner. It is this invisible layer of time which the joiner enjoys and reveals.)

The Hawaiian Wedding, May 1983 (1983), one of the most ambitious of Hockney's photographic works in scale and organisation, reads from left to right. Centred on the moment when the groom puts the ring on the bride's finger, it divides into a wedding album sequence of scenes before and after the ceremony. The space is entirely organised by the narrative, the couple appearing at different stages of the day like saints performing several miracles within a single Renaissance panel. In *Fredda bringing Ann and Me a Cup of Tea*, Hockney achieves an almost unprecedented description of time in a spatial art,

moving from the 'and' which links the poses in the earlier works to 'and then'. The work shows a temporal subject which would be commonplace, banal in a temporal art. Fredda is shown descending a flight of steps holding a cup of tea; she takes one cup to Ann and then approaches Hockney (and the viewer). The subject is represented in spatial terms, with visual priorities and advantages – she was there, she is here. But the eye can still wander from the action to a detail in the background and return to it, having missed nothing. The joiner's time is fixed, but not frozen. When Hockney made a film joiner in 1983 for London Weekend Television[2] the experiment was unsuccessful. Like free-standing Cubist sculpture, the film at once followed on quite naturally from previous work and, by operating in the dimension whose absence had provided the inspirational problem of that work, lacked both intent and purpose.

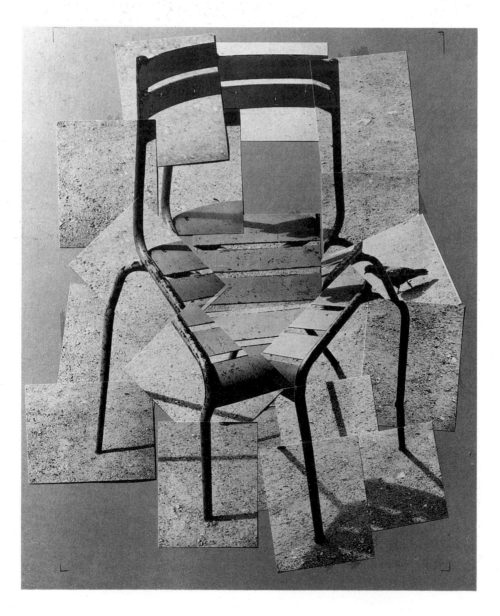

6.9
Chair, Jardin du Luxembourg, Paris, 10th August, 1985, 1985

Hockney's achievement derives from criticisms of photography which are unsympathetic to, or merely uninterested in, the advantages of photography's limitations, the discipline and challenge of the unrepeatable instant which is either captured or lost. The banality of photography is a snap-shot banality; and he has not quite escaped it. It is a banality of subject matter (photography has the power to astonish which he does not invoke); a banality of surface, of texture, or colour (he relies on automatic – in the Polaroids – and commercial printing processes).

On close inspection, the rewards which a drawing or painting offers are not there. The individual photographs, blurred, over-exposed, poorly focussed at times, inclusive of accident, are only photographs. The whole describes – which is Hockney's great achievement – but the detail still records. If one looks as long and as hard as one would look at a painting, the attention and respect paid to the work is cheated by a lack, a substitution. There is a mechanical collision of chemicals and light where the nervous breath of line or brushstroke ought to be. The details of the joiners, unlike the details of the average snapshot, are all noticed, chosen, but they are still not described. (Compare the Polaroids of pools with the wonderful *Paper Pools* of 1978, in which every nuance of light, surface, 'wetness' demanded and was awarded a fresh metaphor.) The weakness of Hockney's photographs is a weakness he has already denounced.

Predictably, the lessons Hockney learnt from his work with the camera were to inform his practice as a draughtsman, printmaker and painter between 1984 and 1985. Yet he also continued to be preoccupied with photo-collage during the mid-eighties. In the December 1985-January 1986 edition of French *Vogue*, he published, alongside paintings and prints, a number of photo-collages including *The Desk, July 1st, 1984* (1984), *Place Fürstenberg, Paris, August 7, 8, 9, 1985* (Figure 6.1) and *Chair, Jardin du Luxembourg, Paris, 10th August, 1985* (Figure 6.9).

In these later works, two strategies are adopted which distinguish them from his earlier collages. One, used in *The Desk* and *Chair, Jardin du Luxembourg*, is 'reverse perspective', referred to but hardly explained in a confused couple of pages in *That's the way I see it*, the second volume of his autobiography (Hockney 1993: 100-1).[3] These photo-collages led, via lithographs such as *Two Pembroke Studio Chairs* (Figure 6.10), to his 1988 painted versions of Van Gogh's chairs. He explains the ambition of the pictures in his autobiography: 'Because of the many viewpoints in these pictures, the eye is forced to move all the time. When the perspective moves, the eye moves, and as the eye moves through time you begin to convert time into space. As you move, the shapes of the chairs change and the straight lines of the floor also seem to move in different ways.' (Hockney 1993: 120)

The massive *A Walk around the Hotel Courtyard, Acatlán* (Figure 6.11), is the most conclusive breakthrough into a distinct painter's language with which to deal with the ideas derived from photography (and inspired, also, by Chinese scrolls).[4] Earlier works such as *Gregory Sleeping*, with its joiner-like use of different canvases and a multiplied profile, can be understood in relation to the joiners, but are unpersuasive as paintings. Nor need one be committed to a naive view of photographic realism to find the photograph of Hockney on the cover of *That's the way I see it* (Figure 6.12) closer to one's sense of him than the five related self-portrait canvases of 1984 before which he stands. The eye does not deduce and create from them the unities it finds either in the photo-collages or the Picassos (the 1932 *Femme couchée*, for example) which were so important to Hockney's rethinking of realism.

6.11
A Walk around the Hotel Courtyard, Acatlán, 1985

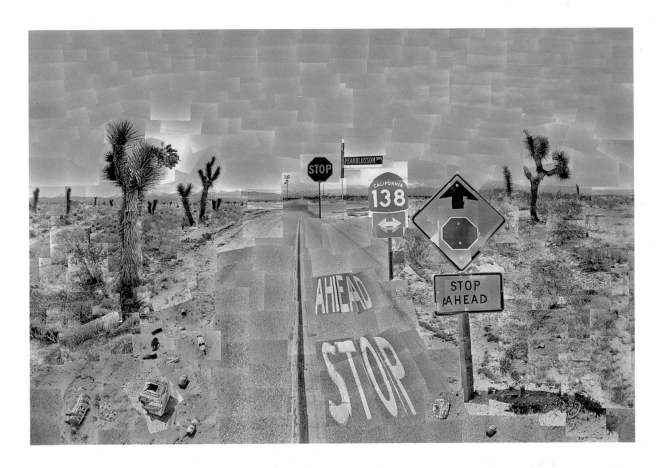

Pearblossom Hwy., 11-18th
April 1986, no. 2, 1986

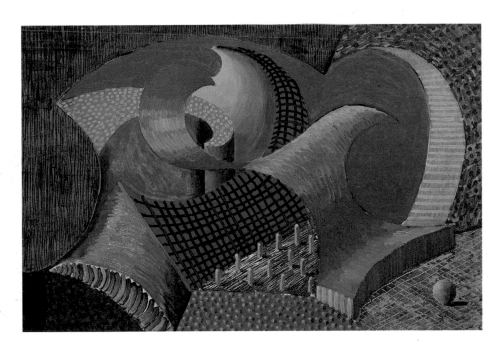

The Eleventh V. N. Painting,
1992

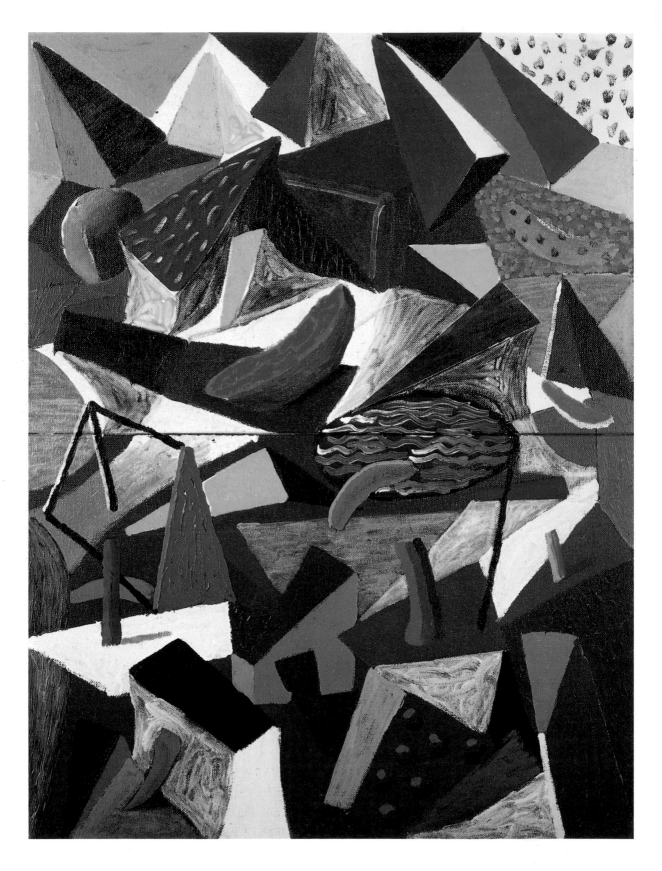

PLATE 17

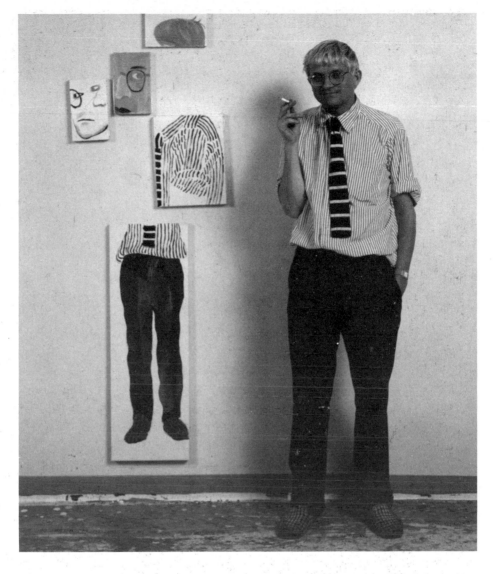

6.12 Jim McHugh
Photograph of the artist
with *Self-Portrait*, 1984

*[facing] Big Landscape
(Medium Size)*, 1988

There are theoretical problems with Hockney's neo-Cubism. He too readily relates photography and Renaissance painting, for example. Although he acknowledges that Renaissance painters 'always suspected the rigid rules of perspective and bent them – as all good painters would' (Hockney 1993: 125), he treats the tradition as realist, rather than idealist, and does not mention how commonplace it was to include a whole series of different vanishing points for narrative ends. A critique of photography can never properly bleed into or amount to a critique of Western painting, since the classic demonstrations of perspective, such as Brunelleschi's, were hardly ever used as models for actual works. Hockney's early work, with its endless plays on style, convention and artificiality, is in many ways closer to the heroic period of Cubism than is his neo-Cubism.

The second strategy that distinguishes the photo-collages of the mid-eighties from the earlier ones is his use of an emphatic, almost diagrammatic,

vanishing point as a framework for an image which then allows our eye to wander over details. *Place Fürstenberg* and his final, magnificent photo-collage, *Pearblossom Hwy., 11th-18th April 1986, no. 2* (Plate 15) are stunning and expansive explorations which widen the boundaries of photography, drawing on our sense of the real in photography as well as questioning it. (The full titles invite us to contrast the fraction of a second recorded in each photograph with the three or eight days over which they were taken.) Rather than challenging any painterly realist tradition, however, they triumphantly bring to photography's perspective spaces, the temporal complexities which perspective painting had always involved.

It is clear from his recent writings and interviews that there are other aspects to Hockney's developing critique of, and interest in photography. One strand of the argument is clearly related to his endless plays with surface and content, flatness and pictorial space. Much of his *œuvre* can be read as a painted commentary on Greenberg; and it is a curiosity of his essay of 1981, *Looking at Pictures in a Book* that he proposes, with a positively Goldbergian false rigour, that

the best use for photography, the *best* use for it, is photographing other pictures. It is the only time it can be true to its medium, in the sense that it's real. This is the only way that you can take a photograph that could be described as having a strong illusion of reality. Because on the flat surface of the photograph is simply reproduced another flat surface – a painting. In any other photograph it's not reproducing a flat surface. (Hockney 1993: 90.)

This is the sort of argument which, when applied to painting, has had Hockney and Kitaj up in arms for years. It is about as sensible as suggesting that to be true to their medium, or to create true illusions, water colours should only be used to paint water. It also fits uneasily with what Hockney says elsewhere about surfaces, which can never be flat (for example, see Hockney 1993: 103). But it led to a creative exploration, throughout the late eighties and early nineties, of such post-photographic processes as photocopiers, fax machines, and computer generated images. *112 L.A. Visitors*, the Uglow-like composite portraits of 1990-91 taken with a video stills camera which uses no film, are the closest in spirit, and appearance, to the joiners.

Photography is increasingly losing that sense of its being a 'trace' which has for so long given it so complex a relation to the real. Computer technology is bringing us closer to a point where the boundaries between 'painting' and 'photography' (we will need new terms) are as impossibly blurred, as Richard Hamilton has long since claimed. Hockney is aware of this, and exploring it. Gallery photography, meanwhile, has been radically changed by the practices of artists using photography who would not describe themselves as photographers, and the monotony of scale to which Hockney referred has long since disappeared.

There are things which Hockney says about traditional 'fine art' photography which are clumsy, even ill-informed. (This is one drawback of the taped,

conversational nature of his books. When he tries to develop arguments, he seldom gets beyond assertions. This does not matter if his statements relate only to his own work, but his desire to do more requires the disciplines of prose.) In the history of photography as a whole, in which photo-journalism plays a prominent part, the notion of an 'original' is complex. At times, it is meaningless, an imported fine art term. But Hockney has claimed: 'Any ordinary photograph can be copied ... A good technician could take a superb copy of an Ansel Adams, say one of the very beautiful black-and-white prints of Yosemite, with a plate camera, and you would hardly know the difference. This, of course, is not possible with my photo-pieces because they are collages of photographs and collage acknowledges surface, it is a physical thing, and therefore you cannot just duplicate it – it would not be the same' (Hockney 1993: 105-6). It was Ansel Adams who compared a photographic negative to a musical score. Hockney's argument is no more accurate than would be a claim that any two performances of a piece of music, indistinguishable to the uninformed listener who only recognises Vivaldi, are as near alike as makes no difference. There are photographers for whom the individual print is as unique, as irreproducible without loss, as any painting, and Adams was one of them.

One difficulty about considering photography is that almost all of us use it. It is as if one was asked to generalise about the use of words; for the relations of gallery photography to other professional and amateur photographies are as various as those between poetry, prose and speech. Hockney, as befits a great populariser, has perhaps changed the ways we might look at snapshot photographs rather than the ways in which we might view photography as an art. He was an artist who used photography, not as an art, but partly as an aid to his painting and also largely as most people use it – unaesthetically – and brought into that usage a painter's curiosity, self-consciousness and consciousness, so that in the end photography became a part of his art.

Notes

This is a revised and updated version of my article 'Hockney's photographs', published in the summer 1985 issue of *Critical Quarterly*. Many of the early photo-collages referred to but not reproduced can be found in Hockney 1984.

1
Drawing with a Camera was the title of the André Emmerich Gallery's June–July 1982 exhibition of Hockney's Polaroid collages.

2
See *Portrait of an Artist, Volume 12: David Hockney*, directed by Don Featherstone, broadcast in the United Kingdom on 13 Nov 1983 by London Weekend Television. This film also shows Hockney making the photo-collage *Fredda bringing Ann and Me a Cup of Tea*.

3
Lawrence Weschler's 1987 interview with Hockney (Tuchman 1988: 77–98) gives a far better account of both reverse perspective and Hockney's explorations of time and space at this period.

4
In 1987, Hockney and Philip Haas made *A Day on the Grand Canal with The Emperor of China or Surface is illusion but so is depth*, a documentary film on an eighteenth-century Chinese scroll painting. It was broadcast in the United Kingdom on 21 Mar. 1988 by London Weekend Television.

7

Novelties: the 1990s

WILLIAM HARDIE

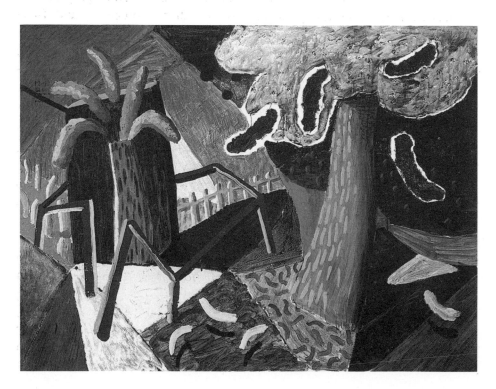

7.1
The Railing, 1990

Le propre du classicisme est de venir après. (Paul Valéry)

All the work I have done in the theatre has been useful to me and I have never regretted any of the time spent on it. What is most important is using real space. You begin to think spatially much more. (David Hockney 1993: 71)

I've been attempting to alter pictorial perspective simply because I knew you could alter it. I tried to do it in photography and did succeed and found it was possible there, you could use collage. (David Hockney, Hardie 1993)

To some who acknowledge the classic stature of Hockney's early work and its beauties of technique and imagery, the artist's involvement in recent years with a bewildering array of disciplines and procedures has sometimes seemed at best a distraction, at worst an aberration. But the evident relish with which he has conducted his interventions in stage design and photography, decisively altering our perception of their possibilities, and his fascination with new technology,[1] should not disguise the seriousness of Hockney's aims. 'Nothing I do is a sideline, if I decide to do it ... it's not a sideline, I actually get into it and explore it myself' (Hardie 1993). *Explore* is the *mot juste*; his work is exploratory rather than experimental. Hockney approaches an unfamiliar medium purposefully, not only with an extraordinary sensitivity to its inherent properties and therefore its possibilities, but also with the ability to wrest from it whatever may help him resolve tensions in his own work. Anyone who doubts this should read the extraordinary story of his creation of the *Paper Pools* (Hockney 1980). He invariably emerges from these explorations refreshed and further equipped to return to the easel.

Since 1988, the year of the retrospective exhibition organised by the Los Angeles County Museum which opened there in February, Hockney's output has been prodigious, even by his standards, in terms of its scope and invention. A summary may be useful at this point. Characteristically, Hockney returned to painting immediately after completing work on the models for *Tristan and Isolde*[2] in 1987 and painted a group of still lifes, 'putting them on a colour background and making a space with them' (Hockney 1993: 180). These were the most recent works shown in the Los Angeles exhibition, but by the time of the Tate Gallery showing in London at the end of 1988 Hockney was able to add a further group of new works, including *Large Interior, Los Angeles*, 'exploring spatial ideas of perspective' (Hockney 1993: 180), and *My Mother, Bridlington*, one of a group of some thirty-six bust portraits of the artist's friends and family painted in 1988-89. A series of landscape and seascape paintings were also painted then. Panoramic views of the Santa Monica Mountains or the distant

city of Los Angeles seen from the Hollywood Hills alternate with the closer and more intimate perspectives from Hockney's beach house at Malibu, where a tiny studio is connected to the back of the house by a miniature funicular. Here were painted the seascapes some of which, laser-copied and collaged, were then transmitted to friends and museums worldwide by fax from what Hockney was pleased to call 'The Hollywood Sea Picture Supply Co.'. His contribution to the Sao Paulo Biennale of 1989 was entirely sent by fax. The 144-sheet *Tennis*, sent to 1853 Gallery, Saltaire, may be seen there in a large frame decorated by the artist. The last of the series of about 114 fax pictures, was a 288-page fax, again a sea picture.[3]

In conscious contrast to such hi-tech activity, Hockney, during excursions to his sister's comfortable house at Bridlington where his mother lives, was also painting flower still lifes: not 'cut flowers, which fade', but 'living plants potted in earth' (Brown 1991). The faxes led directly to a new group of sixteen paintings exhibited in New York at the end of 1990.[4] Work was begun in September 1990 on *Turandot*, which Hockney has said 'was the only Puccini opera I would do because it is not *verismo*, there is some fantasy in it' (Hockney 1993: 215), for the San Francisco Opera and the Lyric Opera of Chicago, and finished by March 1991. Hockney then began another series of oil paintings 'that looked like abstractions, but are concerned with space as subject matter' (Hockney 1993: 218).[5] This series came to an end in September 1991 when the artist had to begin design work for *Die Frau ohne Schatten* for Covent Garden, which he finished in April 1992.

Hockney immediately left the big studio in the Hollywood Hills for the beach house and commenced yet another series of paintings, since called 'V.N.' (very new) paintings, which were first shown in New York in January 1993 (Plates 16, 18, 19).[6] Since then he has completed a suite of six colour lithographs (one of them in four panels) which were published in February 1994 and further portraits of his friends. As of May 1994 he is currently engaged on a group of works in gouache and further portraits of his friends in charcoal.

The importance of David Hockney's *Very New Paintings* of 1992-93 is that they are a summation of themes that have engaged him over the last three decades. They also represent the culmination of a search for a language appropriate to these themes: a search in which the portraits, the faxes, and the opera designs – especially those for *Die Frau ohne Schatten* – have all played their part. The *Very New Paintings* reflect many of his abiding as well as his more recent concerns as an artist while also suggesting possibilities for the future. Deriving from Hockney's multi-disciplinary, or inter-disciplinary approach, the new paintings, though predominantly landscapes, retain vestiges of his work in the theatre and in photography, in fax and in copier-printing but they hint at potential developments in areas other than pure painting, such as sculpture or film.[7] His belief in the redemptive power of art and in art's duty to communicate parallels the suggestions of human love and communication present in the new works. The artist's *métier* is at one with the content of his work.

Produced immediately after his designs for *Die Frau ohne Schatten*[8] and before the publication of the second volume of his autobiography, the *Very New Paintings* were immediately followed by a group of related colour lithographic prints 'carrying on the ideas using printing as a medium'.[9] The creation of the original work of art goes hand in hand with publication, dissemination, communication. Hockney's friend, the master printer Ken Tyler, has called the *Very New Paintings* 'narrative abstractions'. One might think these two words to be the antithesis of each other and anathema to Hockney's own predilections (he has campaigned against 'pointless abstraction', and narrative art has a Victorian ring to any child of the 1960s). But the term aptly emphasises the artist's desire in these sophisticated works to hold his audience's attention. And, as Hockney himself has recently said, 'There aren't two things like abstraction and representation, each must contain the other' (Hardie 1993).

French influences

Hockney has long admired the protean genius of Picasso – 'He is even in the Guinness Book of Records – not even a hack has painted more!' (Hockney 1993: 117). The Zervos catalogue of which he acquired the last ten volumes in 1978 revealed to Hockney how Picasso worked in series. Today Hockney's career has lasted about half the span of Picasso's, and his work is unusually well documented. To this David Hockney, who has a way with words, has of course been a major contributor as writer and commentator. He has recently remarked on the transitoriness of reputations and the very low survival rate of works of art in posterity's esteem but his conjecture that his life's work will be remembered through books should not be construed as a very English-seeming tribute to the primacy of the written word. The Hockney bibliography, with its vivid texts by the artist, remains essentially visual and constitutes a faithful record of the workings of an acute visual intelligence. That he too works in series – 'Love' paintings, 'Water' paintings, 'Curtain' paintings, 'Pool' paintings, double portraits, the printed suites ranging from the etched *A Rake's Progress* of 1961-63 to the colour lithographs of 1993 – has long been evident. What becomes clearer with time is the extent to which the succession of thematic or stylistic concerns link with each other.

The creative influence of Picasso has been a *leitmotiv* since at least as early as 1976. In that year, having read at Henry Geldzahler's suggestion the poem 'The Man with the Blue Guitar' by Wallace Stevens, Hockney made ten drawings in coloured crayons interpreting the poem. The drawings were soon amplified to twenty etchings, *The Blue Guitar*, 1977, which showed the influence of Picasso – whose *The Old Guitarist* of 1903 had been the inspiration for Stevens's poem – and of Hockney's own graphic *tour-de-force* of the previous year, his theatre designs for *The Rake's Progress* (Figure 7.2). Hockney also followed in Picasso's footsteps when he was asked to design *Parade* in a triple bill for the Metropolitan Opera House in 1981. Hockney drew on Picasso's analytical

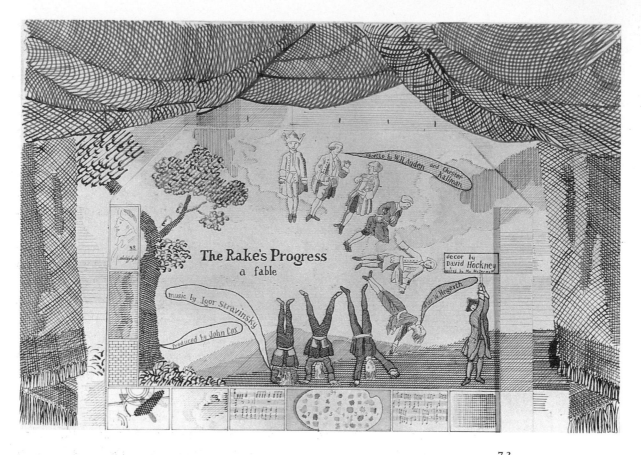

7.2
'Drop Curtain' for *The Rake's Progress*, 1975

Cubist work for the Polaroid collages of 1982 and the 35mm 'joiners' made between 1982 and 1986 brilliantly apply the lessons of analytical Cubism to photography.[10] Unlike Renaissance or photographic perspective which implies a single fixed viewpoint, the reverse perspective principle, as rediscovered by Cubism, suggests that the viewer is in movement and hence implies time. Referring to his own representational style of the early seventies, Hockney has said, 'I couldn't play in that space – the one-point perspective was terribly constricting – and it's only by playing with the space in the years since then that I've been able to make it clearer. Everything since than has been a progression towards a playful space that moves about but is still clear'. The dialogue with Picasso has been vigorously resumed in Hockney's paintings of the 1990s. It was his astonished first reaction to Picasso's sovereign mastery of style that led in 1961-62 to the youthful *tour-de-force* of the four *Demonstrations of Versatility*.[11] Hockney has recently suggested that the *Very New Paintings* could equally well be titled *Demonstrations of Versatility* (Hockney 1993: 233).[12]

Among modern masters, Picasso remains the dominant influence on Hockney because of his treatment of space, but Matisse, Dufy and Dubuffet have affected other aspects of his work. Dubuffet's early influence was the most directly contemporary; in adopting a Dubuffet-like 'primitive' automatism in the 'Love' paintings, Hockney was being determinedly modern. Matisse's

colour and economy of line and the 'beautiful marks' of Dufy inform Hockney's work from about 1980, and it is fascinating to observe that the work of all three French artists is highly relevant to the *Very New Paintings*. The drawing in these paintings has a strongly 'automatic' character, their *alla prima* application is balletic in its poise like Dufy's, and some of the *Very New Paintings* resemble nothing so much as *papiers collés à la* Matisse raised to the third dimension (see Plate 16). The stylistic changes, including some of the borrowings indicated here, are the servants, clearly, of changes of theme and of meaning.

Thematically, in terms of the content of Hockney's work, the changes have been radical and dramatic. Yet there are important links connecting early with recent work. In *A Bigger Splash* (1967) (Figure 2.7) the forms assumed by the water are a function of its movement in time, which Hockney contrasts with the studied banality of the static surroundings. Hockney is fascinated, in the paintings of the mid-sixties, by the illusoriness and ephemerality of water-forms – as splash, spray; as a sky-reflecting mirror; as ripples on a pool's surface or refracted on its floor; water as rain, or *Different Kinds of Water Pouring into a Swimming Pool, Santa Monica* (1965). Twenty years on, in the photo-collages, the faxes, and the *Very New Paintings*, time and space become central concerns, and the Pacific Ocean on Hockney's doorstep or the River of Life from his latest opera design are present as symbols of a timeless and infinite life force.

Again, the theme of human love unites Hockney's earliest work from his Royal College days in London to certain of the most recent Californian paintings which derive from the love themes of opera. The curtain motif of the 1960s reappears in the 1990s, each time proposing the work of art itself as a drama of spatial illusion. Yet again, what Hockney has called 'textual perspective' in the *Very New Paintings* derives immediately from the fax images which were their close precursors; both link back to the 'French marks' of the 1981 Triple Bill; and yet further back to the engraver's hatchings which provide the stylistic unity in *The Rake's Progress* (1975).[13] The marks are the message. The textured finish specified for the sails in *Tristan* in order to draw the eyes of the audience evolves, in Hockney's thinking, into the very deliberate changes of texture in the *Very New Paintings* which are there to lead the eye of the viewer from passage to passage of the painting.

Designing for the theatre

Hockney's method of designing for the opera stage is not to impose a set of preconceptions but rather to allow the meaning of the music to determine the visual effects intended, as he has said, to 'help' the production (Hardie 1993). There is an organic continuity to the creative sequence: out of a deep knowledge of the music, the designs are realised, and they in turn provide further stimulus to the artist's work as a painter. The painting of 1975, *Kerby (after Hogarth) Useful Knowledge* (Figure 7.3) is the first indication that his practice as a painter would be affected by his work for the theatre, in this case *The Rake's Progress*. It

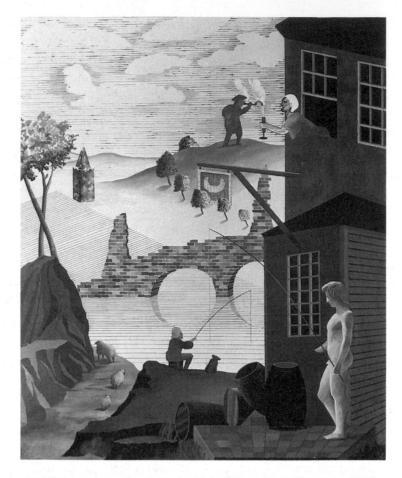

7.3
Kerby (After Hogarth)
Useful Knowledge, 1975

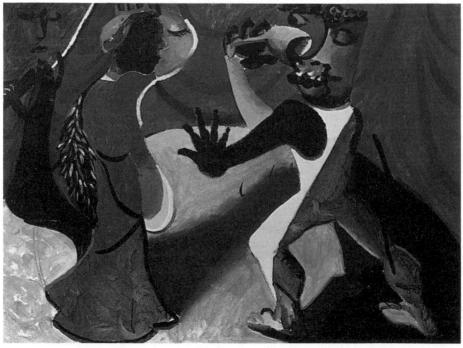

7.4
The Love Potion, 1987

is a free adaptation of Hogarth's frontispiece to *Dr. Brook Taylor's Methods of Perspective* – published by Joshua Kirby, 1754. Although Hogarth's engraving was used to illustrate the mistakes that could result from a false understanding of perspective, Hockney thought that the 'ghastly errors ... created space just as well, if not better, than the correct perspective he was praising' (Hockney 1993: 31). Among the 'errors' demonstrated by Hogarth is a spectacular example of reverse perspective.

The fascinating story of the immensely fruitful interaction between Hockney's theatre design and his painting is well told elsewhere (Friedman 1983): we note here only the increasing technical assurance which allows Hockney to progress from the quotation-laden polish of *The Magic Flute* designs (1978)[14] via the spontaneity and invention of the Dexter productions (1981)[15] to the satisfying unity of music-drama and colour-design in *Tristan* (1987). Silver (1988) has pointed out that these three stage works parallel the artist's concurrent preoccupations with perspective and light in *The Magic Flute*, collage and space in *Parade*, and themes of love and death and love-beyond-death suggested by colour as rich as Wagner's chromaticism, in *Tristan*.

Tristan inspired 'an odd little group' (Hockney 1993: 180) of paintings – *Tristan in the Light, Tristan looking for Shade, The Love Potion* (Figure 7.4), and several other canvases on the subject of *Tristan and Isolde* (all 1987) – created to 'picture the characters'. Tristan's question '*Hoer' ich das Licht?*' conveys a Wagnerian synaesthesis of music and vision which Hockney emulates in his

7.5
Hotel by the Sea, 6 July 1989

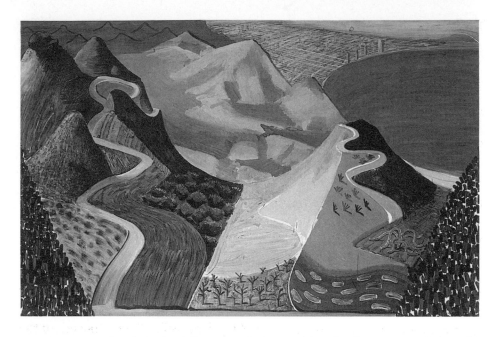

7.6
*Pacific Coast Highway and
Santa Monica*, 1990

recent opera-related works. These mark a transition in the nature of the rela-
tionship between Hockney's painting for the theatre and the work on the easel
in that the content of the opera itself and not just the forms to which it had
given rise – the draughtsman's contract of *The Rake*, the French marks of
Parade – flows back from the stage into the studio. This relationship was to
become ever closer with the two subsequent Hockney opera designs, for
Turandot and *Die Frau ohne Schatten*.

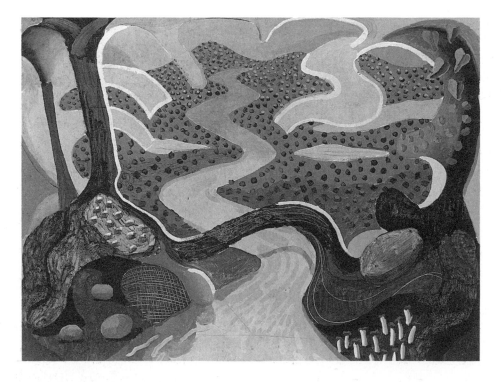

7.7
The Golden River, 1992–93

Landscape, perspective and space

An art aspiring to truth must concern itself with the nature of reality and the language in which that reality can be made intelligible. The relationships of surface, space and time have seemed to Hockney inadequately conveyed by conventional perspective, and it was inevitable that his preferred vehicle for the exercise of these notions should be the bigger theatre of landscape which, moreover, progresses from an outer to an inner landscape in his recent work.

The milestones on his road are clear. *Mulholland Drive: The Road to the Studio* (1980) (Plate 12) carries in it the seed of much of Hockney's subsequent landscape painting. It anticipates the discovery of Ching scroll painting in 1984 which so excited him. It has the appearance of an essay in Chinese landscape painting informed by the colour of Matisse, Seurat and Dufy. The vast horizontality of this very large work (it is over twenty feet wide) encourages the viewer to obey the verbal noun of the title: Drive. It is Hockney's first great attempt to break out of the straitjacket of one-point perspective and his own realist virtuosity, and to come to terms with the extraordinary landscape visible from his newly acquired house in the Hollywood Hills. There, indeed, in the painting is the sequence of familiar landmarks on the winding route to Santa Monica Boulevard: trees, pylons, knolls, tennis courts, and the vast grid of Los Angeles' suburbs to the north, far below.

It was a short step from the linearity of such an approach to landscape to the choreographed drives which the artist devised, setting an excursion through the Santa Monica Mountains to the music of Wagner. *A Walk around the Hotel*

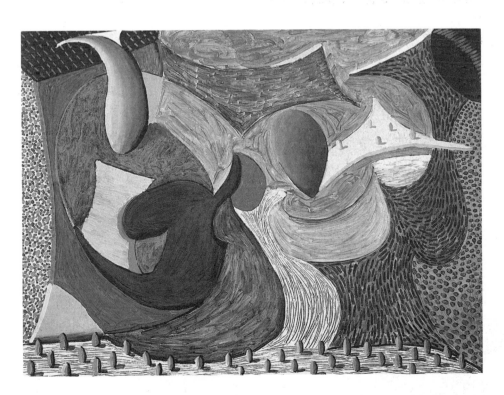

7.8
The Nineteenth V. N. Painting, 1992

Courtyard, Acatlán (1985) (Figure 6.11) takes an enclosed space as pretext for a perambulation by the reflective as well as the seeing eye: 'the spectator ... wanders in the space. You are a lonely figure. Aren't we all?' (Hockney 1993: 155). But if on one level this painting is a meditation on solitude by a single man beginning to experience deafness, a celebratory inner vision still triumphs in the harmonious forms and joyful colours of the work. The figure painting *The Love Potion* (1987) and the sequel, so to speak, to *Mulholland Drive, The Road to Malibu* (1988) develop a calligraphic sweep which frankly acknowledges the surface, so that we are conscious of the two-dimensionality of the composition which the eye follows through yet another dimension – time. The riot of form and texture in *Big Landscape (Medium Size)* (1988), similarly invites the eye to find its way through its tight spaces (Plate 17). *The Railing* (1990) (Figure 7.1) shows the further enrichment of texture suggested by fax textures (Figure 7.5) translated into terms of oil paint by means of *sgraffito*, *frottage*, different kinds of marks and different sizes of brush. The free style of the fax drawings as well as their surface textures also had an effect on Hockney's painting, and several of the works in oils closely follow them compositionally.

What I have called the calligraphic sweep of the work of 1987-88 is conspicuous in the fax images and is a feature of the design of *Turandot*, with its Chinese curlicues and S-scrolls. *Turandot* is, of course, predominantly an

7.9
The Twenty-sixth V. N. Painting, 1992

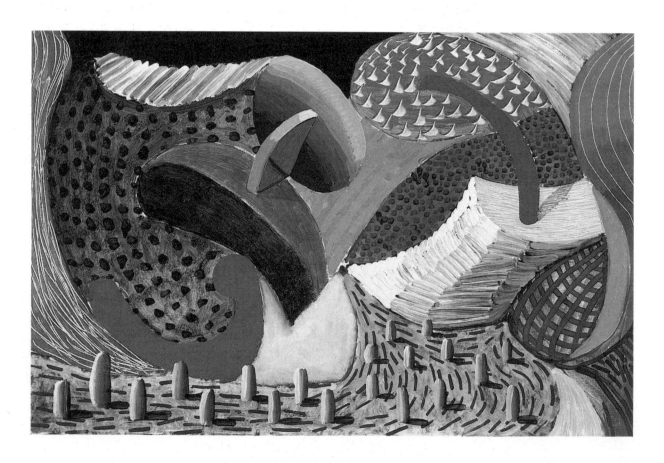

architectural as opposed to a landscape design. *Die Frau ohne Schatten* is set (with the exception of the Dyer's Cave) in a vast landscape and therefore sits more comfortably with the flow of Hockney's work of this recent period. For the landscape of the opera is Hockney's own landscape: *Pacific Coast Highway and Santa Monica* (1990) (Figure 7.6) resembles *The Golden River* (1992–93) (Figure 7.7) from *Die Frau ohne Schatten*.

Other landscapes from the exhibition 'Things Recent' show Hockney grappling with the majestic scenery of the Santa Monica Mountains. In contrast, the paintings shown in Chicago in the following year frequently look in the opposite direction, to the ocean on Hockney's doorstep at Malibu. Certain ciphers begin to appear in them: the grid which had earlier signified Los Angeles, little shrubs which cast shadows on distant hilltops, the presence of a rocky shore. Thus the paintings of the last three or four years synthesise three elements: the free flowing draughtsmanship of the faxes; a sense of surface and texture; and the increasing subjectivity of Hockney's approach to landscape, which finally becomes a vehicle for human themes of love and creativity which connect them to the opera.

A striking example of this is *The Thirteenth V. N. Painting* (Plate 18). This, like the fourth and eighth paintings in the series, might almost be a *Maternité*, a mother and child, because 'the shapes and tenderness of the links might suggest it' as the artist has commented (Hardie 1993). Motherhood, fertility and procreation are essential themes of *Die Frau ohne Schatten*, where they define humanity as opposed to the crystalline, shadowless, barren creatures of the spirit world. The ovoid dots of white in the upper left passage balance the spermatozoid black strokes to the right, and in the upper middle of the picture are golden shapes like corn stooks standing upright in the light, which causes them to cast shadows. It is difficult to imagine a richer metaphor for 'The Song of the Unborn Children' from the opera. The frequent use in these paintings too of passages of repeated textures or dots links with Hockney's fascination with the non-Euclidean geometry of fractional dimensions (called fractals) which use iteration like a computer to describe the self-similarity which occurs in the structures of nature.

The paintings exhibited in Chicago in early 1992 were on the walls of Hockney's large studio while he was working on *Die Frau ohne Schatten* during the remainder of that year, and their interest in textures and play on spatial ambiguity had an immediate bearing on the new stage designs, although 'The Golden River' in the opera derives ultimately from *Pacific Coast Highway and Santa Monica* of 1990, Hockney, as has become his custom, was visualising the design by means of 1:1.5 inch scale model of the stage and using a material called Foamcore for the models. In one instance, *Running Construction* (1991), he had tried the effects of gravity on running colour as a prototype of the design for 'The Dyer's Cave' scene. He tells us that he was 'totally absorbed by the opera' (Hardie 1993) but as soon as it was completed he left Hollywood for the small studio at Malibu where, still imbued with the immense piece of theatre

which had monopolised his attention for many months, he embarked on the *Very New Paintings*. It is possible to discern themes from the opera in them: the idea of The Unborn, of Mother and Child, of Emperor and Empress (*The Nineteenth* and *Twenty-Sixth V. N. Paintings* (Figures 7.8 and 7.9)), the Falcon (*The Fifteenth V. N. Painting*), the Bridge image from Hofmannsthal's libretto, are all present. Their presence is all suggestion, inference, subtlety. There is however no mystery about their immediate compositional origin.

The germ of *The First V.N. Painting* (Plate 19) and hence (at another remove) of the *Very New* series and of the six colour lithographs which followed them was a tiny drawing (Figure 7.10); similarly the gouaches on which Hockney is working at the time of writing stem from an idea which first saw the light as a little drawing. In these recent works, the composition drawing on the

7.10
Study for the First V. N. Painting, 1992

canvas is often free and lyrical, based in certain cases on a fax image,[16] while the apparent painterliness and immediacy of the application belies a high level of calculation. The individual passages in these works, indeed, frequently demonstrate the utmost refinement and inventiveness of handling. They are intended to delight the eye, and moreover to require it to linger on the painting as one lingers on a piece of music. That these works have become more abstracted in no way diminishes their life-celebrating content. What Hockney has described as the pleasure principle is today as firmly entrenched as it has ever been at the centre of his creative activity.

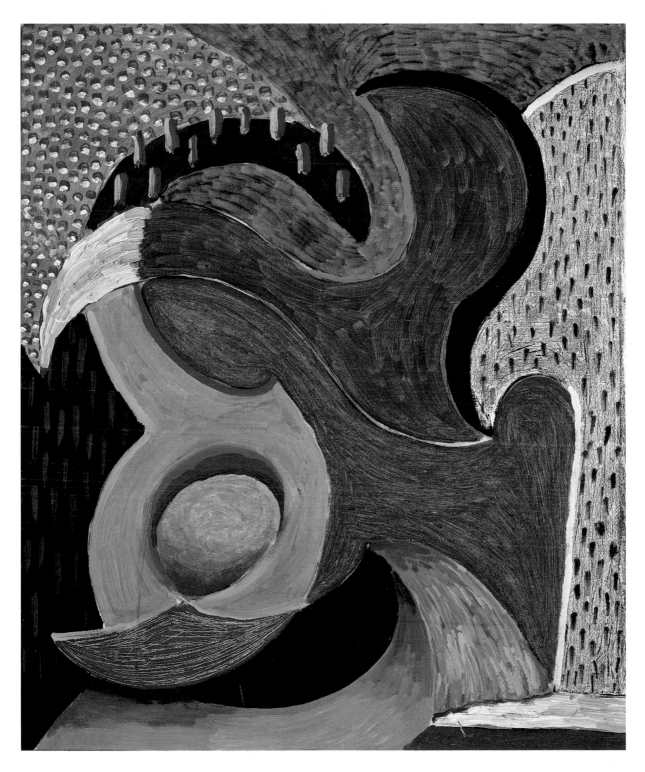

The Thirteenth
V. N. Painting, 1992

PLATE 18

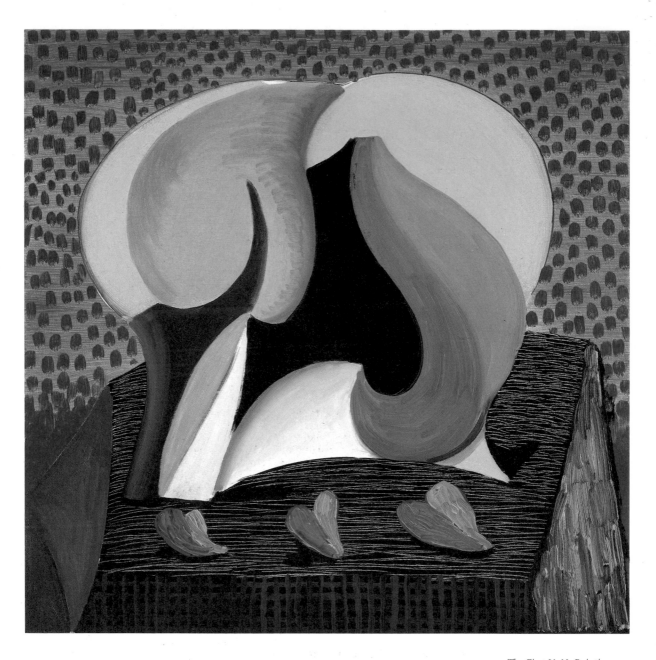

The First V. N. Painting,
1992

PLATE 19

Notes

1

For example, a Quantel Paintbox computer, an electronic still camera, a Canon colour copier and an Apple Mac computer with Oasis software.

2

Commissioned by Los Angeles Music Center.

3

The fax period lasted six months. See *David Hockney: Fax Cuadros*, exhibition catalogue, Mexico City, 1990.

4

David Hockney: Things recent and a Catalogue with new kinds of reproduction. André Emmerich gallery, 5 Dec. 1990-5 Jan. 1991.

5

David Hockney, Recent Pictures, Richard Gray Gallery, Chicago, 11 Jan.-Feb. 1992, 19 paintings.

6

David Hockney: Some Very New Paintings, André Emmerich Gallery, 7 Jan.-13 Feb. 1993, 26 paintings.

7

The *Very New Video View*, edited and overdubbed by Hockney with assistance from Bing McGilvray, was compiled by Hockney from two super-8 videotapes of a conversation between William Hardie and David Hockney, 1 May 1993.

8

Die Frau ohne Schatten by Richard Strauss, with libretto by Hugo von Hofmannsthal, produced by John Cox, conducted by Bernard Haitink, with sets by Hockney, was performed at Covent Garden in November 1992.

9

The colour lithographs, *Some New Prints*, made immediately after these paintings were published by Gemini Gallery, Los Angeles, February 1994.

10

Cf. the composite Polaroid works, *Henry Cleaning his Glasses* and *Yellow Guitar Still Life, Los Angeles, April 3 1982* illustrated in Tuchman (1988).

11

For example, see Larry Rivers and David Hockney, 'Beautiful or Interesting', *Art and Literature* 5, summer 1964 (pp. 94–117).

12

Hockney had of course seen the Picasso retrospective exhibition at the Tate gallery in 1960, and the 1973 Homage to Picasso in Avignon. A little painting by Picasso, *Reclining Nude and Man in Profile*, is the only major work by another painter in Hockney's own collection. Perhaps the earliest direct reference to Picasso in Hockney is *Three Chairs with a section of a Picasso mural* of 1970.

13

Hockney's analytical approach to texture is wittily announced from the outset of *The Rake*: on the overture curtain two passages from the musical score flank a palette which carries, not the usual painter's colours, but instead a whole repertoire of the different types of hatching which provide the *tessitura* of the design for the whole opera (See Figure 7.2). This was a brilliant intuition on Hockney's part. Stravinsky's manuscript scores were in reality often written with calligraphic precision in coloured inks.

14

The rocky landscape in Act I and Sarastro's realm in Act II Scene I are quotations from two very different masterpieces of perspective, Paolo Uccello's *St George* and the Herrenhausengarten at Hanover, while the great staircase at the Metropolitan Museum inspired Sarastro's Hall. K. F. Schinkel's 1816 design for the Hall of Stars also influenced Hockney. The artist employed at least two of his own earlier works as sources: his photograph of the colossal statue of King Rameses II at Memphis, and his etching 'The Start of the Spending Spree and the Door Opening for a Blonde' (1961-63) provide archeological fragments and the sunburst in the opera.

15

Parade, Les Mamelles de Tirésias, L'Enfant et les sortilèges, performed at the Metropolitan Opera House, New York, produced by John Dexter. This French triple bill was followed later the same year by a Stravinsky triple bill, also produced by Dexter at the Met.

16

The Mexico City fax catalogue (see n. 3 above) is not paginated. In that catalogue several of the fax images dated 21 Aug. 1990 relate closely to *The Twenty-Fourth V. N. Painting*. One of the faxes dated 16 Aug. 1990 is related to the most recent gouaches of 1994.

Bibliography

Tuchman (1988) contains an extensive bibliography on the artist. A more comprehensive bibliography is available for consultation in the library of the Tate Gallery, London.

Aitken, J. (1967), *The Young Meteors*, London, Secker and Warburg.

Aldrich, R. (1993), *The Seduction of the Mediterranean: Writing, Art and Homosexual Fantasy*, London, Routledge.

Bailey, D. (1965), *David Bailey's Box of Pin-ups*, London, Macdonald.

Banham, R. (1971), *Los Angeles: The Architecture of Four Ecologies*, London, The Penguin Press.

Beaton, C. (1978), *Cecil Beaton's Diaries: 1963-74, The Parting Years*, London, Weidenfeld and Nicolson.

Booker, C. (1969), *The Neophiliacs: The Revolution in English Life in the Fifties and Sixties*, London, Collins.

Brett, G. (1963), David Hockney: A Note in Progress, *London Magazine* 3: 73-5.

Brown, J. (1991), Hockney: Nietzche and Nature in Paris, *Spectrum*, 8 Dec.

Clark, D. L. (1983), Los Angeles: Improbable Los Angeles, in R. M. Bernard and R. R. Bradley (eds.), *Sunbelt Cities: Politics and Growth since World War II*, Austin, University of Texas Press.

Cooper, E. (1986), *The Sexual Perspective: Homosexuality and art in the last 100 Years in the West*, London, Routledge and Kegan Paul.

Cork, R. (1970), Hockney, Sixties Swinger on the Edge of Greatness, *Evening Standard*, 14 April.

Culler, J. (1981), Semiotics of Tourism, *American Journal of Semiotics* 1: 1-2.

Davie, M. (ed.) (1976), *Diaries of Evelyn Waugh*, London, Weidenfeld and Nicolson.

Davies, H. (1966), Pop Artist Pops Off, *The Sunday Times*, 9 January.

Davis, M. (1990), *City of Quartz: Excavating the Future in Los Angeles*, London, Verso.

Dyer, R. (1983), Coming to Terms, *Jump Cut* 30.

Dynes, W. R. (ed.) (1990), *Encyclopedia of Homosexuality*, London, St James Press. (Entries on Los Angeles, travel and exploration.)

Ferris, P. (1990), *Sir Huge: The Life of Huw Wheldon*, London, Michael Joseph.

Fine, D. (ed.) (1984), *Los Angeles in Fiction*, Albuquerque, University of New Mexico Press.

Friedman, M. (1983), *Hockney Paints the Stage*, London, Thames and Hudson.

Fuller, P. (1980), An Interview with David Hockney, *Beyond the Crisis in Art*, London, Writers and Readers Publishing.

Geelhaar, C. (1978), Looking at Pictures with David Hockney, *Pantheon* 36: 230-9.

Hamilton, R. (1982), *Collected Words 1953-1982*, London, Thames and Hudson.

Hardie, W. (1993), *David Hockney: Some Very New Paintings*, exhibition catalogue, Glasgow.

Haworth-Booth, M. (1983), Introduction to *Hockney's Photographs*, London, The Arts Council of Great Britain.

Hebdige, D. (1988), *Hiding in the Light: On Images and Things*, London, Routledge.

Henstell, B. (1984), *Sunshine and Wealth: Los Angeles in the Twenties and Thirties*, San Francisco, Chronicle Books.

Herbert, R. (1991), *Georges Seurat*, New York, Metropolitan Museum of Art.

Hewison, R. (1981), *In Anger: Culture in the Cold War, 1945-60*, London, Weidenfeld and Nicolson.

Hewison, R. (1986), *Too Much: Art and Society in the Sixties, 1960-75*, London, Methuen.

Hill, J. (1986), *Sex, Class and Realism: British Cinema, 1956-1963*, London, British Film Institute Publishing.

Hockney, D. (1976), *David Hockney by David Hockney: My Early Years*, ed. Nikos Stangos, London, Thames and Hudson.

Hockney, D. (1980), *Paper Pools*, ed. Nikos Stangos, London, Thames and Hudson.

Hockney, D. (1981), *Looking at Pictures in a Book*, London, National Gallery (repr. Hockney (1993), pp. 89-95).

Hockney, D. (1984), *Cameraworks*, London, Thames and Hudson.

Hockney, D. (1985), *On Photography: A Lecture at the Victoria and Albert Museum, November 1983*, Bradford, National Museum of Photography, Film and Television.

Hockney, D. (1993), *That's the way I see it*, ed. Nikos Stangos, London, Thames and Hudson.

Hoggart, R. (1957), *The Uses of Literacy*, Harmondsworth, Chatto and Windus.

Hopkins, H. T. (1988), A Remembrance of the Emerging Los Angeles Art Scene, *Billy Al Bengston Paintings of Three Decades*, San Francisco, Chronicle Books.

Jarman, D. (1987), *The Last of England*, London, Vintage.

Jarman, D. (1987), *At Your Own Risk*, London, Vintage.

Kahnweiler, D. H. (1947), Notes on my Painting, in *Juan Gris. His Life and Work*, London, Lund Humphries.

Klein, N. M. (1990), The Sunshine Strategy: Buying and Selling the Fantasy of Los Angeles, in N. Klein and M. Schiesl (eds.), *20th Century Los Angeles: Power, Promotion and Social Conflict*, California, Regina Books.

Knight, C. (1988), Composite Views: Themes and Motifs in Hockney's Art, in Tuchman (ed.), *David Hockney: A Retrospective*, Los Angeles County Museum of Art.

Krauss, R. (1978), *Grids*, New York, Pace Gallery; repr. in R. Krauss (1985), *The Originality of the Avant Garde and other Modernist Myths*, Cambridge, Mass., MIT.

Livingstone, M. (1981), *David Hockney*, London, Thames and Hudson (rev. edn. 1988).

Lucie-Smith, E. (1970), At Last – the Real David Hockney Steps Forward, *Nova*, April.

Lynton, N. (1965), London Letter, *Art International*, April.

MacCannell, D. (1976), *The Tourist: A New Theory of the Leisure Class*, London, Macmillan Press.

Marchand, B. (1986), *The Emergence of Los Angeles*, London, Pion Ltd.

Masters, B. (1985), *Swinging Sixties*, London, Constable.

Melia, P., and Luckhardt, U. (1994), *David Hockney: Paintings*, Munich, Prestel.

Mellor. D. (1983), David Bailey, 1961-66: From 'New Wave Photographer' to the 'Box of Pin-ups', in D. Bailey, *Black and White Memories*, London, Victoria and Albert Museum.

Mellor, D. (1993), *The Sixties Art Scene in London*, London, Phaidon Press.

Melly, G. (1970), *Revolt into Style: The Pop Arts in Britain*, Harmondsworth, Allen Lane, The Penguin Press.

Melly, G. (1993), Pop Record, *Art Review*, April.

Nehring, N. (1993), *Flowers in the Dustbin: Culture, Anarchy and Postwar England*, Michigan, The University of Michigan Press.

Nelson, H. J. and Clark, W. A. V. (1976), *Los Angeles The Metropolitan Experience*, Cambridge, Mass., Ballinger Publishing Company.

Nevett, T. R. (1982), *Advertising in Britain: A History*, London, Heinemann.

Pollock, G. (1992), *Avant-Garde Gambits 1888-1893: Gender and the Colour of Art History*, London, Thames and Hudson.

Pointon, M. (1993), *Hanging the Head: Portraiture and Social Formation in Eighteenth Century England*, New Haven, Yale.

Procktor, P. (1991), *Self-Portrait*, London, Weidenfeld and Nicolson.

Prust-Walters, J. (1965), The Young Peacock Cult, *Daily Express*, 3 May.

Quant, M. (1966), *Quant on Quant*, London, Cassell.

Rechy, J. (1964), *City of Night* [1963], London, MacGibbon and Kee.

Robertson, B. (1963), The New Generation: Opportunities and Pitfalls, *The Times*, 17 December.

Robertson, B., Russell, J. and Snowdon, Lord (1965), *Private View*, London, Nelson.

Ross, A. (1989), *No Respect: Intellectuals and Popular Culture*, London, Routledge.

Shapiro, M. (1973), *Words and Pictures: On the Literal and the Symbolic in the Illustration of a Text*, The Hague, Mouton.

Shone, R. (1988), Pop Goes the Myth, *The Observer*, 30 October.

Sigal, C. (1960), *Weekend in Dinlock*, London, Penguin.

Silver, K. (1988), Hockney on Stage, in Tuchman (ed.) *David Hockney: A Retrospective*, Los Angeles County Museum of Art.

Silver, K. (1992), Modes of Disclosure: The Constructions of Gay Identity and the Rise of Pop Art, in R. Ferguson (ed.), *Hand Painted Pop*, Museum of Contemporary Art, Los Angeles.

Soja, E. (1989), *Postmodern Geographies*, Verso, London.

Sontag, S. (1966), Notes on 'Camp', in S. Sontag, *Against Interpretation*, New York, Farrar, Strauss and Giroux.

Sorkin, M. (1982), Explaining Los Angeles, *California Counterpoint: New West Coast Architecture* catalogue 18. Institute for Architecture and Urban Studies and Rizzoli International Publications, Inc.

Stemp. R. (1988), David Hockney, *The Artist*, January.

Tuchman, M. (ed.) (1981), *Art in Los Angeles: Seventeen Artists in the 1960s*, Los Angeles, Los Angeles County Museum of Art.

Tuchman, M. (ed.) (1988), *David Hockney: A Retrospective*, Los Angeles and London, Los Angeles County Museum of Art and Thames and Hudson.

Watney, S. (1989), The Warhol Effect, in G. Arrrels (ed.), *The Work of Andy Warhol*, Seattle, Bay Press.

Webb. P. (1988), *Portrait of David Hockney*, London, Chatto and Windus.

Weeks, J. (1977), *Coming Out: Homosexual Politics in Britain from the Nineteenth Century to the Present*, London, Quartet.

Weight, C. (1967), Retrospective, *Queen*, June.

Weschler, L. (1982), *Seeing is Forgetting the Name of the Thing One Sees: a Life of Contemporary artist Robert Irwin*, California, University of California Press.

Weschler, L. (1988), A Visit with David and Stanley, Hollywood Hills 1987, in Tuchman (ed.), *David Hockney: A Retrospective*, Los Angeles County Museum of Art.

Whiteley, N. (1987), *Pop Design: Modernism to Mod*, London, The Design Council.

Whittet, G. S. (1963), David Hockney, *Studio*, December.

Wraight, R. (1963), Hic, Haec, Hockney, *The Tatler*, 19 December.

Wraight, R. (1965), *The Art Game*, London, Leslie Frewin.

Yorke, E. (1962), Clown With Vision, *Town*, September.

Index

Page references in italic refer to figures; the prefix 'pl.' refers to colour plates and is followed by the plate number.